Locating the Past / Discovering the Present

Locating the Past /

Discovering the Present

Perspectives on Religion, Culture, and Marginality

EDITED BY DAVID GAY AND STEPHEN R. REIMER

 The University of Alberta Press

Published by
The University of Alberta Press
Ring House 2
Edmonton, Alberta, Canada T6G 2E1
Copyright © 2010 The University of Alberta Press

Library and Archives Canada Cataloguing in Publication

Locating the past/discovering the present : perspectives on religion, culture, and marginality / edited by David Gay and Stephen R. Reimer.

Includes bibliographical references and index.
ISBN 978-0-88864-499-2

1. Religion and culture. 2. Marginality, Social—Religious aspects.
I. Gay, David Brian, 1955- II. Reimer, Stephen R. (Stephen Ray), 1955-

BL65.C8L63 2010 201'.7 C2009-906600-9

First edition, first printing, 2010.
Printed and bound in Canada by Houghton Boston, Saskatoon, Saskatchewan.
Copyediting and Proofreading by Brendan Wild.
Indexing by Adrian Mather.

The University of Alberta Press is committed to protecting our natural environment. As part of our efforts, this book is printed on Enviro Paper: it contains 100% post-consumer recycled fibres and is acid and chlorine free.

The University of Alberta Press gratefully acknowledges the support received for its publishing program from The Canada Council for the Arts. The University of Alberta Press also gratefully acknowledges the financial support of the Government of Canada through the Book Publishing Industry Development Program (BPIDP) and from the Alberta Foundation for the Arts for its publishing activities.

The University of Alberta Press gratefully acknowledges the Dimic Institute for Comparative and Cross-Cultural Studies for supporting the publication of this book.

 Canada Council for the Arts / Conseil des Arts du Canada

In memory of Dietlind Bechthold

Contents

Acknowledgements

This book originated in a conference held at the University of Alberta in May 2006: *Meaningful Marginalities: Religious Influences and Cultural Constructions.* We thank all of the speakers and delegates who attended the conference. In particular, we are grateful to Earle Waugh, former Director of the Dimic Institute for Comparative and Cross-Cultural Studies at the University of Alberta, for initiating the conference. We also wish to thank Patricia Demers and Odile Cisneros, current Co-Directors of the Dimic Institute, for their encouragement of this publication. This book reflects the Dimic Institute's mission to promote studies that engage comparative perspectives and cross-cultural contexts. We also wish to thank the conference organizing committee, which, along with the co-editors of this volume, consisted of Alexandra Amiekus, Willi Braun, Patricia Demers, Waclaw Osadnik, Natalia Pylypiuk, and Earle Waugh. The committee, with members from across the Faculty of Arts at the University of Alberta, reflects the commitment to interdisciplinary studies found in this book. We are very grateful to the many colleagues who assisted us in the selection of essays for this volume in the weeks after the conference. We thank the University of Alberta Conference Fund for its generous support of the conference. We particularly appreciate the efforts of Willi Braun, then Director of the Interdisciplinary Program in Religious Studies at the University of Alberta, for his advice and support, and for his efforts in securing a Social Sciences and Humanities Research Council (SSHRC) of Canada grant in support of the conference, and we express our gratitude to SSHRC for supporting this publication as part of that grant.

Linda Cameron, Director of the University of Alberta Press, and her staff have been generous in their support of this project. In particular, we are grateful to Peter Midgley for overseeing the publication process with consummate professionalism and constant encouragement. We also wish to thank Lindsay Parker for her indispensable and efficient management of the evaluation of the manuscript. The anonymous readers engaged by the press contributed much to the final product through their recommendations and suggestions. We are also grateful to Alan Brownoff for helpful

consultations on design and illustration in the book; to Mary Lou Roy for providing valuable editorial support during the book's production; and to Cathie Crooks and Jeff Carpenter who assisted with its promotion. We also appreciate the contribution of Michael Luski in our early consultations with the press. The editors take pride in contributing this volume to the list of publications of the University of Alberta Press.

No effort in the academic world can succeed without the help, advice, and expertise of support staff in departments, faculty offices, and other academic units. We thank Melanie Marvin of the Department of History and Classics for her assistance in managing the SSHRC grant that supported this effort. In particular, we offer our abiding gratitude to the late Dietlind Bechthold who, from her position in the Department of History and Classics, worked diligently to ensure the ultimate success of this project. Her work in publicity and her help with the overall co-ordination of the originating conference demonstrated her exceptional level of creativity and professionalism. Faculty and staff who had the pleasure of working with Dietlind valued and admired these qualities. Since her passing in 2007, she is greatly missed by all who knew her. We dedicate this book to her memory.

Introduction

> The concept of culture I espouse...is essentially a semiotic one.
> Believing, with Max Weber, that man is an animal suspended in webs
> of significance he himself has spun, I take culture to be those webs, and
> the analysis of it to be therefore not an experimental science in search
> of law but an interpretive one in search of meaning. It is explication
> I am after, construing social expressions on their surface enigmatical.
> —Clifford Geertz, "Thick Description" (5)

This famous articulation of an "interpretive anthropology" is used here to
contextualize a collection of essays that explore a number of these enig-
matical surfaces, examining the webs of semiotic connection through
which their cultural significations can be read. Taking as their starting
points a wide variety of social actions and behaviours, these essays are
a series of explications of these actions as human, social, and cultural
expressions, taking "culture" in the sense that, again, Geertz gives it, as
the context within which social actions take on significance and through
which they can be understood (Geertz 14). These essays, moreover, are
cross-cultural explorations that seek meanings across broad categories—
European and non-European, historical and contemporary, similar and
other—in order to study the variegated performance of fluid identities
within cultural contexts. Specifically, these are studies of contact and
conflict between insiders and outsiders, centres and margins, Jews and
Christians, Slavs and Greeks, ancient ritual behaviours and modern televi-
sion broadcasting, as part of the negotiation of new identity positions, rela-
tionships, accommodations, and syncretic formations. While this volume
presents comparative perspectives and the meaningful juxtapositions they
make available, it does not seek to reinforce or stabilize basic polarities or
familiar binaries; rather, these trans-historical and cross-cultural perspec-
tives attend to the mobility and persistence of cultural influences derived
primarily from religion. These essays explore the many ways in which it is
apparent that genders, classes, and ethnicities are not primordial, not fixed

and stable, but are fragmented, conflicted, unstable, and constantly recombining in response to cross-cultural contact.

The essays fall into two groups: "Locating the Past" focuses on the medieval and early modern period; "Discovering the Present" explores modern and contemporary texts and contexts. This clustering highlights the central goal of the collection, which is to examine how religious ideas, themes, and images, emanating from different times and locations, undergo new forms of production, interpretation, and recreation in other historical and cultural settings. While the individual essays offer new perspectives on the relationship between religion and culture, the basic juxtaposition of past and present between these groups achieves a comparative perspective on the persistence and the transmission of religious influences.

The three key terms in the subtitle—religion, culture, and marginality—inform the volume. Religion is central. Each essay explores religion as it is established in human associations and social formations, expressed in communal and ritual practices, and communicated in the recreation and interpretation of cultural texts. The two traditional etymologies of *religion*, though basic and familiar, call attention to the enigmatical surfaces this term evokes. *Religion* is thought to have been derived from the Latin *religare*, meaning "to bind, to tie up"; the word thus suggests a sense of religion as "obligation" ("ligature," "fastening," the binding obligation to show reverence to the divine), but *religare* also carries the sense of "mooring," being safely bound to a dock within a sheltered harbour. The social ligature that is religion, furthermore, can be a form of "binding together" the diverse parts of the self, the community, the culture, and in some sense the cosmos as a particular culture may understand it. In this way, then, religion has, historically, played a central role in the formation and re-formation of cultures and communities. The alternative etymology, from *relegere*, identifies religion as reading, discerning, and recognizing. This aspect of religion impels the activities of explication and interpretation that Geertz asserts. Reading makes religious influences from the past visible in the present through comparative perspectives.

Culture is the second term informing these essays. Geertz's emphasis, in our epigraph, on the semiotic focus of cultural studies is particularly fruitful for this collection: each author in this volume identifies and interprets

distinctive patterns of meaning framed in disciplinary and interdisciplinary modes of inquiry. Moreover, these patterns are not isolated in singular cultural contexts; they offer remarkable instances of the mobility of religious ideas in trans-historical, cross-cultural, and even multi-media environments. We encounter this movement between media, for example, in Robert Menzies's study of the representation of Hindu religious epics in the medium of television, and between "high" and "popular" culture in Shya Young's consideration of the tension between orthodox religious scholarship and the lore of popular magic and superstition surrounding the Kabbalah. We find it also in the relation of life and art in medieval Paris (Sheila Delany), in orthodox and dissenting religious cultures in seventeenth-century England (Paul Dyck), in the narrative juxtaposition of ancient Macedonia and contemporary Canada (Myrna Kostash), in recreations of visual texts from the medieval world to the modern (Eva Maria Räpple), and in the interaction of sight and blindness from biblical narrative to contemporary film (David Gay). Questions of subjectivity, agency, identity, and memory in relation to feminism (Janet Catherina Wesselius) and martyrdom (Chris K. Huebner) include the disciplines of philosophy and critical theory as sites of reading religious influences.

The third term in this set of relationships, *marginality*, calls attention to the cultural conditions under which religious ideas, texts, and images re-emerge in successive contexts. Marginality is not an assumed or fixed idea in this collection: it is a function of the different perspectives the writers provide. Consider, for example, the familiar, even pejorative, definition of the *marginal* as found in the *Oxford English Dictionary*: "Of an individual or social group: isolated from or not conforming to the dominant society or culture; (perceived as being) on the edge of a society or social unit; belonging to a minority group (frequently with implications of consequent disadvantage). Also: partly belonging to two differing social groups or cultures but not fully integrated into either." The social emphasis in this definition is unquestionably important and pertains to a number of oppressed groups and communities identified in this volume; nevertheless, the more basic sense of marginality as a phenomenon "relating to an edge, border, boundary, or limit" suggests the full range of possibilities that the writers in this volume claim. Edges, boundaries, borders, and limits become sites for what Stuart Hall calls "the production and exchange of meanings—'the giving

and taking of meaning'—between the members of a society or group" (2). Enigmatical surfaces are not end points, but become interfaces, borders, or membranes of cultural exchange. The essays in this collection observe these surfaces in the movement of religious ideas, practices, and texts; as such, the volume is ultimately a collective effort to discern through comparative perspectives the continuing influence of religion on culture, and the interplay between religious influences and cultural productions.

The essays of the first part of the volume examine some particular "enigmatical surfaces" encountered in historical contexts, particularly medieval and early modern. In the first essay, for instance, Sheila Delany draws connections between Chaucer's *Prioress's Tale* and a specific historical act of anti-Semitism in Paris to examine the "socio-literary dynamic of poetic process," while her "hypothesis has the advantage of being based in a well-known event of Chaucer's later years." While Chaucer's tale is "traditional" in one sense (the story survives in thirty-eight versions besides Chaucer's), Delany argues that Chaucer's treatment of the tale shows the influence of an event that occurred in Paris in 1394 and that represents "a strand of late-medieval history often effaced from medieval literary and historical scholarship generally." The event concerns the disappearance of a Jewish convert to Christianity and the subsequent retaliatory persecution of the Jewish community. *The Prioress's Tale* illustrates a case of life influencing art: uncertainty over Chaucer's attitude about the events he imported into his writing from across the English Channel makes the tale a "multi-vocal representation of Jews in late Middle English literature."

Following Delany's examination of Jewish-Christian relations in medieval Europe, Shya Young's consideration of Christian Kabbalah explores the appropriation of Jewish mystical texts into Christian forms in the early modern period. Locating the Christian Kabbalah within a world view that assumed the interpenetration of natural and supernatural spheres, Young examines the cross-religious and cross-cultural encounters between Kabbalistic texts and practitioners in early modern Europe. The Christian Kabbalah could be used for a range of religious and cultural purposes, including converting the Jew to Christianity, linking religion to magic, and expanding the perspective of orthodox Christian theology. Marginalized by academic and religious elites in the period, the Christian Kabbalah persisted as a cultural influence, and it represents a synthesis

"carved out of different religious traditions and philosophies." As such, the transmission and interpretation of these texts challenge the concept of marginality as an effect of the overall organization of knowledge.

Paul Dyck's study of book production at Little Gidding extends the examination of early modern textual and devotional practices to the case of a self-marginalized Christian community. Founded by Nicholas Ferrar and located in a town north of London, Little Gidding was a religious community living at the margins of the contentious and polarized religious and political culture of seventeenth-century England. The community became a unique confluence of religious influences, sharing the Puritan rejection of the extravagance of the Stuart court while valuing many of the ideas and practices of the Roman Catholic tradition that was often anathematized in Protestant England. The circulation and production of religious texts as acts of self-definition for the community is the focus of this study. Members designed conversations to explore the significance of specific days in the liturgical calendar, and they constructed gospel harmonies by cutting apart and reforming printed copies of the New Testament. Textual production at Little Gidding illustrates the reception and expression of a range of religious texts and influences, thereby presenting another instance of the interaction of life and art: the community "read, wrote, translated, edited, and compiled texts that not only recorded its key ideas, but enacted them, so much so that Little Gidding's textual practices played a central role in the community's ongoing formation."

Similar to Janet Wesselius's critical alignment of feminism and religious thought later in the volume, Eva Maria Räpple's "The Seductive Serpent" focuses on the body of Eve in representations of the moment of the Fall, of Original Sin. With particular attention to Eve's encounter with the serpent, Räpple shows how visual experience encompasses both "immediate perception" and "cognitive conceptualization." The essay explores the visual interpretation of the Fall in five examples comprising a chronology from the medieval, early modern, and modern periods. These include the iconography of the Fall in the tenth-century Escorial "Beatus," the frieze of Eve in the Cathedral of St Lazare in Autun, the fresco of the *Creation of Eve and Original Sin* in the Green Cloister of Santa Maria Novella in Florence, and *Eve, the Serpent, and Death* by Hans Baldung. Through this trans-historical comparison, Räpple shows how the "different roles that

diverse female bodies take on in their respective traditions" reflect "histori-
cally located perspectives on the flesh and sexuality," and she illustrates
the interplay between "biblical textual tradition" and images that "refer to
those traditions while also recreating them."

The second group of essays focuses upon "contemporary configurations,"
and this section begins with "Memoirs of Byzantium." In this memoir of
travel and ancestry, Myrna Kostash focuses on the figure of St Demetrius,
the patron and guardian of the Greek city of Thessalonica. Martyred in
304 CE, Demetrius would prove to be "one of the most powerful saints in
Christendom," being credited with the repulsion of Slavic invaders three
hundred years after his martyrdom. As a member of the Ukrainian Orthodox
Church in Canada, which celebrates the annual feast day of Demetrius,
and as a person of Slavic ancestry and hence a descendant of the invaders
Demetrius repelled, Kostash reflects on the borders and margins inherent
in her narrative point of view. In a rich interweaving of anecdotal biography,
family history, national and ethnic identities, and Byzantine historiography
and iconography, the author seeks to understand, from the perspective of a
contemporary Ukrainian-Canadian writer, "what happened at the moment
of [the] transformation of the Slavic world by the Christian Gospel."

In the next essay, David Gay considers *The Strange Encounters and Timeless
Wanderings of a Man Named R*, a short film produced in 1992, in which British
filmmaker Ken McMullen travels imaginatively from Europe to Greece to
ancient Assyria alongside "R," an artist searching for Rembrandt and his
sources. As an artist working in a visual and verbal medium, McMullen
explores and combines the themes of sight and blindness in Milton and
Rembrandt, emphasizing their shared interest in the biblical figure of
Samson. McMullen introduces the figure of Menasseh ben Israel, a member
of the Amsterdam Jewish community, a friend of Rembrandt, and an advo-
cate for the readmission of Jews to England in the 1650s. A member of a mar-
ginalized religious community, Menasseh provides the insights of rabbinic
learning to both Milton and Rembrandt in their treatment of Samson and
other biblical narratives. Notably, Menasseh ben Israel decodes the "writing
on the wall" depicted in Rembrandt's *Belshazzar's Feast*, demonstrating how
marginal influences can inform prominent works of Western art. This essay
complements Kostash's focus on travel and identity while introducing the
medium of film into the collection.

Following from Kostash's questioning of the interplay of religious and ethnic heritages, Chris K. Huebner's "Marginality, Martyrdom, and the Messianic Remnant" offers a broad theoretical interrogation of the concept of marginality. Observing how the figure of St Paul functions in recent critiques of marginalization and global capitalism by Badiou and Žižek, Huebner identifies Paul's new kind of subject with the martyr as an "alternative to the standard metaphors of subjectivity and political agency, namely victory and victimhood." The essay traces current thinking on martyrdom and marginality in the writings of the English cleric Rowan Williams and the German novelist W.G. Sebald, whose novel *Austerlitz* presents the "complicated relationship between memory, identity, and the possibility of speech in the midst of marginalization and meaninglessness." Invoking recent work by Giorgio Agamben, Huebner argues that the martyr continues to represent a "transformed subject" and a "new kind of political agency."

Complementing Huebner's theoretical appraisal of marginality and subjectivity, Janet Wesselius offers a broad perspective on the shared marginalization of feminism and religion in relation to the discipline of philosophy. Despite the distance that can exist between their two communities, Christian philosophers and feminist philosophers share a condition of marginalization because their respective religious and political commitments "do not submit to the judgement of reason alone," and so place them on the defensive within a larger discipline. The feminist axiom, that all knowledge is situated, presents a challenge to the central-versus-marginal orientation of "mainstream" philosophy; in consequence, the capacity of feminist philosophy to contest its marginalization resonates with the condition of Christian philosophy. Feminist philosophers challenge the male gender of a sovereign reason in mainstream philosophy by situating knowledge; similarly, Christian philosophers can argue that the assertion of autonomous reason is an inherently religious choice on the part of philosophy. The analysis of "common motivations and strategies" between these two marginalized philosophic communities can mark a starting point for those seeking to integrate the "identities of philosopher, feminist, and Christian."

Extending the religious and cultural compass of the collection, and complementing treatments of film and visual art by other contributors,

Robert Menzies, in the final essay, considers the transformation of a religious text by the visual and dramatic medium of television. The 1987–1988 adaptation of Valmiki's *Ramayana*, an ancient Sanskrit epic translated into nearly every language in India, became the most-watched television broadcast in India up to that time, with an audience estimated at eighty million people. Menzies attributes the popularity of the adaptation to the "aesthetic of the whole of the *Ramayana* tradition," rather than to artistic merit or commercial success. Watching the broadcast became a form of participatory religious ritual for many viewers, as is evident in the practices and activities Hindu families engaged in at the time of each episode. As Menzies argues, this manifestation of Hindu devotion "demonstrates the vibrancy of the tradition by using a new technology and in so doing modifies the use of that technology to maintain the continuities with the past."

This collection, then, considers a range of particular actions and moments that can be read as sites of conflict and accommodation, points at which new and syncretic identity positions are emerging. The essays presented here thus offer a series of studies in the ways in which cultural and religious expressions, in various times and various places, are central to the transactional nature of identity formation.

Works Cited

Geertz, Clifford. "Thick Description: Toward an Interpretive Theory of Culture." *The Interpretation of Cultures: Selected Essays*. New York: Basic Books, 1973. 3-30.

Hall, Stuart. "Introduction: The Work of Representation." *Representation: Cultural Representations and Signifying Practices*. Ed. Stuart Hall. Culture, Media and Identities. London: Sage Publications, in assoc. with the Open U, 1997. 1-11.

One Locating the Past

Historical Contexts

The Jewish Connection

Chaucer and the Paris Jews, 1394

SHEILA DELANY

And what rough beast, its hour come round at last,
Slouches toward Bethlehem to be born?
—W.B. Yeats, "The Second Coming"

But it isn't Bethlehem we need to look toward: rather, it is to Washington, DC,
Jerusalem, or Kabul, where all three Abrahamic religions have spawned
once-marginal factions that have become central, and the fundamental-
ist religious right creates national policies both domestic and foreign. This
and the last century offer ample instruction in how the marginal becomes
central—sometimes for better, sometimes for worse. We are, perhaps, dis-
tinctively well-suited to appreciate the nuances and contradictions of the
term *marginal* itself.

Even the history of medieval Jews gives pause here, for their social
"marginality," or exclusion from civic life in Catholic (though not Islamic)
regimes, is offset by their economic and ideological importance. In the
economic realm, huge sums in loans and taxes were extorted by Catholic
kings; ideologically, the Christian construction of Judaism as theological
arch-enemy engendered a mythos crucial to Christian self-definition and
collective coherence.

What follows, then, is an exercise in literary historicism that excavates
a small corner of that history, producing a unique palimpsest of religion,
culture, and marginality in a particularly poignant mix. Yet *historicism*, as
much as the other terms that form the thematic of this volume, comes in
many guises. It varies with the writer's notion of history in general, and
again with the kind of history she or he considers important to a given
work of art. Will it be the history of ecclesiastical thought, of urban devel-
opment, of peasant revolt, of nascent mercantile capital, of prostitution,

or leprosy? Will it be history diachronic or synchronic, *longue durée* or current events?

The history evoked here is the simplest of these: current events. But what is a "current event" if not the tip of an iceberg, the clue signifying and containing all the rest? The text I engage here, Chaucer's *Prioress's Tale*, could be treated with any historicism, as could any other text. For some readers, this narrative about Jews killing a Christian child is self-evidently anti-Jewish, privileging a narrator whose authority rests on her ecclesiastical status and her powerful rhetoric. Others have devised approaches to the tale that elicit a proto-humanist, satirical, anti-clerical author animating an oblivious and thus unreliable narrator in a critique of late medieval anti-Semitism. My reading cannot resolve this long-standing and probably unresolvable interpretive dilemma. It does, though, like other historicist readings of the *Prioress's Tale*, permit a tantalizing glimpse into the socio-literary dynamic of poetic process. My hypothesis has the advantage of being based in a well-known event of Chaucer's later years.

Chaucer's *Prioress's Tale*, a Marian miracle story, has thirty-eight extant variants and analogues, sharing with them the following plot: a young Christian male is murdered by a Jew or Jews; the Virgin Mary's miracle enables detection of the crime; the perpetrator is usually punished or converts. Yet, distinctively among these versions and variants, the Chaucerian tale also resembles, in several important details, a notorious incident of anti-Jewish violence that occurred in Paris in 1394. This incident in turn resembles and was certainly influenced by the same type of popular Marian miracle tale on which Chaucer modelled the narrative of his Prioress. Hence this particular ensemble of events and texts offers an especially striking instance of the imbrication of life and art.

The events I adduce preceded—though are unlikely to have caused—the expulsion of the Jews from France under King Charles VI in 1394. These events have not been discussed in connection with Chaucer; they represent a strand of late-medieval history often effaced from medieval literary and historical scholarship.[1] Much as "women's history," some decades ago, had to be placed on the scholarly agenda in sometimes contrived ways until it was mainstreamed, so Jewish socio-cultural history still requires a conscious effort of inclusion, and will do until it is seen as a source of data for medievalists that is equivalent to any other.

In the conspicuously hard-to-date Chaucer canon, the *Prioress's Tale* is even more slippery than most of the master's works. Beverly Boyd, editor of the Variorum text, observes that "the date…has awakened little interest and no real argument" (*Variorum* 27), but critical opinion has run the spectrum of possibilities. Florence Ridley writes that the tale "cannot be dated precisely," but that verse form, style, and sources seem to place it in Chaucer's "Italian period," that is, the early 1370s (Chaucer 913). Sumner Ferris places the tale in mid-career: 1387, when Richard II visited Lincoln Cathedral in an attempt to reconsolidate his disputed royal power.[2] The Variorum edition offers a consensus that the poem is "late"—probably from the 1390s—on the basis of stylistic sophistication and the use of rhyme royale. My hypothesis weighs in on the side of the Variorum, although the dating is not my main concern here but, rather, a side effect.

Chaucer and Jews

Little of Chaucer's work takes explicitly religious form. The *Prioress's Tale*—heavily liturgical in rhetoric, ardently devotional in genre, and the only Chaucer work to animate post-biblical Jews directly, as characters—is anomalous in his oeuvre.[3] As prelude to the relevant historical narrative, I should like to establish both textual and biographical justification for making "the Jewish connection."

First to textuality. The words that Chaucer places in the Host's mouth when Harry Bailey solicits the Prioress for a tale already anticipate the Jewish-oriented subject matter to come. "But now passe over, and let us seke aboute" (VII.1633), says Harry, punning on the Jewish holiday, Passover, that is celebrated in early spring, the time of the Canterbury pilgrimage.[4] Passover is precisely the event that initiated the Jews' "seeking about," their proto-pilgrimage as they wandered the desert seeking the promised land, after the angel of death had passed over Jewish households in Egypt and the Jews had crossed the Red Sea (Exodus 12:23, 27).[5] We are thus placed in the figural discourse of Jewish "old law" and Christian "new law"—indeed, a medieval Catholic would say we are "always already" in that discourse, for it is a doctrinal premise of the Christian belief system (cf. esp. Hebrews 8–9). This interpretation fits Chaucer's overall portrayal

of Harry Bailey as pre-salvational "natural man"; it is also consistent with the pervasive Pauline-Augustinian doctrinal undercurrent in the *Tales* as a whole.

What, or how, could Chaucer have known about Jews when they were expelled from England in 1290? Does this mean that his awareness of Jews was completely and only textual? This simplistic inference can be maintained only at the cost of biographical and social reality. To be sure, Chaucer might have encountered the occasional Jew or converso in London (cf. Kelly, "Jews and Saracens"), but much more likely, in my view, are foreign experience and information. Chaucer was a government official, a courtier, a career diplomat, a customs officer, and a member of parliament. He moved in the exalted social circle of John of Gaunt, probably the most powerful man in Europe, and he travelled extensively. Among the cities he visited were Rheims, Chartres, Calais, Paris, Montreuil, Milan, Genoa, and Florence; he spent time in Lombardy, in the Spanish province of Navarre, and probably several cities in Spain. Some of these places had thriving Jewish communities, as did other towns near them.[6] Chaucer is thus likely to have seen or met Jewish merchants, physicians, scribes, booksellers, musicians, actors, illuminators, scholars, translators, and moneylenders at the courts and in the cities that he visited.

Navarre, England's ally in the ongoing war against France (the "Hundred Years War"), welcomed Jews and Muslims and treated both fairly well. Pedro of Castile, later father-in-law to John of Gaunt and celebrated by Chaucer in the *Monk's Tale*, had good relations with Jews and Muslims, thus earning the sobriquet "king of the Jews." Among Pedro's officers was Don Samuel Halevi of Toledo, his chief treasurer, who helped fund the construction of a Toledo synagogue in 1357 (Russell 444).[7] John of Gaunt's dynastic ambitions in Castile, his personal military campaign there on behalf of Pedro, and England's general Iberian interests would require substantial knowledge of current events in that area for a courtier-ambassador, even without direct witness.[8] But there were dramatic events to witness, for the Jewish question was high on the Iberian agenda precisely during the several weeks of Chaucer's attested presence there (22 February–24 May 1366) and for years afterward. Pedro's protectionist attitude became a major bone of contention in the civil war between Pedro and his half-brother, Henry of Trastamara. Estow observes that "Pedro's

apparent defense of 'his Jews' offered his opponents…a powerful ideological tool with which to undermine the king's authority and garner wider support for [Henry's] political ambitions" (155). To quote Baer at length:

> In 1366 the decisive struggle…began….One of the demands of this revolt was…the dismissal of all foreign advisors—in this instance, the Jews….All [Pedro's] harsh and evil deeds were attributed to his Jewish advisors. Henry's French knights, in whose country the Jews were not so influential as in Spain, exaggerated the importance and the role of the Jews…in their polemical verses. Henry used the anti-Jewish class bias as it served his purposes. The Jews suffered equally from the depredations of the soldiery of both parties. In the spring of 1366 the whole Jewish community of Briviesca, numbering about two hundred families, was massacred by Henry's troops and those of Bertrand du Guesclin, the famed commander of the French mercenaries.
>
> Later, in April 1366, when Henry took the city of Burgos, he demanded an immense sum of money…from the local Jews; and those who could not pay their share were sold into slavery. One of Henry's first acts on ascending the throne was to declare a general moratorium on Jewish loans. This prompted the Christians of Segovia and Avila to attack their Jewish neighbors and to seize the promissory notes and pledges they had given them. [In the Cortes of February 1367, the estates demanded cancellation of Jewish loans and demolition of protective forts in Jewish quarters; that no Jewish officials or physicians should be employed by any royalty; that Jewish tax-farmers be dismissed.][9]
>
> Meanwhile, the Black Prince (of Wales) came to Pedro's help. The English soldiery wiped out the Jewish communities of Villadiego and Aguilar de Campóo. (364–66)

It is unthinkable Chaucer would not have known about these developments, particularly as they impacted his own nation's foreign policy. Persecution of Jews in Spain intensified throughout the century, and the English played a part in this trend too, for the Lancastrian settlement in Castile during the 1370s imposed new measures for segregating Jews and Muslims from Christians (Russell 497). Persecution spread to Andalusia

and Navarre during the remainder of the century, culminating in what Baron called "the catastrophic year 1391" (10: 153), a year when, as Graetz wrote, Spain became "a purgatory to the native Jews" (4: 177): a year of widespread pogrom, massacre, and forced conversion.

By the same token, Chaucer would have to have known about the expulsion of the Jews from France in 1394 and the well-publicized episode leading up to it. England and France were at war or at truce throughout Chaucer's lifetime; the two cultures were virtually interpenetrated at the upper levels; the incident in question was no obscure rural brouhaha but involved Parlement (equivalent to the Supreme Court), high ecclesiastical officials, and royal authority in the capital city. There is no way a man in Chaucer's position could avoid knowing about the scandal. Here, then, is a brief account, synthesized from several sources, of that sad story and the background to it.

The Jews in France

The Jews' residence in France was extremely unstable. They had already been expelled twice during the fourteenth century (in 1306 by Philip le Bel, and in 1322 by Charles IV).[10] They had been threatened with expulsion at other times and had averted it by paying large sums (e.g., in 1363); they suffered frequent individual abuse, violence, and property seizure, as well as organized pogroms throughout the realm. The "fort/da" quality of their presence and absence was dictated, as elsewhere, by economic and ideological considerations.

In France, the financial motive was revealed with special blatancy in 1359, when Charles V, then regent, authorized the Jews' return from exile for a period of twenty years in order to use their taxes to pay the ransom for his father, John II (the Good), then held prisoner in England. Still, the reign of Charles V (1364–1380) was a relatively benign one for French Jews. The monarch granted various financial concessions and released the Jews from two particularly humiliating obligations: one decreed by the Fourth Lateran Council of 1215, that of wearing the identifying badge (*rouelle*), the other locally decreed, requiring attendance at Christian sermons.

The next reign, that of Charles VI, began ominously in 1380 with nobles demanding a new expulsion of the already diminished Jewish population, and with anti-tax and anti-Jewish riots. Jews were regarded by the masses as accomplices of the corrupt, spendthrift regime, which Jews did in fact help to finance with loans, so a protest against new taxes often became an attack on Jews. Again in 1382 the so-called "Maillotin" rioters, armed with lead pipes, protested new taxes and pillaged Jewish homes in Paris and elsewhere for days.

In January 1394 there occurred in Paris a well-publicized event—indeed "une affaire célèbre," as Boulet puts it—with some structural similarities to the Chaucerian narrative and to its literary analogues in the Marian miracles.[11] A convert from Judaism to Christianity, Denis Machaut, disappeared. It was rumoured he had been abducted by Jews. Seven prominent Jews were accused of kidnapping him, or killing him, after bribing him to renounce his new faith;[12] several of them were tortured. A jurisdictional dispute between civil and ecclesiastical authorities erupted but was resolved in favour of the former: although the bishop of Paris claimed the case because it involved the Christian faith, the "procureur du roi" nonetheless ruled it a civil case because it did not touch the faith directly, and because the Jews, being outside the faith, were not bound by its laws. The case was therefore turned over to the provost of Paris (Félibien 4: 546 ff., following Galli). The accused formally denied the charges but, despite a complete lack of evidence against them, were condemned to the stake. As the contemporary monastic chronicler Michel Pintoin remarks, Machaut was well known and had previously complained about violence from the accused, and when he was no more seen, the suspects were subsequently condemned because strong presumption worked against them.[13] However, the provost's death sentence struck many as obviously too harsh ("nimis dura": Galli, in Boulet 422), so that the parliamentary lawyer Joannes Galli and others won commutation of the sentence. Instead, the accused were transported through the city, naked, in a wagon on a Saturday (the Jewish Sabbath), and whipped bloody ("usque ad sanguinem": Pintoin) in an area of dense Jewish population.[14] Further whippings were appealed and, in turn, commuted to confiscation of property, imprisonment, and a large fine (most of which went to renovate a bridge, the Petit-Pont).

Later that year—some say on 15 July, others say on Yom Kippur, 17 September—King Charles issued an edict of expulsion. It seems that no official reason was given beyond reference to general trouble and complaints. The departure of the Jews took place over the next year or more, through 1395, and was accompanied by an increase in taxes paid by Jews in both 1394 and 1395; the 1394 amount came to nearly 11 per cent of the total royal income for that year (Kohn, "Les Juifs" 44).[15] The group imprisoned from the Machaut affair were kept in Paris until 1397, when they were taken to Macon, at the limit of French territory, and exiled. In a house at Faubourg St-Denis there were later found 114 volumes of Jewish books, four Torah scrolls, and many books of the Bible; these the Treasurer of France delivered to Gilles Mallet, the king's librarian at the Bibliothèque de la Louvre (Sauval 521).[16]

There is more to this story. Let us come back to the missing convert, Denis Machaut, who was not a nobody. Some chroniclers write that he may have been a rich merchant; others, a petty criminal and money-clipper.[17] Were he prosperous, he might, as Kohn suggests, have benefited from a new ordinance of April 1393, permitting the convert to retain his property (Kohn, *Les Juifs* 253). Moreover, Machaut was not unknown to the Parisian courts, or to leaders of the Jewish community. In the year before his disappearance, 1393, he had been at the centre of another religious-legal controversy, and a particularly poignant one at that: a custody dispute stemming from his conversion. This first part of his story is as relevant as the second to my hypothesis of Chaucerian representation.

According to law of the period, when a married Jew converted but his wife did not, their children could be taken from the mother to be educated and baptized as Catholics, at the expense of the parents. Denis Machaut and his Jewish wife, Lyonne de Crenu, had four children, ranging in age from two months to eleven years, whom the provost of Paris ordered taken from their home. Lyonne de Crenu appealed this ruling to Parlement on behalf of her five-year-old son, who was ill and whom the father therefore wanted baptized immediately; moreover, the boy himself said that he desired baptism.[18] A lawyer and king's counsellor, Guillaume Porel, was appointed to visit the child and make a decision (Sauval 524); he confirmed the provost's ruling.

One may suppose that the Jewish leadership would be distressed at the forcible distraint and loss of four Jewish children, and might well attempt a financial intervention—not necessarily to persuade the father to apostasize, but perhaps to convince him to waive custody in favour of the mother to preserve the remaining integrity of a Jewish family and the number of their already diminished community. Moreover, Machaut's defection would increase the community's financial burden, for it would have to absorb his share of the communal tax (Schwarzfuchs 74-75); thus, there could well have been an effort to get him to pay his share.

Chaucer's Version

With this real-life narrative in mind, let us return to the Chaucerian miracle. Does it contain any features that more closely reflect social reality than do other Marian miracles? I think so. To be sure, several motifs in Chaucer's tale are common to both some literary analogues and the Machaut case. In both literature and life, there is the male who performs an act of special Christian piety: in the miracle tales it is the little clergeon's song; in real life it is Machaut's conversion. In both, there is the alleged slaying or abduction of this pious Christian male by a Jew or Jews. In both, a distraught mother makes a public outcry on behalf of the son she has lost: in the literary analogues, a Catholic mother goes house to house to find a murdered son; in Paris, a Jewish mother goes to Parlement to reclaim a forcibly estranged son. In both art and life the Jews are extravagantly punished, with little attention paid to judicial process.

What, then, is distinctive about Chaucer's version of the Marian miracle? What Chaucer imports from history is, first and foremost, money. In Marian miracle stories Jews are perfidious, impious, malicious, envious, and/or cruel. The tales' focus is on their immorality, as might be expected in these items of doctrinal propaganda.[19] In almost all Marian miracles, though, the Jews are not placed in a social context. Only infrequently is any Jew given a specific occupation; normally, the Jews are represented simply as an undifferentiated mass of evildoers.[20] They are rarely even said to be moneylenders or usurious—an especially surprising omission

considering the real prominence of moneylending in urban Jewish life and in representations of Jews in late medieval visual art, especially that of thirteenth-century France.[21]

By contrast, Chaucer takes unusual pains to insert his Jews into the complex web of socio-financial relations specific to one occupation: moneylending. He does so in the most prominent possible spot—the opening stanza of his poem:

> Ther was in Asye, in a greet citee,
> Amonges Cristene folk a Jewerye,
> Sustened by a lord of that contree
> For foule usure and lucre of vileynye,
> Hateful to Crist and to his compaignye;
> And thurgh the strete men myghte ride or wende,
> For it was free and open at eyther ende.

The Chaucerian Jewry is subsidized by a landowner. Its purpose is moneylending, which produced income for landlords in the form of loans provided by the Jews and in taxes paid by them. This activity is reserved to Jews and generates resentment from Christians—both of these for doctrinal reasons, says the Prioress, but in reality for reasons political and economic as well.[22]

Unlike the literary analogues, contemporary chroniclers of the Paris events do give usury first place in their accounts. Michel Pintoin—an ecclesiastical chronicler born about the same year as Chaucer and writing about 1410—opens his chapter on the expulsion much as Chaucer opens his tale, by specifying usury as the main factor. Jewish usury, says Pintoin, had reduced many (Christian) families to misery and had attracted the hatred of all the French (4.xvii, 119).[23] Another ecclesiastical author, Honorat Bovet, in 1398 wrote a dream-vision in which a Saracen, a Jew, a physician, and a Dominican appear to the narrator, along with Jean (Jehan) de Meun, who regulates the discussion among them. The Jew is upbraided for being in France despite the expulsion: "Don't you know," asks Maistre Jehan, "that because of usury and your evils and sins, they threw you out of the kingdom?" Usury is the only offence specifically named:

Ne savez vous pas que jadiz
Par vostrez grans iniquitez,
Par usures, par vos pechiez,
On vous getta hors du royaume? (232-35)[24]

The Jew replies that his mission is to see whether the Jews can be read-
mitted to France, since merchant-usurers (evidently Catholics) are doing
so well there. He says: if we return, we will charge a lower rate of interest
(presumably lower than before the expulsion, or perhaps lower than the
Catholics' rate). Both of these French accounts, addressing an important
recent public event—the expulsion—suggest that, in highlighting usury,
Chaucer followed current events and public opinion about them rather
than Marian miracle tales.

The other unusual aspect of Chaucer's narrative is the relatively elabo-
rate attention it gives to what follows the discovery of the child's corpse.
Many have noticed the glaring legal deficiencies in the *Prioress's Tale*. There
is no formal accusation, no investigation, no trial, and no confession. The
actual murderer is never caught. All this is very like the Machaut case but
not like most miracle tales, in which the murder is normally caught—
often red-handed and often with a confession—and punished; demon-
strated guilt is, after all, part of the moral economy and the propagandistic
thrust of such tales. Despite the lack of evidence or due process, Chaucer's
Jews are tortured and executed—not for committing the murder but for
allegedly knowing about it: "This provost dooth thise Jewes for to sterve /
That of this mordre wiste" (VII.1819-20), although nothing is said about
how it is known they know. Again, this could be seen as an only somewhat
exaggerated version of the gross miscarriages of justice in the Machaut
affair as commented on by contemporary lawyers, parliamentarians, and
clerics, and which provided the basis for commutation of the original
death sentence.

Also like the Machaut case and unlike most literary analogues is the
Chaucerian split jurisdiction of civil and ecclesiastical authorities, par-
ticularly the role of the city provost.[25] Not every analogue has a provost as
authority figure; sometimes it is a mayor, sometimes the Christian popula-
tion, or an ecclesiastic. In Chaucer, the people send for the provost when
they hear the dead boy's song, and it is he who arrests the Jews (VII.1810).

The boy's corpse is taken to a different place, a nearby abbey. Back in the city, the provost sentences the Jews to death, much as the Parisian provost did. First, though, they are dragged by wild horses about the town—a unique and distinctively elaborate punishment for Jews in a Marian miracle, who are far more likely to be simply hanged, burnt, beaten, or converted.[26] This scenario does, however, resemble the public humiliation and the equine-transportational punishment of the Parisian Jews, taken by horse and wagon through Paris. Meanwhile, at the other, ecclesiastical, scene of resolution, the child is exorcised by an abbot; the Virgin's grain is removed from his tongue and he can finally die.

I hypothesize, then, a distinctive blend of literary sources and current events as inspiration for the *Prioress's Tale*. On the textual level, the poem is a hybrid or pastiche, and there is little point in seeking a mysteriously absent single comprehensive "source."[27] The Marian miracle was part of the literary arsenal of medieval anti-Judaism, along with popular theatre and the sermon, in which the anti-Jewish Marian tale often served as exemplum.[28] In its many versions, this type of story offered a ready-made representational vehicle requiring only some adjustments in order to be recognized as an allusion to contemporary events across the Channel— events that did not occur (as many other anti-Jewish atrocities did) in a remote village or provincial town, but in major institutions in the capital of France.

What commentary is being made with the Chaucerian narrative? Unfortunately, historicizing the *Prioress's Tale* does not resolve the puzzle of intentionality. Chaucer may be exposing the blatant excess and injustice of the French provost and Parlement, their nakedly cynical money grab, and the absurdity of anti-Jewish murder accusations in life and art. Or, on the contrary, he may be approving the literal and literary punishment of Christianity's oldest opponents, those whom even Chaucer's model Parson calls "cursed Jews." The existence of both possibilities seems to telescope into one relatively short poem the multi-vocal representation of Jews in late Middle English literature.[29]

For Chaucer's artistic purpose, Marian miracle and the Machaut episode may have created a fortuitous conjunction of life and art. For the Jews, no miracle brought their persecutors to justice, or averted their domestic

and collective tragedies. For ourselves, the relations in our own day among religion, culture, and marginality warrant close attention.

Notes

Earlier versions of this essay were given at Hebrew University (1998), the Kalamazoo International Medieval Congress (1999), Ben Gurion University of the Negev (2000), the Association for Jewish Studies (2001), and in Poznan and Warsaw (2002). Special thanks to Larry Besserman and Henry Ansgar Kelly for their encouragement and advice.

1 This issue, with respect to medieval historiography, is engaged by Colin Richmond, and James Shapiro has made much the same point about scholarship of the early modern period (*Shakespeare* 2-3).

2 Sumner Ferris hypothesizes that Richard II may have commissioned Chaucer to write something for this visit, noting that all five saints mentioned in the poem have some connection with Lincoln. Another occasional dating, to the previous year (1386, when Philippa Chaucer and others were inducted into the Fellowship at Lincoln Cathedral), was suggested by John Manly. Other historicizations are not concerned with date. Gavin Langmuir looks to various versions of the story of little Hugh of Lincoln. Carol M. Meale urges the importance of contextualization for understanding Chaucer's attitude toward Jews, albeit with liturgy rather than event as referent. The interpretive consequence of an ecclesiastical contextualization would presumably be authorial sincerity: could Chaucer risk irony in such a setting? Lee Patterson sets the tale in the context of several centuries of Jewish-Christian relations, from the 1096 pogroms along the Rhine to late fourteenth-century crusade revivalism. In emphasizing Jewish martyrdom, this follows the path initiated by Louise Fradenburg's pioneering essay to which (despite differences) I am indebted. H.A. Kelly offers a survey of literary material.

3 There is, of course, the Second Nun's "Life of St Cecelia" as well as the Retraction, and I believe there is a steady undercurrent of orthodoxy throughout. Nonetheless, the proportion of explicit religiosity in Chaucer's work is relatively small.

4 It is tempting but ultimately fruitless to try to pin down dates here. In the Man of Law's Introduction (II.5-6), the pilgrimage is dated April 18, though of which year is uncertain; on Skeat's choice of 1387, see the discussion in *The Riverside Chaucer*, 796. Of course the date of composition of the Prologue has no necessary

implication for date of composition of a tale, whether earlier or later. I would have liked to discover that Passover fell on or very close to 18 April in 1394 or 1395, but the figures provided me by Remy Landau of Columbia University's Astronomy Department for first days of Pesach, i.e., Nisan 15, the full moon, from 1386 through 1395, permit no such correlation. (The closest are 11 April for 1389, 9 April for 1392, and 6 April for 1393. My grateful thanks to Professor Landau.) On clock and calendrical time in the fourteenth century, see Peter Travis, who notes that April 27 is our "Gregorian equivalent to Chaucer's Julian April 18" (11) and argues that various Chaucerian cruxes of time and date are not only insoluble but probably meant to be insoluble.

Harry Bailey uses the same phrase in addressing the Pardoner (VI.303), and I shall argue elsewhere that it functions there too as a clue to concerns about Jewishness in that Prologue and tale.

5 Although the compound word *passover* does not appear in the *Middle English Dictionary* and is not cited in *OED* before 1530 (Tyndale), nonetheless the Wycliffite Bible translation uses locutions that would make the association inescapable. It originates, of course, in two words: a verb and an adverb. Samples from Exodus, which narrates the events of the first "pass over" (*Pesach* in Hebrew; *paske* in Middle English), include 12:11, "It is the passyng forth of the Lord. And Y shall passe thurgh al the loond"; 12:13, "and Y shal overpasse yow"; 12:23, "the Lord forsoothe shal passe forth"; 12:27, "passyng of the Lord, whan he passide for the." The only occurrence of *overpast* in the Towneley cycle is associated with the Exodus in the "Pharao" play, when Pharaoh punningly laments, "Then is oure pride over past" (line 359). In the York cycle, the only occurrence of *over-past* is also in its Exodus play, "Moses and Pharaoh": "To tyme there parellis be over-past" (line 306). In the same play, God says "let my people pass," a line echoed by Jesus in "The Harrowing of Hell": "Opynne uppe and latte my pepul passe" (line 194). Such supersessionist figuralism is, of course, what enables Chaucer's linguistic-theological pun.

6 Genoa and Florence more or less excluded Jews from residence in the city proper during Chaucer's lifetime, although Milan under Gian Galeazzo Visconti readmitted a group of German Jewish businessmen in 1387; their quite generous charter appears in Simonsohn (1: 1387–1477, first item). This was a significant development, opening the way for the return of Jews to northern Italy after more than a century's absence; it would have captured the attention of those English nobles who were interested in northern Italy for business or political reasons. Pisa, Sicily, and Siena had significant Jewish communities. William Jordan writes, "After 1322 there were virtually no Jews in France,…no livelihood to be earned [in Paris] licitly," and assumes a tiny population in all France by the 1390s (248, 250). Roger Berg also writes of "un communauté très peu nombreuse" (68) but gives no numbers. On the other hand, Anchel discusses two legal

documents from 1365 that reveal that "les Juifs avaient à Paris une organisation solide et d'assez grandes libertés" ("Deux documents inédits" 63-66). Rheims was also a centre of Jewish life; see Gross. For a discussion of widely discrepant estimates of the Jewish population in Spain, see Estow (157-58) and Wolff (4-18). Schwarzfuchs offers possible figures for various European cities.

7 John of Gaunt married Pedro's daughter Costanza in 1371. On Halevi, see Baer (1: 362 ff.) and Estow (167 ff.). On Jews in the relatively tolerant kingdom of Navarre, see Leroy, "Dans le royaume de Navarre à la fin du XIVe siècle"; also her "Recherches sur les Juifs de Navarre à la fin du moyen âge," and her "Le royaume de Navarre et les Juifs aux XIVe et XVe siècles."

8 For more on John of Gaunt's so-called "crusade," see the discussion in Delany (172). On Chaucer's presence in Spain on a safe-conduct granted by King Charles II of Navarre, see Honoré-Duvergé (9-12); also Garbáty's fine-tuning of Duvergé's discovery; and Baugh.

9 Bracketed words are my condensation.

10 Elizabeth A.R. Brown writes that Charles IV "was encouraging an exodus,...[but] surviving administrative documents...contain no record of formal expulsion," although many chroniclers wrote of expulsion rather than, say, of extreme discouragement, persecution, or general hounding (320-22).

11 My account is based on Marguerite Boulet, *Étude sur les Quaestiones Johannis Galli*. The *Quaestiones* is a collection of significant cases (*notabilia*) heard in Parlement, where the author, Jean LeCoq (Johannes Galli), was a king's advocate; it became a classic of legal literature, cited for centuries after its composition. The Machaut case, in which Galli played an important role, is treated at length in Q. 341 in Boulet, 418-22, in Latin with notes and French translation. Also Félibien (cf. vol. 2, bk. 14, and vol. 4, 544 ff.); and Sauval, book 10 (which, although mainly a relatively sympathetic account of Jewish life in early France, is apparently meant as a catch-all of sorts, including records of marginalia such as meteors and accidents, monsters and freaks, unnatural or patricidal sons, duels and combats, etc.). Kohn discusses the episode in Part IV ("L'expulsion") of his *Les Juifs de la France* (253-59). Kohn's interest is to determine whether it played a role in the expulsion; he concludes that, while the Machaut affair may have served as a minor catalyst or as a pretext, the expulsion itself was "une decision mûre" thoroughly prepared by precedent and legislation.

12 These may have been the seven *boni homines* or elected community leaders, though the number of actual leaders might have been larger or smaller than seven (Schwarzfuchs 50). Galli and Félibien list names, though not exactly the same ones. Some sources say that another eight were imprisoned along with the first seven.

13 My translation. The year 1394 is covered in volume 2, book 5, but the expulsion of the Jews is treated (incorrectly) under 1393, in book 4, chapter 17 ("les juifs

sont chassés du royaume")—an error for which Sauval criticizes Pintoin. Pintoin (c. 1342–1421) wrote this section about 1410. He was cantor and librarian of his abbey, which had a major historiographic studio.

14 Les Halles, which Sauval writes was "le fort des Juifs," where "ils composaient... un petit peuple séparé comme une petite république"; quoted in Anchel, *Les Juifs de France* (69). The other sites of Jewish population were the Place de Grève and Place Maubert (Berg, *Histoire des Juifs à Paris*). The miscarriage of justice that struck so many contemporaries has continued to shock historians; Anchel observes that "Peu des affaires qui nous sont connues attestent un tel mépris de toute justice; il n'en est peut-être pas où se voie aussi nettement la rigeur des châtiments mise au service d'une spoliation éhontée" (Anchel, *Les Juifs* 117).

15 This statistic, if accurate, would seem to contradict Jordan's notion of a negligible Jewish community in France at the time.

16 The 1397 transfer to the new royal library of Bibles, Talmuds, and 114 other volumes found in a private home in Faubourg St-Denis is attested. However, "aucun des volumes de ce premier noyau n'est aujourd'hui connu" (Sed-Rajna and Fellous vii).

17 Although historians from various periods assert Machaut's wealth, I was unable to verify that detail in Galli's account; perhaps it is simply a stereotype on the part of later historians. On the accusation of money-clipping, see Kohn, *Les Juifs*, 256–57. Machaut's bad reputation worked to the benefit of the accused, as his alleged offences were deemed to deserve a death penalty.

18 Anchel observes that Crenu, though female and Jewish, was entitled to undertake this legal battle, and that she obviously believed she could succeed in changing the Provost's removal order and regain custody. Equally notable, he adds, is that the Provost would respect a child's wishes. Hence Anchel sees this episode as an instance of relative tolerance, and it appears in his chapter 5, called "La tolérance au moyen-age" (Anchel, *Les Juifs*).

19 Miracle-stories featuring Jews are found in Horstmann; Brown; Tryon; Ross; Bryan and Dempster; Wilson; Boyd, *The Middle English Miracles of the Virgin*; and the new *Sources and Analogues of the "Canterbury Tales,"* ed. Robert Correale and Mary Hamel, with the *Prioress's Tale* section by Laurel Broughton (2: 583–647).

20 One exception is "The Jewish Boy," from the Vernon Manuscript (Oxford, Bodleian Library, MS Eng. poet. a.1, copied probably about 1385), a story first found in sixth-century Greek writings, and in which the Jew is a glassblower (a plot requirement because his evil deed is to stuff the Christian child into a furnace). However, later versions omit this honourable occupation, replacing the furnace with an oven, which everyone would have at home regardless of occupation or lack of same; cf. Boyd, *Middle English Miracles*, 118; Horstmann, 141–45.

21 See Robert Chazan's discussion of the development of moneylending (*Medieval Stereotypes* 21-34 and passim). In chapter 2 of *Images of Intolerance,* Sara Lipton discusses the social background and ideological significance of the "Jews and money" topos in the illumination programme of two thirteenth-century manuscripts.

22 There were, of course, plenty of Catholic moneylenders. For a detailed study of the financial aspect of the Jews' presence in England, see Mundill. According to Mundill, the consensus—based on tax records and other documentation—is that about 2,000 to 2,500 Jews, including women, children, and poor, lived in, and left, England in 1290 (26). Other studies include Robert Stacey, "Jewish Lending" and "Royal Taxation."

23 Pintoin adds another supposed reason for the expulsion: that Jews employing Christian servants and wetnurses "ridicule Christianity, so that many Catholics become tepid in their faith" ("tepidi in fide reddebantur"). The Third Lateran Council (1179) had forbidden the employment of Christian servants by Jews (Chazan 100), but this restriction, like many others, was widely flouted.

24 The definitive edition is now that of Michael Hanly, replacing the older Arnold version, which I used in earlier versions of this essay and which gives the author's name as Honoré Bonet. The translation is mine.

Hanly's biographical essay on Bovet records that the Benedictine prior—like Chaucer, a diplomat in service of the royal court—attended the Anglo-French peace parley of 1392 and published his interview with John of Gaunt, leader of the English delegation. It is not impossible that Chaucer might have known Bovet's text.

25 One English story with a split civil-ecclesiastical jurisdiction appears in the Vernon Manuscript ("How the Jewes...threw a child in a gong," in Horstmann and Furnivall, 141-45, repr. in Broughton 624-27). Set in Paris, this narrative has no reference to usury; it does bring in the mayor to investigate and judge the Jews, and a bishop to revive the child, so there is split jurisdiction—but, curiously, there is no explicit punishment of the Jews. I think Brown was too quick to dismiss this tale as a possible source for the *Prioress's Tale,* impelled as he was to posit a virtually identical but always missing "original source."

26 Richard Rex discusses whether "draw" includes equine quartering (as in "drawn and quartered") or denotes only dragging. Dragging was a punishment for treason. Rex notes that only one case of equine quartering is recorded for England, in the early thirteenth century, although it was better known on the continent as a romance convention. He also notes, as I have done, that in none of the analogues to the *Prioress's Tale* are the Jews dragged by horses (or quartered): Rex, *"The Sins of Madame Eglentyne,"* chapter 4; also see his "Wild Horses, Justice, and Charity in the *Prioress's Tale.*" Roger Dahood also supports

the "dragging" interpretation in "The Punishment of the Jews, Hugh of Lincoln, and the Question of Satire in Chaucer's *Prioress's Tale.*"

27 The pastiche method is emphasized in Laurel Broughton's description of the narrative's interweaving and layering, especially of liturgical sources (586, paraphrasing Boyd, *Variorum* 6).

28 See Robert W. Frank's groundbreaking article "Miracles of the Virgin, Medieval Anti-Semitism, and the 'Prioress's Tale.'" Also on the continuity of the link between Mariolatry and anti-Semitism, see R. Po-chia Hsia, *The Myth of Ritual Murder*, 58–59, 119 ff., 145.

29 On multi-vocal representation of Jews, see Elisa Narin Van Court, "The *Siege of Jerusalem* and Augustinian Historians: Writing about Jews in Fourteenth-Century England," and Denise Despres, "The Protean Jew in the Vernon Manuscript." Also Van Court, "Socially Marginal, Culturally Central: Representing Jews in Late Medieval English Literature."

 I tend, despite this commendation of even-handedness, to agree with Dahood, who finds little evidence of satirical intent in the *Prioress's Tale.* A recent and thorough restatement of the "liberal Chaucer" position appears in Lawrence Besserman's "Chaucer, Spain, and the Prioress's Antisemitism."

Works Cited

Anchel, Robert. "Deux documents inédits sur les Juifs de Paris au XIVme siècle." *Revue Juive de Genève* 4 (1935–1936): 63–66.

———. *Les Juifs de France.* Paris: Janin, 1946.

Baer, Yitzhak. *A History of the Jews in Christian Spain.* 2 vols. Philadelphia: Jewish Publication Society of America, 1961–1966.

Baron, Salo. *A Social and Religious History of the Jews.* 2nd ed. 18 vols. New York: Columbia UP, 1952–1983.

Baugh, Albert C. "The Background of Chaucer's Mission to Spain." *Chaucer und seine Zeit: Symposion für Walter F. Schirmer.* Ed. Arno Esch. Tübingen, Ger.: M. Niemeyer, 1968. 55–69.

Berg, Roger. *Histoire des Juifs à Paris.* Paris: Cerf, 1997.

Besserman, Lawrence. "Chaucer, Spain, and the Prioress's Antisemitism." *Viator* 35 (2004): 329–95.

Boulet, Marguerite. *Étude sur les Quaestiones Johannis Galli.* Paris: Boccard, 1944.

Boyd, Beverly. *The Middle English Miracles of the Virgin.* San Marino, CA: Huntington Library, 1964.

[Bovet, Honorat.] *L'Apparicion Maistre Jehan de Meun.* Ed. Ivor Arnold. Paris: Société d'édition, 1926.

———. *Medieval Muslims, Christians, and Jews in Dialogue: The "Apparicion Maistre Jehan de Meun" of Honorat Bovet.* Ed. and trans. Michael Hanly. Tempe: Arizona Center for Medieval and Renaissance Studies, 2005.

Boyd, Beverly, ed. *A Variorum Edition of The Canterbury Tales, Part 20: "The Prioress's Tale."* Norman: U of Oklahoma P, 1987.

Broughton, Laurel. "The Prioress's Prologue and Tale." *Sources and Analogues of the "Canterbury Tales."* Ed. Robert Correale and Mary Hamel. 2 vols. Cambridge: Brewer, 2002-2005. 2: 583-647.

Brown, Carleton. "Chaucer's *Prioress's Tale* and its Analogues." PMLA 21 (1906): 486-518.

Brown, Elizabeth A.R. "Philip V, Charles IV, and the Jews." *Speculum* 66 (1991): 294-329.

Bryan, W.F., and Germaine Dempster, eds. *Sources and Analogues of Chaucer's "Canterbury Tales."* Chicago: U of Chicago P, 1941.

Chaucer, Geoffrey. *The Riverside Chaucer.* Ed. Larry D. Benson. 3rd ed. Boston: Houghton Mifflin, 1987.

Chazan, Robert. *Medieval Stereotypes and Modern Antisemitism.* Berkeley: U of California P, 1997.

Dahood, Roger. "The Punishment of the Jews, Hugh of Lincoln, and the Question of Satire in Chaucer's *Prioress's Tale.*" *Viator* 36 (2005): 465-91.

Delany, Sheila. *The Naked Text: Chaucer's "Legend of Good Women."* Berkeley: U of California P, 1994.

Despres, Denise. "The Protean Jew in the Vernon Manuscript." *Chaucer and the Jews.* Ed. S. Delany. New York: Routledge, 2002. 145-64.

Estow, Clara. *Pedro the Cruel of Castile, 1350-1369.* Leiden, Neth.: E.J. Brill, 1995.

Félibien, Michel. *Histoire de la ville de Paris.* 5 vols. Paris: G. Desprez et J. Desessartz, 1725.

Ferris, Sumner. "Chaucer at Lincoln (1387): The *Prioress's Tale* as a Political Poem." *Chaucer Review* 15 (1980-1981): 295-321.

Fradenburg, Louise. "Criticism, Anti-Semitism, and the *Prioress's Tale.*" *Exemplaria* 1 (1989): 69-115.

Frank, Robert W. "Miracles of the Virgin, Medieval Anti-Semitism, and the 'Prioress's Tale.'" *The Wisdom of Poetry: Essays in Early English Literature in Honor of Morton W. Bloomfield.* Ed. L. Benson and S. Wenzel. Kalamazoo: Medieval Institute Publications, Western Michigan University, 1982. 177-88.

Garbáty, Thomas. "Chaucer in Spain, 1366: Soldier of Fortune or Agent of the Crown?" *English Language Notes* 5.2 (December 1967): 81-87.

Graetz, Heinrich. *A History of the Jews.* 6 vols. Philadelphia: Jewish Publication Society of America, 1891-1898.

Gross, Henri. *Gallia Judaica.* Paris: Cerf, 1897.

Honoré-Duvergé, Suzanne. "Chaucer en Espagne?" *Recueil de travaux offert à M. Clovis Brunel.* Paris: Société de l'école des Chartes, 1955.

Horstmann, Carl, and F.J. Furnivall, eds. *Minor Poems of the Vernon Manuscript.* 2 vols. Early English Text Society OS 98, 117. London: K. Paul, Trench, Trübner, and Co., for the Early English Text Society, 1892–1919.

Jordan, William. *The French Monarchy and the Jews.* Philadelphia: U of Pennsylvania P, 1989.

Kelly, Henry Ansgar. "Jews and Saracens in Chaucer's England: A Review of the Evidence." *Studies in the Age of Chaucer* 27 (2005): 125–65.

———. "'The Prioress's Tale' in Context: Good and Bad Reports of Non-Christians in Fourteenth-Century England." *Studies in Medieval and Renaissance History* 3rd ser. 3 (2006): 71–129.

Kohn, Roger. "Les Juifs de la France du Nord à travers les archives du Parlement de Paris (1359–1394)." *Revue des études juives* 141 (1982): 5–138.

———. *Les Juifs de la France du Nord dans la seconde moitié du XIVe siècle.* Louvain, Belg.: Peeters, 1988

Langmuir, Gavin. "The Knight's Tale of Young Hugh of Lincoln." *Speculum* 47 (1972): 459–82.

Leroy, Béatrice. "Dans le royaume de Navarre à la fin du XIVe siècle: Les Juifs, la Cour et la Diplomatie." *Les Juifs au regard de l'histoire.* Ed. Gilbert Dahan. Paris: Picard, 1985.

———. "Recherches sur les Juifs de Navarre à la fin du moyen âge." *Revue des études juives* 140 (1981): 319–432.

———. "Le royaume de Navarre et les Juifs aux XIVe et XVe siècles: Entre l'accueil et la tolerance." *Sefarad* 38 (1978): 263–92.

Lipton, Sara. *Images of Intolerance: The Representation of Jews and Judaism in the "Bible Moralisée."* Berkeley: U of California P, 1999.

Manly, John. "Sir Thopas: A Satire." *Essays and Studies* 13 (1928 [1927]): 52–73.

Meale, Carol M. "Women's Piety and Women's Power: Chaucer's Prioress Reconsidered." *Essays on Ricardian Literature in Honour of J.A. Burrow.* Ed. A.J. Minnis et al. Oxford: Clarendon P, 1997. 39–60.

Mundill, Robin. *England's Jewish Solution: Experiment and Expulsion, 1262–1290.* London and New York: Cambridge UP, 1998.

Patterson, Lee. "'The Living Witnesses of Our Redemption': Martyrdom and Imitation in Chaucer's *Prioress's Tale.*" *Journal of Medieval and Early Modern Studies* 31 (2001): 507–60.

Pintoin, Michel. *Chronica Karoli Sexti....* Ed. L. Bellaguet. 2 vols. Paris: Crapelet, 1842; repr. Paris: Éditions du Comité des travaux historiques et scientifiques, 1994.

Po-chia Hsia, R. *The Myth of Ritual Murder.* New Haven, CT: Yale UP, 1988.

Rex, Richard. *"The Sins of Madame Eglentyne" and Other Essays on Chaucer.* Newark: U of Delaware P, 1995.

———. "Wild Horses, Justice, and Charity in the *Prioress's Tale.*" *Papers on Language and Literature* 22 (1986): 339–51.

Richmond, Colin. "Englishness and Medieval Anglo-Jewry." *Chaucer and the Jews.* Ed. S. Delany. New York: Routledge, 2002. 213-27. (Orig. pub. in *The Jewish Heritage in British History: Englishness and Jewishness.* Ed. Tony Kushner. London, and Portland, OR: Frank Cass, 1992. 42-59.)

Ross, Woodburn O. "Another Analogue to the *Prioress's Tale.*" *Modern Language Notes* 50 (1935): 307-10.

Russell, P.E. *The English Intervention in Spain and Portugal in the Time of Edward III and Richard II.* Oxford: Clarendon P, 1955.

Sauval, Henri. *Histoire et recherches des antiquités de la ville de Paris.* Paris: C. Moette et J. Chardon, 1724.

Schwarzfuchs, Simon. *Kahal: La communauté juive de l'Europe médiévale.* Paris: Maisonneuve et Larose, 1986.

Sed-Rajna, Gabrielle, and Sonia Fellous, eds. *Les manuscrits hébreux enluminés des bibliothèques de France.* Leuven and Paris: Peeters, 1994.

Shapiro, James. *Shakespeare and the Jews.* New York: Columbia UP, 1996.

Simonsohn, Shlomo. *The Jews in the Duchy of Milan.* 4 vols. Jerusalem: Israel Academy of Sciences and Humanities, 1982-1986.

Stacey, Robert. "Jewish Lending and the Medieval English Economy." *A Commercializing Economy: England 1086 to c. 1300.* Ed. Richard Britnell and Bruce Campbell. Manchester: Manchester UP, 1995. 78-101.

———. "Royal Taxation and the Social Structure of Medieval Anglo-Jewry: The Tallages of 1239-1242." *Hebrew Union College Annual* 56 (1985): 175-249.

Travis, Peter. "Chaucer's Chronographiae, the Confounded Reader, and Fourteenth-Century Measurements of Time." *Disputatio* 2 (1997): 1-34.

Tryon, Ruth Wilson. "Miracles of Our Lady in Middle English Verse." PMLA 38 (1923): 308-88.

Van Court, Elisa Narin. "*The Siege of Jerusalem* and Augustinian Historians: Writing about Jews in Fourteenth-Century England." *Chaucer and the Jews.* Ed. S. Delany. New York: Routledge, 2002. 165-84.

———. "Socially Marginal, Culturally Central: Representing Jews in Late Medieval English Literature." *Exemplaria* 12 (2000): 293-326.

Wilson, Evelyn Faye. *The Stella Maris of John of Garland.* Cambridge, MA: Wellesley College, and the Mediaeval Academy of America, 1946.

Wolff, Philippe. "The 1391 Pogrom in Spain: Social Crisis or Not?" *Past & Present* no. 50 (February 1971): 4-18

Christian Interpretations of Kabbalah

A Case Study in Marginality

SUSAN (SHYA) M. YOUNG

Christian interpretations of Kabbalah present a fascinating case study
with which to illustrate the interplay of religion, culture, and marginality.[1]
Although they appeared at and disappeared from the margins of official
Christendom in early modern Europe, these ideas flourished within the
culture of its Christian elites; more recently, they have come to influence
contemporary popular culture through Western occultism and New Age
spiritualities.[2] Through an examination of the context within which these
interpretations arose, the concerns they addressed, and an influential text,
I argue that while claims to a particular type of knowledge contributed
to their broader cultural appeal, the way this knowledge was acquired
consigned these ideas to the margins of religious orthodoxy. Further, in
exploring this interplay, I question the concept of marginality itself. What
is marginality? Who decides whether a particular phenomenon exists at
the edges or in the centre?

Context and Concerns

The world view underpinning the culture within which Christian inter-
pretations of Kabbalah arose rested on three interdependent perceptions.[3]
First, God was real, all-powerful, and ever-present in daily life. According
to Berndt Hamm, the early modern Europe *Zeitgeist* was one of piety or
Frömmigkeit, "the practical realization of religion—of modes of believing,
proclaiming, teaching, forming ideas, conceiving and articulating val-
ues, fears, hopes, etc.—in such a manner that daily life [was] formed and
informed by it" (308).[4] Second, God was able to act in the world because
the boundary between the supernatural and natural worlds, if it existed

at all, was porous, allowing a multitude of supernatural entities to enter.[5] For early modern people, not only was the supernatural world "continually present within the material world," it was also "full of power to help or harm" (Scribner, "Elements" 234, 236). Third, such an indistinct boundary allowed for connections among everything in the universe. Paraphrasing the well-known phrase taken from the Hermetic corpora attributed to the mythical Hermes Trismegistus, that which was above was believed to affect that which was below.[6] More importantly, activity performed in the world below apparently affected the world above.

When humans believed that material and immaterial beings were not only connected but also moved freely back and forth between the worlds, and that supernatural beings were so powerful that they controlled all aspects of life before and after death, they thought and acted accordingly. An intimate relationship with such entities was necessary for the health of body and soul. Hence a great deal of time and effort was spent in understanding, ameliorating, and appropriating supernatural power in order to establish some modicum of control in both the present and the afterlife (Scribner, "Elements" 249).

All levels of early modern society, whether rich or poor, educated or illiterate, noble or peasant, depended on some type of ritual interaction to influence the supernatural, from "crudest" superstition to officially sanctioned Church sacraments (Cameron 13–15). Processions, enhanced with incense, holy water, and sacred relics, proceeded around the church during Mass or through the streets following behind the Host during the feast of Corpus Christi; popular drama and carnival festivities centred on the religious calendar (Cameron; Duffy; Scribner, "Ritual," and "Elements"). Priests depended on rituals of prayer, music, words of consecration, incense, lights, and wine to influence the supernatural; magicians used incantations, Orphic singing, talismans, amulets, and astrological paintings (Walker 75–84). Baptismal water sprinkled on a newborn purified its soul from sin (Scribner, "Reformation" 478); holy water blessed by the priests cured illness in humans and protected cattle ("Ritual" 63). The letters of the divine name, properly used, not only raised one's soul toward God, they also combated ill health and other worldly problems (Reuchlin 351); penitential words spoken in confession brought absolution of sins.

Because many in early modern Europe believed the end of the world was imminent, the ability to influence God and control the fate of the soul as well as of the body was particularly important. The Revelation to John had warned that, before the Messiah could return and God triumph, the world would experience the full destructive force of the Devil.[7] It was easy to interpret the social, economic, political, and ecclesiastical crises of the fourteenth and fifteenth centuries as "the disasters of a declining age" (qtd. in Clark, *Thinking with Demons* 326),[8] and to believe, like Luther, that these were evidence of the "great cosmic showdown" between God and the Devil (Scribner and Dixon 15). The Black Death had reduced the population of Europe by a third to a half, agrarian crisis had created famine, wheat prices had declined dramatically, urbanization had accelerated, political strife and popular unrest had led to war and uprisings, and the Avignon captivity and papal schism,[9] combined with the way in which the Church handled its secular responsibilities, had weakened the moral authority of the Church (Cameron; Kristeller; Waley).

The perception that human actions could influence the supernatural fuelled a broad intellectual debate on the causes of certain effects. Participants attempted to categorize effects according to supernatural, preternatural, or natural causes, and to determine which were real and which were illusory. Only God and his agents were capable of causing real supernatural effects or *miracula*, phenomena that broke God's laws of nature. Observable natural properties caused real natural effects, phenomena that obeyed these laws. What or who caused preternatural effects, phenomena that appeared to be real but for which there was no obvious explanation? These included the marvellous wonders catalogued by Pliny and Isidore,[10] and the spells, charms, exorcisms, and soothsaying performed by various types of magical practitioners.[11] They were clearly not miracles, and, because everything else was assumed to operate within the laws of the natural world, only hidden properties could explain *mira*. This was the realm of magic, the attempt to understand and perhaps manipulate the occult properties of nature to deliberately create such effects.[12]

Who was able to produce such effects, for what purpose, and how? Did only the devil and magicians associated with him have the knowledge to manipulate these occult properties? Or could magicians work through

their own will and the will of God rather than draw on the power of the devil? Could magic achieve spiritual as well as material goals? Did certain words and actions produce real effects? If so, what was efficacious and what was not? If not, did they create mere illusions that preyed on the gullibility of the superstitious mind?

Opinions and arguments ranged along the continuum between the two poles of early modern magic: natural and demonic (Clark, *Thinking with Demons* 214-50). The defenders of *magia naturalis* suggested a number of causes for its effects, from terrestrial, stellar, and planetary influences at lower levels, to angels and ultimately God at the higher. According to this interpretation, the magician was healer, doctor, and, ultimately, priest. Giovanni Pico della Mirandola (1463-1494) argued that "voices and words [had] efficacy in a magical work, because in that work in which nature first exercises magic, the voice [was] God's" (Farmer 501).[13] Marsilio Ficino (1433-1499) wrote that natural magic assumed "its benefits from natural investigations into the propitious disposition of the heavenly bodies" (qtd. in Brann, *Trithemius* 27). In 1482, a Masters candidate at the University of Paris argued that magic was a legitimate aid in the salvation of the faithful (Thorndike 4: 488).

Doctor Bernard Basin's argument, also presented at the University of Paris, for the prohibition of anything involving the invocations of demons and pacts represented the other end of the spectrum. Demonic magic, as its name implied, was thought to draw its power from the devil and his minions; efficacy was directly attributable to the devil, and all else was superstition. This interpretation gives us the magician as sorcerer. The Bishop of Barcelona and Inquisitor Pedro Garsias, in his *Determinationes magistrales contra conclusiones Joannis Pici*, written in 1489, argued that if there was any power in words and numbers, it came from evil spirits instead of God (Zika 126). The Benedictine abbot and scholar Johannes Trithemius (1462-1516) contrasted one type of magic, which taught "how to produce marvellous effects through the mediation of powers residing in nature," against another "which, by virtue of calling on evil spirits for assistance, [was] condemned by the Church" (qtd. in Brann, *Trithemius* 245).

Early modern people turned to authority to resolve such debates. Authority rested with the Church, its theologians, and its ancient texts. However, the disagreement over which of these ancient authorities took

precedence led to more debate. Scholastics deferred to Aristotle and the interpretations of medieval theologians. Scholasticism as an intellectual mode of thinking developed from the attempts of Christian scholars to reconcile their faith with the works of Aristotle and his Muslim and Jewish interpreters, which came to the West in the twelfth century. Similarly, the introduction of Neoplatonic, Hermetic, Chaldean, and Kabbalist texts in the fifteenth century sparked a new approach to learning. Humanists, with their slogan of *ad fontes*, looked to the original sources of ancient Greek, Latin, Arabic, and Hebrew texts for answers.[14]

The discovery and translation of previously unknown or unread texts fuelled efforts to make these "new" ideas fit with existing knowledge. Ficino translated Platonic and Neoplatonic works, as well as the fourteen treatises within the *Corpus Hermeticum*.[15] This was the basis for Ficino's synthesis of Greek philosophical works and the *Hermeticum* and *Chaldean Oracles*[16] with early Christian theologians such as Augustine and Pseudo-Dionysius, and with later scholastic theologians such as Thomas Aquinas.

Perhaps the most audacious attempt made to reconcile the apparently irreconcilable came from the man credited with first bringing the Kabbalah to the attention of Christian intellectuals. In 1486 Giovanni Pico della Mirandola posted his *Nine Hundred Conclusions* in Rome.[17] In the first four hundred conclusions he offered what he considered the key concepts of thinkers from the Latin Scholastics back through the Arabs, Greek Peripatetics, Platonists, Pythagoreans, Chaldeans, and Egyptians to the Hebrew Kabbalists. The last five hundred were conclusions according to his own opinion, beginning with "seventeen paradoxical conclusions...first reconciling the words of Aristotle and Plato, then those of other learned men who seem to strongly disagree" (Farmer 365), and ending with "seventy-one Cabalistic conclusions...strongly confirming the Christian religion using the Hebrew Wisemen's own principles" (Farmer 517). Pico, like Ficino, constructed a theological genealogy of wisdom from the ancient past leading to his Christian present. Whereas Ficino believed that this transmission began with Hermes Trismegistus, Pico traced its origins to Moses and included at the beginning of his genealogy the Hebrew Kabbalist Wisemen. This was the conventional, if not the actual, beginning of Christian interpretations of Kabbalah. While Pico may have

been the first Latin scholar to promote Kabbalist ideas (Blau 19; Scholem, "Beginnings" 17), Jewish apostates before him used these ideas to justify Christian doctrine and persuade other Jews to convert to Christianity (Scholem, "Beginnings" 24).

The issue of conversion was part of a broader concern in medieval and early modern society about how to "deal" with the Jews, a group perceived as a "separate breed capable of the grossest immortalities, the deepest hatreds and the blackest crimes" (Overfield 172; Bonfil). Would it be better to expel or convert them? If the latter, was force or persuasion more effective? For instance, in 1505 Johannes Reuchlin published a letter to an unnamed nobleman in which he argued that the only way to save the Jews from their sin of killing Christ was through conversion (Oberman 331-33; Po-chia Hsia 119).

Christian Interpretations of Kabbalah at the Centre

The Christian intellectuals who studied the Kabbalah found in it ancient textual answers to such contentious issues as Church reform, the way to salvation in troubled times, the legitimacy and efficacy of ritual, and Jewish intransigence. Some considered their interpretations an enhancement of, rather than a challenge to, their Christian faith. Pico thought it would be an effective way of converting Jews to Christianity. His fifth cabalistic conclusion, "confirming the Christian Religion," read, "every Hebrew Cabalist, following the principles and sayings of the science of the Cabala, is inevitably forced to concede, without addition, omission, or variation, precisely what the Catholic faith of Christians maintains concerning the Trinity and every divine Person, Father, Son and Holy Spirit" (Farmer 523). He also wrote that he proposed "nothing assertively or tentatively unless it is judged true or probable by the sacred Roman Church and its deserved head, the supreme Pontiff INNOCENT the Eighth—to whose judgement, anyone who does not submit the judgement of his own mind, has no mind" (Farmer 365). Johannes Trithemius used his understanding of Kabbalah to develop a theology linking magic to miracle (Brann, *Trithemius* 247-52). He considered himself "a faithful Christian nourished in the Catholic faith, at one with the Holy Roman Church in all things which

are of the faith" (qtd. in Brann, "The Shift" 155). Guillaume Postel (1510–1581) saw Kabbalist teachings as a means of creating harmony out of the chaos of a splintered Christian church and different religious traditions (Bouwsma; Petry). Kabbalah for Johannes Reuchlin (1455–1522) represented the knowledge of salvation and the means by which to achieve it. Reuchlin ended *De arte cabalistica*, published in 1517, with the comment that he submitted the book to the authority of Pope Leo X, "in whose judgement the opinion of all the world is enshrined" (357).

Reuchlin declared that the first Kabbalah of all was God's revelation and Adam's receiving of the announcement of salvation through the angel Raziel:[18]

> The primal sin will be purged in this way; from your seed will be born a just man, a man of peace, a hero whose name will in pity contain these four letters—YHWH—and through his upright trustfulness and peaceable sacrifice will put out his hand and take from the Tree of Life, and the fruit of that Tree will be salvation to all who hope for it. (73)

The second Kabbalah was God's revelation and Moses's receiving of the art of interpreting the Torah through the permutation of letters. Reuchlin understood that Moses, under God's instruction, had then passed on to the elect the knowledge of "ordering and varying the order of the letters or of sweetly interpreting the Sacred Scripture to elevate the mind" (293). Through this teaching, Kabbalists had learned how to go "'to the place where there is life'...still in mortal form, from time into eternity, and ascend from the depths to the highest" (99). Reuchlin described the higher knowledge of salvation as "that golden heavenly apple," and the methodology to acquire that knowledge as the silver thread binding the apple in "complicated rules and human skills" (95).

Salvation to Reuchlin meant journeying beyond the material world to the immaterial, where one could rest in the soul of the Messiah and blissfully gaze across to the super-supreme world of God and a vision of the Divine (61, 159, 243).[19] The methodology of travel was "assiduous, continuous and diligent, day- and night-long meditation" (293). The Kabbalist art was not passive contemplation but an active manipulation of holy letters, words, and numbers.[20] Men could both "drag" themselves toward divinity

and summon the angels into the material world by speaking their names (267). Reuchlin quoted Pico in explaining that "meaningless sounds [such as the names of the seventy-two angels had] more magical power than meaningful ones. Any sound [was] good for magic in so far as it [was] formed from the word of God, because its nature work[ed] magic primarily through the word of God" (271). In other words, the names of the seventy-two angels were magically efficacious because they derived their power from the name of God. The non-semantic power of the Hebrew language rather than "sordid sophistic reasoning" (57) drew the devout Christian close to the Messiah and salvation.

While salvation through Christ was certainly orthodox, Reuchlin's reliance on the perceived powers of the Hebrew language was not. Ritual manipulation of meaningless letters and sounds to ascend upwards and bring angels downwards appeared to have more to do with magic than with salvation.

Christian Interpretations of Kabbalah at the Margins

Reuchlin's insistence that divine knowledge came through the Kabbalist art, and Pico's statement that "there [was] no science that assure[ed] us more of the divinity of Christ than magic and Cabala" (Farmer 497), opened Christian understandings of Kabbalah to charges of foolishness at best and heresy at worst. Luther relegated the Kabbalah to the ranks of "curious and idle scholars" (qtd. in Oberman 346). Erasmus wrote to Wolfgang Capito, "Talmud, Cabala, Tetragrammaton, Portae Lucis—empty names! I had rather see Christ infected by Scotus than by that rubbish" (qtd. in Overfield 199). Ortwin Gratius depicted Reuchlinists as "pagans and enemies of the church" with a "love for sorcery and magic" (Overfield 189). Conrad Mutian found Reuchlin's ideas "offensive and confusing to the unlearned laymen of the Church" (qtd. in Overfield 195). Pedro Garsias declared Pico's *Theses* heretical. Trithemius's work on a form of cryptography soliciting the aid of angels was condemned as necromancy and witchcraft. The inquisitor Jacob van Hoogstraten attacked Reuchlin's interest in the Kabbalah. Postel was committed to a monastery as insane. Giordano Bruno (1548–1600) was burned at the stake for heresy.

Why does any association with magic marginalize? Historically, the word has always referred to those on the margins of Western culture. Herodotus in the sixth century BCE applied the Persian word *magos*, meaning "priest" or "religious specialist," to a member of a tribe or secret society responsible for royal sacrifices, funeral rites, divination, and interpretation of dreams (Graf, "Excluding" 30). Although originally distinct, the "exotic skills" (Kieckhefer, *Magic* 10) of the *magos* on the geographical borders of Greece were gradually conflated with the unorthodox skills of the indigenous Greek practitioner inhabiting society's religious and political margins: the *agurtēs* ("beggar") or "beggar priest," the *mántis* ("soothsayer") or "diviner," the *kathartēs* ("cleanser") or "purification priest," the *alazon* ("impostor") or "quack," and the *goēs* ("sorcerer") associated with funerary rites, ecstasy, divination, and healing (Graf, "Excluding" 32, 38). Roman texts also reflected this association of magic with outsider. Cicero in the first century BCE had labelled priests from Persia as *magi* and defined them as wise men and scholars (Graf, *Magic* 36). The words *malum carmen* and *veneficium*, rather than *magia*, were used to describe indigenous ritual practices with malevolent intent (Graf, *Magic* 46–48, 56). However, a century later, Pliny the Elder labelled magic "the most deceitful of all the arts" (qtd. in Graf, *Magic* 49) and stated that magical rites included killing and eating men (Janowitz 2).

The disreputable aspects of *goēteia* ("sorcery") and *veneficium*, and their challenges to institutional power, continued to marginalize magic as an unorthodox means of seeking religious knowledge. In *De arte cabalistica*, Reuchlin attempted to distance himself from magic, with such words as *fictio magica*, *versuti magici*, and *magicae vanitatis* (94, 122). However, against the false magic of sly magicians who "employed the names of ghosts and evil spirits" to bring about man's downfall, he juxtaposed the miracles of Kabbalists who used "the names of light and the blessed angels" to work for the good of man (123–25).

The concept of "false" magic implies a belief in the existence of "true" magic. Apparently, Reuchlin equated "true" magic with the original usage of magic (*mageia* and *magia*) as religious wisdom. However, although the "true" magic of the Kabbalist art was more importantly concerned with salvation, Reuchlin acknowledged its efficacy in improving worldly conditions. Kabbalists "put together excellent amulets that use[d] the divine

letters and prove[d] efficacious in continuous use in combating illness and other problems" (Reuchlin 351).

From the Margins to the Centre

Reuchlin stressed that Kabbalist amulets used "not magic but solemn and sacred words" derived from the permutation of the letters of the names of God (Reuchlin 351). In making this distinction, I suggest that he hoped to move his methodology from the margin to the centre of acceptability by labelling it "contemplation" rather than "true magic" and thereby aligning himself with philosophers rather than magicians. In his introductory dedication, Reuchlin bemoaned the demise of the *ancient* philosophy[21] and declared that he wrote *De arte cabalistica* to revive the Pythagorean doctrine through an explication of the "symbolic philosophy of the art of Kabbalah" (39). Reuchlin concurred with Pico in his assessment that Pythagoras gleaned his knowledge from the Kabbalists. His character Simon repeatedly emphasized the contemplative aspect of Kabbalah and equated Kabbalah with theology, which dealt with "subjects that [were] separate from the natural world" and gave "a more reliable, more robust form of knowledge" (57). Reuchlin's methodology of contemplation was neither magic nor syllogistic reasoning. Reasoning could take the seeker to the edge of the material world. From there, only contemplation could facilitate the rise to divinity (49–51, 137).

The argument that one could achieve knowledge of God through one's own will and actions was compelling. This attempt to differentiate a methodology from magic and yet not surrender the apparently powerful methodology of ritual to magicians, sorcerers, and swindlers[22] (Luck 188) did not begin with Reuchlin. Scholars have speculated that the word *theurgy*, derived from the Greek *theos* or "god," and *ergon* or "work," paralleled the word *theology* as working with and experiencing rather than talking about the gods (Janowitz 17–18; Majercik 22; A. Smith 84–85). Naomi Janowitz describes *theurgy* as a theory of efficacy addressing the central religious concern of how to span the gulf between humanity and divinity (17–18). While its purpose, to obtain knowledge of God and salvation of the soul, falls within the realm of religion and philosophy, its methodology remains,

for the most part, within the realm of magic. Reuchlin used the word *con-templation* to describe his methodology. I use the word *theurgy*.[23]

The *Chaldean Oracles*, the "Bible" of theurgy (Luck 185), declared that the souls of mortals had the ability to "press God into itself" (Majercik 87). The Neoplatonic philosopher Iamblichus (c. 245-c. 325) contended that ritual performance rather than intellectual understanding connected theurgists to the gods. He wrote,

> Intellectual understanding does not connect theurgists with divine beings, for what would prevent those who philosophize theoretically from having theurgic union with the gods? But this is not true; rather, it is the perfect accomplishment of ineffable acts, religiously performed and beyond all understanding, and it is the power of ineffable symbols comprehended by the gods alone, that establishes theurgical union. Thus we do not perform these acts intellectually; for then their efficacy would be intellectual and would depend on us, neither of which is true. In fact, these very symbols, by themselves, perform their own work, without our thinking; and the ineffable power of the gods to whom these symbols elevate us, recognizes by itself its own images. It is not awakened to this by our thinking. (qtd. in Shaw 10)

Differentiating contemplation, theurgy, and magic is a contentious issue. There is some indication that Iamblichus considered theurgy to include more than external ritual. In commenting on a passage from the *Hermetica*, he wrote, "they certainly do not just speculate about these things. They recommend rising up through priestly theurgy toward the higher and more universal levels above fate, to the god and craftsman, and *without material attachment or any other help at all except observing the proper time*" (qtd. in Copenhaver, *Hermetica* xl [my italics]; Celenza 81-82). Contemporary scholars have grappled with this problem in the thought of Neoplatonic philosophers. A. J. Festugière and Hans Lewy draw a distinct boundary, postulating that Neoplatonists recognized two ways of ascending to and uniting with the divine: the philosophic means of contemplation and the ritual means of theurgy. Others are not so sure, suggesting that Neoplatonic theurgy may have included, at the highest levels of ascent, "a genuine noetic/contemplative element" (Majercik 25). Laurence

Rosan and Andrew Smith divide theurgy into lower and higher modes, with Rosan calling the former "practical" and the latter "theoretic" (Shaw 7), and Smith equating the former with the material world of humans and *daemons* and the latter linking man with the gods. Within the works of Proclus (411–85), Anne Sheppard identifies three levels of theurgy: one concerned with human affairs, one that makes the soul intellectually active, and one with no ritual component that brings about mystical union. Jean Trouillard, in his studies of Proclus, suggests that there was one path of ascent, which included both internal philosophical and external ritual methods; he sees in later Neoplatonism "one integral path leading from moral purifications to contemplation and finally to theurgy which brought about the *unio mystica*" (Shaw 6). Similar to Reuchlin, he argues that the Neoplatonists, because they recognized the limits of rationality in knowing God, saw the need for another method to carry man beyond those limits.[24]

What is the boundary between theurgic or magical practice and official church practice? While acknowledging the distinction between magic and theurgy, St Augustine of Hippo rejected theurgy as "filthy cleansings by sacrilegious rites" (*City of God* 10.10, 314) that appealed to deceitful, wicked spirits and demons. Only saints acting with pure intention and the sanction of the church and God, and not theurgists and necromancers using incantations and charms, could produce miracles (Graf, "Augustine" 94; Augustine, *City of God* 10.9–12, 312–18). Unlike Augustine, Pseudo-Dionysius did not reject theurgy.[25] Instead he claimed that Christian sacraments were theurgic mysteries. He suggested that the ritual of the Eucharist was the material symbol that facilitated the rise toward deity, and Jesus was the principle and essence of every theurgy (Janowitz 13; Shaw 3). Andrew Louth has described as shocking Pseudo-Dionysius's application of the word *theurgy* to the rites and sacraments of the Church: "it is as if we were to refer to the sacraments as magic" (163). E.R. Dodds called theurgy "a manifesto of irrationalism" because it suggested that "vulgar magic" rather than reason led to salvation (287–88, 291).

These declarations have more to do with the position and perception of the observer defining the phenomenon than the phenomenon itself. Jonathan Z. Smith comments that what is "ours" is "true" and "correct," whereas what is "theirs" is "false" and "incorrect" ("Classification" 39).

Jacob Neusner observes that "what I do is miracle; what you do is magic" (63). In 1607, a ruling of the Grand Council of Malines, the supreme court of justice in the Low Countries, illustrates this distinction well: the ruling asserted that "it [was] superstitious to expect any effect from anything, when such an effect [could not] be produced by natural causes, by divine institution, *or by the ordination or approval of the Church*" (qtd. in Thomas 49 [my italics]).

The Church defined priestly ritual as efficacious and all other unsanc- tioned ritual practice as superstition or heresy. In a similar vein, contem- porary culture judges belief in incantations as a means to effect change "a more 'primitive' and 'lower' stage in man's evolution," far distant from the stage of "pure" thought into which Western man has evolved (Shaw 9). Ioan Couliano, Richard Kieckhefer ("Specific Rationality"), and Stuart Clark ("Scientific Status") challenge this assessment by pointing out that medi- eval and early modern concepts of magic were based on an entirely logical and coherent set of principles consistent with their understanding of the universe. In contrast, we could label our acceptance of the ritual power of the priestly or judicial word to forge the bond of marriage (Austin) as irra- tional. Couliano suggests that some early modern magical techniques for manipulating the imagination are the distant ancestors of psychoanalysis, applied psychosocial psychology, and the mass psychology used by today's advertising media (xviii). Who, then, is "primitive" and who is not?

Likewise, contemporary scholars have not been kind in their assess- ment of Christian interpretations of Kabbalah, which appeared to have more in common with "primitive" magic than "pure" thought. They have marginalized it by declaring it a "fad of no lasting significance" (Blau vii) and an obscure doctrine inhabiting a "bizarre, illogical realm visited only by magicians, visionaries and the superstitious" (Dan, "Kabbalah of Reuchlin" 80). They have removed it from the field of serious religious dis- course with definitions that emphasize its use as a means of demonstrat- ing the truth of Christianity and converting Jews (Scholem, "Beginnings" 17; Dan, "Introduction" 14). Dan calls it an "essentially Christian phenom- enon, a discourse between Christians about the nature of Christianity" ("Kabbalah of Reuchlin" 68).[26]

What is marginal from one perspective is central when viewed from another. While these interpretations existed and then disappeared from

the margins of Christian religion, they appear to have been central in elite cultural circles of early modern Europe.[27] Although perceiving them as an insignificant fad, Blau comments on these ideas as "an interesting example of the remarkable rapidity with which cultural interests passed from one country to another during the Renaissance period. Every corner of Europe knew and talked of cabala soon after it had been presented in the works of Pico" (114). More recently, scholars have pointed out its influence on such enlightenment thinkers as Bacon, Leibniz, and Newton, on such literary figures as Spenser, Shakespeare, and Milton, and on such spiritual movements as Rosicrucianism and Freemasonry (Beitchman; Coudert; Dan, "Kabbalah of Reuchlin"; Yates, *Rosicrucian*). It continues to influence contemporary Western popular culture in a variety of syncretic discourses often defined and marginalized as esoteric, occult, or New Age (Hutton 66–83).

Conclusion

The quest for wisdom is central to human existence; it crosses both time and space. If we re-define the ideas of Reuchlin and other Christian interpreters as constituting part of this quest for higher knowledge, perhaps we can better understand its attraction and the reason for its continued influence. Perhaps we move it from the margin to the centre of Western thought and culture. Kocku von Stuckrad takes the same perspective in his discussion of Western esoteric traditions: like religion, philosophy, and science, these traditions, he asserts, make claims to higher knowledge and offer methodologies with which to achieve that knowledge.[28] He suggests this discourse of higher knowledge based on "conflicts of religious world views, identities, and forms of knowledge lie[s] *at the heart* of Western cultural history" (Stuckrad, "Western Esotericism: Towards an Integrative Model" 78 [my italics]). From this perspective, we might understand Christian interpretations of Kabbalah as a coherent synthesis of "elements and doctrine" carved out of different religious traditions and philosophies by intellectuals who based their thinking on a particular understanding of the universe, authority, human agency, and the End Times, in order to serve contemporary debates on causality and salvation.[29]

Stuart Clark comments, in *Thinking with Demons*, "If some general lesson is to be gleaned,...it is only that the purportedly most essential, objective, and timeless truths have nothing to commend them but the descriptions of those who happen to call them true" (x). I conclude this essay with the observation that too often moral judgement patrols the definitional lines separating true from false and central from marginal (Needham 36). From a religious perspective, the label of "magic" pushes a ritual practice beyond the bounds of orthodoxy. From a cultural perspective, the label of "irrationality" thrusts the search for knowledge beyond the bounds of acceptability. I suggest that theurgy attempts to remove such judgements and disrupt such boundaries by including internal and contemplative ritual as well as external practice in a search for higher knowledge, which in the case of early modern Christian scholars meant salvation through Christ. Using the example of *De arte cabalistica*, I have argued that Christian interpretations of Kabbalah disrupt any judgement of marginality. The last words I leave to Marranus, a character in *De arte*: "I am not bound by the rules of any school of thought. I do not want to be prevented by the constraints of any sectarianism from freely defending what my conscience allows" (41).

Notes

1 Gershom Scholem defines *Kabbalah* as "the traditional and most commonly used term for the esoteric teachings of Judaism and for Jewish mysticism, especially the forms that it assumed in the Middle Ages from the 12th century onward. In its wider sense it signifies all the successive esoteric movements in Judaism that evolved from the end of the Second Temple and became active factors in Jewish history" (*Kabbalah* 3).

2 For an excellent discussion of the distinctions between occultism, Western esotericism, and New Age spiritualities from an academic perspective, see Wouter Hanegraaff's *New Age Religion and Western Culture*. He classifies occultism as a subcategory of esotericism (422). See also Faivre and Needleman, xi-xxii, 279-81.

3 I use *world view* both in its more general sense, defined in *The HarperCollins Dictionary of Religion* as "a group's most general, shared ideas concerning life and the world," and in a narrower sense, as "a certain structure of thought that

the men of a particular period cannot escape" (Foucault 191). I use *culture* in its broadest sense to include religious, political, social, and artistic aspects of life.

4 See also Scribner's "Elements of Popular Belief" and *Religion and Culture in Germany.*

5 Scribner itemizes a vast array of supernatural entities: God, the Devil, and their entourages; holy persons including Mary, the Apostles, and the saints; the souls of the damned and of purgatory; strange beings such as will o' the wisps, fiery men, and phantom horsemen; pre-Christian creatures such as elves, fairies, and sprites ("Elements" 236).

6 "That which is above is like that which is below....And as all things have been derived from one,...so all things are born from this thing" (from a translation of the *Emerald Table* or *Tablet,* qtd. in Yates, *Giordano Bruno,* 150n2).

7 "Then I heard a loud voice in heaven, proclaiming, 'Now have come the salvation and the power and the kingdom of our God and the authority of his Messiah....Rejoice then, you heavens and those who dwell in them! But woe to the earth and the sea, for the devil has come down to you with great wrath, because he knows that his time is short!'" (Rev. 12:10–12 [NRSV]).

8 This quotation comes from the "Apologia auctoris" prefacing the infamous *Malleus maleficarum* written by Heinrich Krämer and, possibly, Jakob Sprenger.

9 Seven popes resided in Avignon from 1305 to 1378 as a result of conflict between Philip IV of France and the Papacy, and political intrigue among nobles and cardinals. The move from Avignon back to Rome created a schism with, at one point, three men claiming the papal throne.

10 Pliny in Book 32 of his *Natural History* listed the electric ray and the "ship-holder" (marine lamprey?) as examples of natural objects possessing occult powers (Copenhaver, "Natural Magic" 278). Marsilio Ficino wrote in *De vita libri tres,* "The marine torpedo also suddenly benumbs the hand that touches it, even at a distance through a rod, and by contact alone the little echinus fish is said to retard a great ship" (qtd. in Copenhaver, "Natural Magic" 275).

11 As Valerie Flint and Keith Thomas have so aptly pointed out, priests were only one among many categories of magical practitioners in medieval and early modern Europe.

12 This is a paraphrase of Stuart Clark's definition: "For in early modern Europe, as in the normal science of the preceding period, 'magic' was the term given to the study and manipulation of many of those phenomena" (Clark, *Thinking with Demons* 214). Definitions of *magic* are plentiful and contentious, but a full engagement with this literature is beyond the scope of this essay; I have used a definition applicable to its usage in early modern Europe. For a succinct overview and historiographical analysis of definitions of *magic,* see Jolly, 3–25.

13 This is conclusion nineteen of the twenty-six "Magical Conclusions According to His Own Opinion."

14 Although there is a great deal of literature on the conflict between these
 two schools of thought, Erika Rummel's *The Humanist-Scholastic Debate in the
 Renaissance and Reformation* is particularly good.

15 These were published under the title *Book on the Power and Wisdom of God, Whose
 Title is Pimander*. The Hermetic literature grew out of the Graeco-Egyptian
 culture of ancient Egypt under Ptolemaic, Roman, and Byzantine rule. Scholars
 suggest that works attributed to or involving Hermes Trismegistus may be dated
 from the fourth century BCE to the fifth century CE. Scholars have categorized
 these manuscripts into several different groupings, which may have more to
 do with "the accidents of textual transmission" (Copenhaver, *Hermetica* xxxii)
 or the prejudices of ancient compilers and modern scholars than with any
 meaningful distinctions derived from the manuscripts themselves. Hermes
 appeared in the more technically focused astrological, alchemical, and natural-
 historical *Hermetica*, as well as the Greek and Demotic Magical Papyri, which
 aimed to manipulate "the divine and the natural worlds for more or less
 concrete and immediate purposes" (xxxvi). He also appeared in what scholars
 label the more theoretically or philosophically oriented seventeen treatises
 of the *Corpus Hermeticum*, the "Latin Aesclepius, the forty Hermetic texts and
 fragments collected in the Anthology of Stobaeus, the three *Hermetica* found
 with the *Nag Hammadi* Codices, the Armenian *Definitions*, and the Vienna
 fragments" (xxxii–xxxiii). The theoretical manuscripts presented a theory of
 salvation through knowledge (xxxvii).

16 The code is a collection of sayings, of which only a few fragments survive. Ruth
 Majercik in her introduction calls the *Chaldean Oracles* "a collection of abstruse,
 hexameter verses purported to have been 'handed down by the gods' to a certain
 Julian the Chaldean and/or his son, Julian the Theurgist, who flourished during
 the late second century CE" (1). Julian the Theurgist was some kind of spiritual
 advisor to Marcus Aurelius. He supposedly used magic to assist the Emperor in
 his military campaigns (Dodds 283-85).

17 In his preface he wrote, "THE FOLLOWING NINE HUNDRED DIALECTICAL,
 MORAL, PHYSICAL, MATHEMATICAL, Metaphysical, Theological, Magical, and
 Cabalistic opinions, including his own and those of the wise Chaldeans, Arabs,
 Hebrew, Greeks, Egyptians, and Latins, will be disputed publicly by Giovanni
 Pico of Mirandola, the Count of Concord....The doctrines to be debated are
 proposed separately by nations and their sect leaders, but in common in respect
 to the parts of philosophy—as though in a medley, everything mixed together"
 (Farmer 211).

18 The word *Kabbalah* means "receiving." It is this meaning that Reuchlin seems to
 stress in his understanding of Kabbalah.

19 Reuchlin attempted to follow the orthodox teachings of the Church, which asserted that there could be no point of direct contact between God and humanity—*creatio ex nihilo*.

20 *Gematria* equated words through their arithmetic totals; *notariacon* substituted letters, words, and sentences; *themurah* replaced a letter in one ordering of the Hebrew alphabet with another letter in a different ordering. Simon, the Kabbalist master in *De arte cabalistica*, gives a lengthy explanation of these techniques (Reuchlin 294–333).

21 I have italicized *ancient* to draw attention to the distinction Reuchlin made between the "corrupt" philosophy of the scholastics and the "pure" philosophy of the ancients. He wrote to Pope Leo X that "philosophy in Italy was once upon a time handed down to men of great intellect and renown by Pythagoras, the father of that school. But over the years it had been done to death by the Sophists' wholesale vandalism, and lay long buried in obscurity's dark night" (37).

22 *Goēs* could be translated as any of these terms.

23 For a discussion of this idea from different perspectives, see Wolfson and also Roling.

24 Much of the information in this paragraph is drawn from Shaw.

25 "Dionysius, or Pseudo-Dionysius, as he has come to be known in the contemporary world, was a Christian Neoplatonist who wrote in the late fifth or early sixth century CE and who transposed in a thoroughly original way the whole of Pagan Neoplatonism from Plotinus to Proclus, but especially that of Proclus and the Platonic Academy in Athens, into a distinctively new Christian context" (Corrigan and Harrington).

26 To be fair, both Dan and Scholem also acknowledge a wider perspective. Dan notes that Christian interpreters of Kabbalah perceived their doctrines as "the keys to divine truth, inseparable from science and logic" ("Kabbalah of Reuchlin" 81). Scholem comments that, in the early sixteenth century, the "Christian Kabbalah was primarily concerned with the development of certain religious and philosophical ideas for their own sake rather than with the desire to evangelize among the Jews, though this latter activity was often stressed to justify a pursuit that was otherwise suspect in many eyes" (*Kabbalah* 199).

27 These included nobles, professors, academicians, theologians, priests, monks, and other clergy.

28 See "Western Esotericism: Towards an Integrative Model," and *Western Esotericism* (1–11).

29 Stuckrad names this process "discursive transfer" ("Western Esotericism: Towards an Integrative Model" 84–85).

Works Cited

Augustine (St). *The City of God.* Trans. Marcus Dods. New York: Random House, 1950.

Austin, J.L. *How to Do Things with Words.* Ed. J.O. Urmison and Sbisà Marina. 2nd ed. 1962; Cambridge, MA: Harvard UP, 1975.

Beitchman, Philip. *Alchemy of the Word: Cabala of the Renaissance.* SUNY Series in Western Esoteric Traditions. Albany: State U of New York P, 1998.

Blau, Joseph Leon. *The Christian Interpretation of the Cabala in the Renaissance.* Port Washington, NY: Kennikat P, 1944.

Bonfil, Robert. "Aliens Within: The Jews and Antijudaism." *Handbook of European History, 1400–1600: Late Middle Ages, Renaissance and Reformation.* Ed. Thomas A. Brady, Jr, Heiko A. Oberman, and James D. Tracy. Vol. 1: Structures and Assertions. Leiden, Neth.: E.J. Brill, 1994. 263-96.

Bouwsma, William J. "Postel and the Significance of Renaissance Cabalism." *Journal of the History of Ideas* 15 (1954): 218-32.

Brann, Noel L. "The Shift from Mystical to Magical Theology in the Abbot Trithemius 1462-1516." *Studies in Medieval Culture* 11 (1977): 147-59.

_____. *Trithemius and Magical Theology: A Chapter in the Controversy over Occult Studies in Early Modern Europe.* SUNY Series in Western Esoteric Traditions. Albany: State U of New York P, 1999.

Cameron, Euan. *The European Reformation.* Oxford: Clarendon P, 1991.

Celenza, Christopher. "Late Antiquity and Florentine Platonism." *Marsilio Ficino: His Theology, His Philosophy, His Legacy.* Ed. M.J.B. Allen and V.R. Rees. Leiden, Neth.: E.J. Brill, 2002. 71-97.

Clark, Stuart. "The Scientific Status of Demonology." *Occult and Scientific Mentalities in the Renaissance.* Ed. Brian Vickers. Cambridge: Cambridge UP, 1984. 351-74.

_____. *Thinking with Demons: The Idea of Witchcraft in Early Modern Europe.* Oxford: Clarendon P, 1997.

Copenhaver, Brian P., trans. *Hermetica: The Greek "Corpus Hermeticum" and the Latin "Asclepius" in a New English Translation.* Cambridge: Cambridge UP, 1992.

_____. "Natural Magic, Hermeticism, and Occultism in Early Modern Science." *Reappraisals of the Scientific Revolution.* Ed. David C. Lindberg and Robert S. Westman. Cambridge: Cambridge UP, 1990. 261-302.

Corrigan, Kevin, and Michael Harrington. "Pseudo-Dionysius the Areopagite." *Stanford Encyclopedia of Philosophy.* Spring 2007 edition. Ed. Edward N. Zalta. <http://plato.stanford.edu/archives/spr2007/entries/pseudo-dionysius-areopagite/>. Accessed 21 May 2007.

Coudert, Allison P. *The Impact of the Kabbalah in the Seventeenth Century: The Life and Thought of Francis Mercury van Helmont.* Brill's Series in Jewish Studies 9. Leiden, Neth.: E.J. Brill, 1999.

Couliano, Ioan P. *Eros and Magic in the Renaissance* (*Eros et magie à la Renaissance*, 1484). Trans. Margaret Cook. 1984; Chicago and London: U of Chicago P, 1987.

Dan, Joseph. "Introduction." *The Christian Kabbalah, Jewish Mystical Books and Their Christian Interpreters.* Ed. Joseph Dan. Cambridge, MA: Harvard College Library, 1997. 13-15.

―――. "The Kabbalah of Johannes Reuchlin and its Historical Significance." *The Christian Kabbalah, Jewish Mystical Books and Their Christian Interpreters.* Ed. Joseph Dan. Cambridge, MA: Harvard College Library, 1997. 55-95.

Dodds, E.R. "Appendix II: Theurgy." *The Greeks and the Irrational.* Berkeley: U of California P, 1973. 283-311.

Duffy, Eamon. *The Stripping of the Altars: Traditional Religion in England c.1400–c.1580.* New Haven, CT, and London: Yale UP, 1992.

Faivre, Antoine, and Jacob Needleman, eds. *Modern Esoteric Spirituality.* World Spirituality: An Encyclopedic History of the Religious Quest 21. New York: Cross Road, 1992.

Farmer, S.A. *Syncretism in the West: Pico's 900 Theses (1486): The Evolution of Traditional, Religious, and Philosophical Systems.* Medieval and Renaissance Texts and Studies 167. Tempe, AZ: Medieval and Renaissance Texts and Studies, 1998.

Flint, Valerie I.J. *The Rise of Magic in Early Medieval Europe.* Princeton: Princeton UP, 1991.

Foucault, Michel. *The Archaeology of Knowledge* (*L'archéologie du savoir*). Trans. A.M. Sheridan Smith. 1969; London: Tavistock, 1974.

Graf, Fritz. "Augustine and Magic." *The Metamorphosis of Magic from Late Antiquity to the Early Modern Period.* Ed. Jan N. Bremmer and Jan R. Veenstra. Grönignen Studies in Cultural Change 1. Leuven, Belg.: Peeters, 2002. 86-104.

―――. "Excluding the Charming: The Development of the Greek Concept of Magic." *Ancient Magic and Ritual Power.* Ed. Marvin Meyer and Paul Mirecki. Leiden, Neth.: E.J. Brill, 2001. 29-42.

―――. *Magic in the Ancient World* (*Idéologie et pratique de la magie dans l'antiquité Gréco-Romaine*). Trans. Philip Franklin. 1994; Cambridge, MA: Harvard UP, 1997.

Hamm, Berndt. "Normative Centering in the Fifteenth and Sixteenth Centuries: Observations on Religiosity, Theology, and Iconology." *Journal of Early Modern History* 3 (1999): 307-54.

Hanegraaff, Wouter J. *New Age Religion and Western Culture: Esotericism in the Mirror of Secular Thought.* SUNY Series in Western Esoteric Traditions. Albany: State U of New York P, 1998.

Hutton, Ronald. *The Triumph of the Moon: A History of Modern Pagan Witchcraft.* Oxford: Oxford UP, 1999.

Janowitz, Naomi. *Icons of Power: Ritual Practices in Late Antiquity.* Magic in History. University Park: Pennsylvania State UP, 2002.

Jolly, Karen. "Medieval Magic: Definitions, Beliefs and Practices." *Witchcraft and Magic in Europe: The Middle Ages.* Witchcraft and Magic in Europe. Philadelphia: U of Pennsylvania P, 2002. 1-66.

Kieckhefer, Richard. *Magic in the Middle Ages.* Cambridge Medieval Textbooks. 1989; Cambridge: Cambridge UP, 1990.

——. "The Specific Rationality of Medieval Magic." *American Historical Review* 99 (1994): 813-36.

Kristeller, Paul Oskar. "The Role of Religion in Renaissance Humanism and Platonism." *The Pursuit of Holiness in Late Medieval and Renaissance Religion.* Ed. Charles Trinkaus and Heiko A. Oberman. Studies in Medieval and Reformation Thought 10. Leiden, Neth.: E.J. Brill, 1974. 367-70.

Louth, Andrew. *The Origins of the Christian Mystical Tradition from Plato to Denys.* Oxford: Clarendon P, 1981.

Luck, Georg. "Theurgy and Forms of Worship in Neoplatonism." *Religion, Science, and Magic in Concert and in Conflict.* Ed. Jacob Neusner, Ernest S. Frerichs, and Paul Virgil McCracken Flesher. New York and Oxford: Oxford UP, 1989. 185-225.

Majercik, Ruth. *The Chaldean Oracles: Text, Translation, and Commentary.* Studies in Greek and Roman Religion 5. Leiden, Neth.: E.J. Brill, 1989.

Needham, Rodney. *Primordial Characters.* Charlottesville: UP of Virginia, 1978.

Neusner, Jacob. "Science and Magic, Miracle and Magic in Formative Judaism: The System and the Difference." *Religion, Science, and Magic in Concert and in Conflict.* Ed. Jacob Neusner, Ernest S. Frerichs, and Paul Virgil McCracken Flesher. New York and Oxford: Oxford UP, 1989. 61-81.

Oberman, Heiko A. "Three Sixteenth-Century Attitudes to Judaism: Reuchlin, Erasmus and Luther." *Jewish Thought in the Sixteenth Century.* Ed. Bernard Dov Cooperman. Cambridge, MA, and London: Harvard UP, 1983. 326-64.

Overfield, James H. "A New Look at the Reuchlin Affair." *Studies in Medieval and Renaissance History* 8 (1971): 167-207.

Petry, Yvonne. *Gender, Kabbalah and the Reformation: The Mystical Theology of Guillaume Postel (1510-1581).* Studies in Medieval and Reformation Thought 98. Leiden, Neth.: E.J. Brill, 2004.

Po-chia Hsia, R. *The Myth of Ritual Murder: Jews and Magic in Reformation Germany.* New Haven, CT, and London: Yale UP, 1988.

Reuchlin, Johann. *De arte cabalistica (On the Art of the Kabbalah).* Trans. Martin Goodman and Sarah Goodman. New York: Abaris Books, 1983.

Roling, Bernd. "The Complete Nature of Christ: Sources and Structures of a Christological Theurgy in the Works of Johannes Reuchlin." *The Metamorphosis of Magic from Late Antiquity to the Early Modern Period.* Ed. Jan N. Bremmer and Jan R. Veenstra. Grönignen Studies in Cultural Change 1. Leuven, Belg.: Peeters, 2002. 231-66.

Rummel, Erika. *The Humanist-Scholastic Debate in the Renaissance and Reformation.* Cambridge, MA, and London: Harvard UP, 1995.

Scholem, Gershom. "The Beginnings of the Christian Kabbalah." *The Christian Kabbalah: Jewish Mystical Books and Their Christian Interpreters.* Ed. Joseph Dan. Cambridge, MA: Harvard College Library, 1997. 17–51.

_____. *Kabbalah.* 1974; New York: Dorset P, 1987.

Scribner, Robert W. "Elements of Popular Belief." *Handbook of European History, 1400–1600: Late Middle Ages, Renaissance and Reformation.* Ed. Thomas A. Brady, Jr, Heiko A. Oberman, and James D. Tracy. Vol. 1: Structures and Assertions. Leiden, Neth.: E.J. Brill, 1994. 231–55.

_____. "The Reformation, Popular Magic, and the 'Disenchantment of the World.'" *Journal of Interdisciplinary History* 23 (1993): 475–94.

_____. *Religion and Culture in Germany (1400–1800).* Ed. Lyndal Roper. Leiden, Neth.: E.J. Brill, 2004.

_____. "Ritual and Popular Religion in Catholic Germany at the Time of the Reformation." *Journal of Ecclesiastical History* 35 (1984): 47–77.

Scribner, Robert W., and C. Scott Dixon. *The German Reformation.* 2nd ed. Studies in European History. 1986; Basingstoke, Hampshire, and New York: Palgrave Macmillan, 2003.

Shaw, Gregory. "Theurgy: Rituals of Unification in the Neoplatonism of Iamblichus." *Traditio: Studies in Ancient and Medieval History, Thought, and Religion* 41 (1985): 1–28.

Smith, Andrew. *Porphyry's Place in the Neoplatonic Tradition: A Study in Post-Plotinian Neoplatonism.* The Hague: Martinus Nijhoff, 1974.

Smith, Jonathan Z. "Classification." *Guide to the Study of Religion.* Ed. Willi Braun and Russell T. McCutcheon. London and New York: Cassell, 2000. 35–44.

_____, ed. *The HarperCollins Dictionary of Religion.* San Francisco: HarperCollins, 1995.

Stuckrad, Kocku von. *Western Esotericism: A Brief History of Secret Knowledge.* Trans. Nicholas Goodrick-Clarke. London: Equinox Publishing, 2005.

_____. "Western Esotericism: Towards an Integrative Model of Interpretation." *Religion* 35 (2005): 78–97.

Thomas, Keith. *Religion and the Decline of Magic.* New York: Charles Scribner's Sons, 1971.

Thorndike, Lynn. *A History of Magic and Experimental Science during the First Thirteen Centuries of our Era.* Vol. 4. New York and London: Columbia UP, 1934.

Waley, Daniel, and Denley Peter. *Later Medieval Europe, 1250–1520.* 3rd ed. 1964; Harlow, UK: Pearson Education, 2001.

Walker, D.P. *Spiritual and Demonic Magic: From Ficino to Campanella.* Notre Dame, IN: U of Notre Dame P, 1975.

Wolfson, Elliot R. "Language, Secrecy, and the Mysteries of Law: Theurgy and the Christian Kabbalah of Johannes Reuchlin." *Kabbalah: Journal for the Study of Jewish Mystical Texts* 13 (2005): 7–41.

Yates, Frances A. *Giordano Bruno and the Hermetic Tradition*. 1964; Chicago and London: U of Chicago P, 1991.

―――. *The Rosicrucian Enlightenment*. 1972; London and New York: Routledge, 2003.

Zika, Charles. "Reuchlin's *De verbo mirifico* and the Magic Debate of the Late Fifteenth Century." *Journal of the Warburg and Courtald Institutes* 39 (1976): 104-38.

Reading from the Margins at Little Gidding, c. 1625-1640

PAUL DYCK

The Ferrar family of Little Gidding, which conducted what we might think of as an early seventeenth-century communal experiment, offers the study of marginality interesting subject matter for two reasons. First, the Ferrars demonstrate what seems a general paradox of the "marginal"; that is, the marginal signifies, precisely because of its side position, that its non-centrality can function as a kind of super-centrality. This dynamic is displayed at Little Gidding both in its contemporary and its modern reputations and has acquired central importance because of its position as "marginal." Second, the Ferrars' project consciously takes up both the language of the book and the practice of making books, so that their "marginality" is one that they articulate through the page that lends us that term. Though they did not describe themselves as "marginal," they did articulate themselves via the materiality of the book, seeking a better way of living, one that could be "texted" in them through their own study and use of texts. The Ferrars belonged to a religious culture defined by the book; the English Reformation was accomplished, perhaps more than any other reformation, through a centrally-directed circulation of texts, most centrally the English Bible and the Book of Common Prayer. The Ferrars' religious practice involved a particularly high awareness of the material book as a mechanism for and an analogue of the godly life.

Paradoxically, the Ferrars distanced themselves from the mainstream of English cultural life with the hope of reinvigorating that life, of setting for it a "patterne In an adge that needs patternes" (Blackstone 256).[1] In this project they were partially successful, though not always in ways that they could have foreseen. Their contemporary influence happened largely through the planned and the unplanned circulation of texts. According to his brother John, Nicholas translated three sixteenth-century Catholic

works, two of which were subsequently published: the Belgian Leonard Lessius's *Hygiasticon*, a manual of sober diet, and the Spaniard Juan Valdes's *One Hundred and Ten Considerations*, a manual of the spiritual life. The two together reflect Nicholas's concern for the whole life of the Christian disciple, body and soul. Nicholas translated a third text, the Italian Ludovico Carbone's 1596 *Introductio ad catechismum* under the title "Of the Christian Education of Children," but he was denied permission by the licensors at Cambridge to publish it (Clarke 73).[2] As with the other texts, it spoke directly to his concerns: intellectual and moral formation were central foci at Little Gidding. All three of these texts were prepared with some level of collaboration with George Herbert, and Herbert's *Temple* was itself seen through the publishing process by Nicholas, who wrote the book's introduction.[3] In addition to these printed texts, the family also circulated within itself and to friends, in manuscript, the records of its conversations in what it called the "Little Academy," and, in a similar way, its biblical harmonies, or "concordances," which were made by hand by cutting and pasting printed Bibles and biblical illustrations. Such scriptural harmonizations, which combined biblical books—most often the gospels—into a single story, were not unusual, but the cutting-and-pasting was. Strikingly, some Little Gidding concordances ultimately circulated to the court of Charles I and so became courtly texts as well as familial ones. Perhaps the family's most infamous moment also came about through the circulation of a text, the *Arminian Nvnnery* pamphlet that launched a slanderous attack on the family in the heat of the royalist-parliamentary tensions of 1641.

Little Gidding provides us with a rich example of the complexity of marginality. It is culturally central not in spite of its distance, but precisely because of that distance. At the distance of Little Gidding, because of its very insignificance (an insignificance encoded in its very name, a lesser to the nearby Great Gidding), it was possible for a short time to experiment with religious practices and materials that were becoming increasingly contentious, as the broad conformity of the English church gave way to a polarization of ceremonialists and Puritans.[4] It was possible at Little Gidding, without being Catholic, to adopt and adapt Catholic monastic practices and to marry (though some would have said to adulterate) the Protestant English Bible with biblical images from the printing houses of the Catholic Low Countries. At this distance, it was possible to try out a way

to be Christian, to be family, to participate in the parish, a way that did not exist in its particulars elsewhere but that understood itself as universal.

Introduction to Little Gidding

What was Little Gidding? It is now best known through the poem named for it in T.S. Eliot's *Four Quartets*, describing it as a place "where prayer has been valid" and declaring Little Gidding itself as an English holy site. The Little Gidding community was the project of the Ferrar family, led by Mary Ferrar (c. 1554-1634) and her son Nicholas (1593-1637). They were a wealthy London family; Nicholas Sr (c. 1544-1620), a merchant adventurer, had made the family fortune during his lifetime through his involvement in several companies (most notably the East India Company, of which he was a founding member, and the Virginia Company), and the sugar trade (which involved privateering: capturing Spanish ships loaded with raw sugar, bringing it to England, and processing the sugar there) (D.R. Ransome 16). Nicholas Sr was newly rich, while Mary came from an establishment family of Cheshire. The Ferrar wealth and status, though, were in considerable doubt by the mid-1620s. The eldest surviving son, John, had followed his father in becoming a successful merchant adventurer, but he was now near bankruptcy through liability for the failures of his business partner, Thomas Sheppard. More dramatically, the Crown had seized the Virginia Company, in which the family was deeply invested and which Nicholas and John served administratively from London as Deputies of the Company. Nicholas consolidated the family finances through skilled negotiation, using his mother's dowry to purchase the manor of Little Gidding from Sheppard in May of 1625 for £6,000 in exchange for a limitation of liability (D.R. Ransome 17-21). The family moved there later that year: Mary Ferrar, her daughter Susanna Collet along with her husband John, and many of their sons and daughters (including Mary, Anna, Hester, and Joyce, who are mentioned in this essay),[5] her eldest son John and his wife Bathsheba and son, and Nicholas, along with other members of the family. Nicholas seized upon the opportunity of this forced retreat to do no less than undertake a re-examination of and experiment in the Christian life. The majority of the family participated with vigour, though Bathsheba,

thoroughly a person of the city, never submitted to the authority of her husband's younger brother and the life of retreat that he designed (D.R. Ransome 21).

Little Gidding acted as a family base, a retreat from the city characterized by a vigorous discipline of life that revolved around hours of prayer and that included practices such as offering medical service to villagers, playing music, and learning bookbinding. Its most unusual activities were those fashioned for the young women of the family in the absence of the educational resources available to men. One was the construction of gospel concordances; the other was the recounting of historical stories in dialogue on spiritual topics, in what they called "the little academy." The community was in significant measure constituted by the women. Nicholas and John Collett kept up business in London and elsewhere and so were frequently away for extended periods. John Ferrar and some of the women, though—especially Susanna's oldest daughters, Mary and Anna Collett, who decided not to marry—were there continuously.

Family Piety in the Seventeenth Century

Christopher Hill's landmark work on the puritan movement identifies the rise of the household as an important site of early modern spirituality, a movement continued in the later seventeenth and eighteenth centuries as the family became the site of communal reading and thereby the "key locus of piety" (Cambers and Wolfe 875). As Hill explains, the Reformation reduced the importance of priests in society and simultaneously raised the importance of householders, who were charged with the direct spiritual and educational development of all in their households. This rising importance of the family within the parish crossed confessional lines.[6] However, while family worship offered non-conformists an alternative to parish worship, the Ferrars developed a family practice that complemented and supported the established church.[7] While the Ferrars put extraordinary energy into their family "order," they were loyal, conforming members of the English church, a fact attested to by Nicholas's ordination as a deacon by then Bishop of London William Laud in 1626. One of the key tensions that animated the Little Gidding community was exactly the tension

between retirement and work in the world. In fact, the community never entered into a complete retirement but kept up a vigorous parish work. At the same time, their piety was motivated in part by a reaction to the worldliness of society more generally. The community had both positive and negative motivations: their practice was an intensification of the devotional practices of the English Church, especially its psalmody, and an equally intense response to the perceived failures of English society to be godly. Perhaps not surprisingly, this intensity was responsible both for the community's greatest accomplishments and its greatest failures. Nicholas imagined the community of Little Gidding and its many connections to be bound by a "Webb of freindshyp" (Blackstone 256). This web took the form of correspondence with and frequent visits from family and friends in various places, many of whom they invited into the disciplines of their community. On the other hand, the community also had to deal with the unwilling, especially Bathsheba, who resented her husband's near-worship of his younger brother, and who did not live at Little Gidding by choice. Also, the community's uniqueness attracted an ultimately polarized public response: from some admiration, from others deep suspicion, exemplified by the local rumour, occasioned by the burning of books at his death, that Nicholas was a conjuror (*Herbert's Remains* [A11v]).

The Reputation of Little Gidding

In spite of the efforts of the Ferrars to retreat from the city, the court, and the concerns thereof, the city and court did not leave the Ferrars alone. While Nicholas was not interested in religion as a form of controversy, he was nonetheless interested in forms of religion that others found controversial. The Little Gidding practices drew broadly from the Christian tradition: on the one hand, they shared a puritan rejection of the opulence and idleness of court; on the other, they freely made use of Roman Catholic resources, whether scholarly, artistic, or moral. They based their gospel concordances on patterns from Catholic scholars, they used Counter-Reformation biblical and devotional illustrations in those concordances, and their little academy recounted frequently the spiritual virtues of Catholics, even in opposition to their enemies. They kept a rigorous, even

ascetic, discipline of prayer. The community did, then, become wary of visitors from afar and the reports they might make, which often sought to fix the community's identity. The publisher Barnabas Oley reported having heard Nicholas say "that to fry a Faggot was not more martyrdome than continuall obloquy." Oley continues that Nicholas "was torn asunder as with mad horses, or crushed betwixt the upper and under milstone of contrary reports; that he was a Papist, and that he was a Puritan" (*Herbert's Remains* [A11r]). Such a mixed reputation was possible in part because the community's circle of friends included both Laudians and those opposed to Laud, most notably the Ferrars' bishop, John Williams (J. Ransome, "Monotessaron" 41n5; Muir and White 108).[8]

The lawyer Edward Lenton visited Little Gidding in the early 1630s to investigate charges of its Roman Catholicism, particularly relating to ceremonialism. He left satisfied, having found everything, if not to his liking, at least true to the Ferrars' word: that they were loyal Church of England Christians. Lenton wrote a letter describing what he had seen in some detail. Nonetheless, their peculiar rule of life made them a target, and the most public attack on them was a pamphlet in 1641 that reworked Lenton's letter into a scandalous attack, figuring the celibate women as nuns and the community in general as the titular "Arminian Nvnnery." The pamphlet "dwelt on the crosses and candles and altar furnishings, Nicholas's genuflections and bowing to the altar, the 'friar's grey gown' of Mary Collet Ferrar, and the fact that she and her sister Anna had chosen to remain celibate thus becoming in the eyes of opponents 'the nuns of Gidding'" (J. Ransome, "Monotessaron" 40). John Ferrar records the direct result of this pamphlet:

> though it was most easy to have been confuted,...soldiers then raised, that came out of Essex to pass towards the north way to Gidding, intelligence was given them at Gidding, from good hands, that these books was given to many of them, and that they were hired and animated... to have offered violence to the family and house. But God Almighty, in his special providence, did turn away their fury at that time and it then passed over. (Muir and White 111, para. 187)

War broke out in August 1642, and in 1643 John took his son John, his daughter Virginia, and his niece Mary Collett to Holland for two years

before returning to Little Gidding in late 1645 or 1646. The family suffered anxiety, though not the sacking of the manor by Parliamentary troops wrongly reported by Dr Peckard in 1790 and taken as fact until recently (D.R. Ransome 23).

The Little Academy

The Little Academy consisted of conversations, designed by Nicholas, in which the participants sat together and explored a set topic by contributing stories from a range of sources (many of them from the Church Fathers, others concerning the royalty of Europe) with the goal of discovering the spiritual nature of a given holy day or virtue. The method was based in the conviction that the varying historical witnesses could be brought, through careful and earnest work, to speak together on a topic. For these conversations, the participants took on symbolic names such as "the Mother" for Mary Ferrar, "the Moderator" for her daughter Susanna Collett, and "the Chief," "the Patient," "the Cheerful," and "the Obedient" for some of Susanna's daughters (Williams xiv). The first series of conversations began at the Feast of the Purification in 1631 (2 February) and continued through Christmas of that year. The academy convened again on St Luke's Day 1632 (18 October) and continued, again, through Christmas. A third convening took place two years later, with a reconstituted group.[9] The accounts of these conversations that survive are those that the Ferrars wrote out for family members not living at Gidding, and so they probably do not constitute the whole activity of the academy. They began with a desire to learn wisdom by finding out the ways in which biblical truths have been made manifest in history, so that the members of the academy might better understand how to live. Some of the first conversations took place in Lent, a natural time to consider the vanity of desire for earthly happiness. The conversations were picked up again at Christmas, though, with the desire to replace customary Christmas idleness, such as game-playing, with a spiritual activity that would also be enjoyable. The next year saw a significant raising of the stakes, with the Cheerful (Hester Collet) insisting on a strict and meagre diet in place of Christmas feasting, an idea probably connected to the works of Lessius and Cornaro, mentioned above. This seems to have

been more than the academy could sustain, for when they regrouped about two years later they had lost many of their members, and they began by taking an oath to continue in the work.

The ultimate fate of the academy, however, does not discredit the experiment. The conversations throughout demonstrate a thoughtful grappling with the conditions of life. For example, on St John the Evangelist's Day, 1631, the Little Academy began with a hymn, asking "Teach us by his example, Lord, / For whom we honour Thee today." Once the hymn was finished, the Cheerful began her meditation:

> The Light, Life, and Fellowship with the Divine Majesty, which this Hymne so sweetly descants on, and whereunto wee all pretend with such inflamed Affections, are by no other Steps to be ascended unto then by a stedfast Continuance in an holy fellowship with our Brethren through the Light and Life of Love alwaies abiding and working in us. (Sharland 40)

Here, the sweet descant of the hymn is brought into tension with the "stedfast Continuance" of "holy fellowship," even as that fellowship is articulated and inspired by the hymn. But the Cheerful carefully reminds her audience that the sweetness of the song is readily and easily "pretended" by "inflamed Affections." Thus, from the outset, the Cheerful distinguishes the theme of St John's day, Love, from what we call sentimentality and casts it, rather, as steadfast communal life. To understand the disciplines of Little Gidding, one must understand not only that the community aimed to be loving, but what they meant by love. When they at times seem coldly to question the validity of affections, they do so because they understand that affections do not on their own constitute love. Rather, love abides and works, constituting holy fellowship.

Expanding upon I John 1, the Cheerful goes on to explain that to love is to be born of God, to walk in the light, to live. Those who seek to live by acting maliciously toward others fool themselves, for they actually participate in death. Nothing less is at stake here than the very substance of being: hatred is not simply a feeling or a personal state, but a rejection of life itself, an act of unreason that cuts one off from the condition of existence: "it is a contradiction to reason not to love God in his Image, which wee see,

and to love Him in His owne Nature, which wee cannot apprehend" (42). To love God and to love God's image—the other people around us—is simply what we must do to be human:

> Wee must love one another for Gods sake, and wee must love after Gods example too. His Proceedings must be our Patterne. God layd downe His Life for us, and wee ought to lay down our lives for the Brethren; and if wee must lay down our Lives, much more must wee impart our goods to them that need. Hee that shutts up the Bowells of Compasion to others shuts out the Love of God from his owne heart. How dwelleth the Love of God in such an one? sayth John. (42)

Several points can be drawn out of this passage. First, the community at Little Gidding sought to identify, learn, carry out, and thereby teach a "Patterne," the pattern of Christ himself, which might reform their lives together and, beyond them, the culture in which they lived, which they perceived as negligent of its spiritual resources. Second, that while the pattern of the life of love required setting aside the self for the other, it did so within a relationship of master and disciple, which is to say that the "pattern" was not a token metaphor but real. Thus, setting one's self aside as a leader may (and did) demand the exercise of disciplinary authority. And, third, by implication in the passage, but explicit elsewhere in the community's texts, the life of love is the life of the body and the soul. What is to us the strange metaphor of "shutting up the bowels of compassion" was not meant so much as metaphor as analogy, based in material connection. The life of the body had everything to do with the life of discipleship at Little Gidding. Shutting up the bowels of compassion relates closely to the shutting up of one's digestive system, which was the result of gluttony.[10] This then is the counterpoint to the concern with "inflamed affections." The passions must neither be inflamed nor shut up but kept in healthy regulation. The disciplinary regulation of the body was a necessary condition for the disciplining of the soul, and only through this discipline could acts of love be performed; the rejection of selfishness, corporeal and spiritual, was itself a turn from death toward others, toward life, love, and God.

There is throughout the story books a persistent faith in the ability of the community to reason together and thereby discover the right Christian

way and to discern the errors of the world. At the beginning of the Chief's long discourse on the retirement of Holy Roman Emperor Charles V, she hooks her audience by first describing Charles as the happiest man on earth and then denying his happiness. When the Cheerful objects to this contradiction, the Chief says to her,

> God hath giuen you an vnderstanding capable of deeper poynts than these, & he hath seconded it with a Heart, that dares not, I know, be against the truth. But you haue been so long rooted & fortified in the Common Errour of the world, that I see you haue taken it vp for a maine Principal of truth, so as you are loth to admitt any Question about it. Which would you doe, I doubt not but that *wee should soone grow to* Composition. (Williams 56)

Spiritual formation at Little Gidding was not conceived as a positive act in a neutral environment, but, rather, as an intervention in a contest of ongoing formations. The Cheerful may have a God-given mind and heart for discipleship, but she, like the others around her, has also already actively been formed by the world, "rooted & fortified" in its common error, that is, in the "doctrine" that one can, through possessions, find happiness. This forming belief can only be challenged by the intent action of a competing formative community. This action, notably, is not a passive submission to an established truth, but rather the admission of questions about an established truth. Given the willingness to pose unfamiliar questions, the Chief expresses a confidence in the power of reason within community, both for attaining agreement or "composition" (a word the community also used for their challenging method of gospel harmonizing) and the possibility of carrying out this better way.

The community, under the guidance of Nicholas, undertook a disciplined life based on the mortification of the "old" or "natural" man, an activity that was far from straightforward.[11] As Elizabeth Clarke puts it, "mortification is the key process by which a 'son of Adam' may become a 'son of God'" (204). This theory of mortification and vivification, articulated in Paul's letter to the Romans, necessarily involves certain tensions. In the reformed theology of early modern England, there was a strong push to identify the godly and the ungodly, whose salvation or damnation might

be identified through the quality of their actions. At the same time, however, mortification cannot ultimately make such an identification, because the mortifications and vivifications of this life are necessarily incomplete, an ongoing process for which progress is difficult to chart. Thus, "ironically, it is because sanctification is 'a real change of state' involving a process that it cannot function as a sign" (Clarke 204). One cannot simply tell whether one, or anyone else, is godly.[12] The difficulty of discerning holiness, though, did not stop the community from trying, even as they pursued a life of holiness through the disciplining of body and soul. One finds the group, in the conversations at least, always inclined toward the ascetic. For instance, when the Cheerful attacks the custom of Christmas feasting, the Moderator argues that "Natural reason warranted by scripture & confirmed by the example of the best" suggests that special foods at Christmas are good, for the body as well as the soul is a partaker of Christmas joy. The Cheerful replies, however, that there is a difference between taking delight in eating, and eating for delight, the latter being an idolatry, a minor distinction that makes all the difference in the end (Williams 162–63). Thus, the academy imagines a very narrow way between the idolatry of worshiping food and the heresy of denying the body's part in God's work, ultimately deciding on a course of bodily mortification, with the conviction that they must hit the target: "Let vs not therefore goe hand ouer head & think our selues well because wee are neere the mark. Except wee hitt the white, wee shall not attain the prize" (164). This conviction that close does not count, though, proved the downfall of the Little Academy: its ever-increasing strictness led to its dissolution through the dismay of its voluntary participants.[13]

The Book and the Christian Community

The community read, wrote, translated, edited, and compiled texts that not only recorded its key ideas but enacted them, so much so that Little Gidding's textual practices played a central role in the community's ongoing formation. Writing and book-making serve as a significant source of analogies to the group as they describe their spiritual activities. As seen above, they work toward "composition," an action that can be done to good

or bad ends, for they also refer to certain false prophets who justify "Carnal Licentiousnes" as God's gift, and so have "made a composition between God & the world" (Williams 56, 64). The Chief later explains her slow introduction of her material by referring to God's own use of texts: "That's one thing, which euen the Diuine Providence it self, by the coniunction of many strange & admirable Passages hath seemed as with the Finger of obseruation to mark out vnto vs, as matter of deepest study & vse" (68). The community, by bringing together a wide range of historical stories in their conversations in order to discover a common, but hidden, truth, imitates and participates in the work of God revealing Himself "by the coniunction of strange & admirable Passages." Later, the Chief refers to teaching in the language of the print shop, as she seeks to "enstamp" "prints of reverend admiration" on her audience's desires. She follows Providence in this, which has put the story in so many places it "hath as it were texted it out in Red Letters, as a Passage of Publick & euerlasting record for euery mans behoof & instruction" (99): Providence is a rubricator. At Little Gidding, one was not only formed by books, but as books they were themselves formed: the actions of deepest study and use of texts reworked the reader as text, enstamping and so reforming the listener-reader's desires.

However, along with the texts that the community took hold of in its spiritual journey (the Bible, Foxe's *Book of Martyrs*, histories, spiritual advice) were the texts it correspondingly rejected—most dramatically in the pyre made at Nicholas's funeral comprising books he had earlier collected and had kept locked in a chest. These were the pietist's usual suspects: tragedies, romances, and love poetry. Of these, the books of chivalry hold special interest. In one conversation, the Guardian and the Chief condemn them as violating the Christian virtue of Patience, a virtue they describe as misunderstood and nearly forgotten. Because the heroes of Virgil and Homer, Ariosto and Spenser, depend on violent action rather than patience, they, through their fame, "have been made the destroyers of more Christian soules than ever they killed pagane Bodies." The Chief leaves "full proofe of this Charge" to be made "at the Light of that Bone-fire which is resolved, as soone as Conveniency permitts, to be made of all these kinds of books by our Visitour" (Sharland 119). The "Visitour" was Nicholas; apparently his resolve to rid himself of the books was put off until he finally willed it at his death, perhaps a sign of the persistent

appreciation for the books he had earlier acquired. Nonetheless, Little Gidding in its bookishness did not venerate the book as we do: the community did not finally mind burning books in the name of virtue that they understood to be undermining virtue, and, perhaps more strikingly, they did not mind cutting up bibles and biblical illustrations to use in their gospel concordances, a practice to which we will return.[14]

Such condemnation of books seems bound to involve contradiction, and the inclusion of Edmund Spenser's *Faerie Queene* in this group is particularly ironic. While the speakers do raise valid concerns about the marriage of "Christianity and revenge" (Sharland 120) in just such romances, they also share much with Spenser in ways they do not acknowledge. They describe true patience as "ever the inseparable Consort of Christian religion,...and Christian religion is the onely Profession that gives admittance to true Patience" (118). Spenser surely would have agreed, for his Red Crosse Knight (among other characters) must learn precisely not to rush in and take control by relying on his own resources, but patiently proceed to learn the deeper virtues of his Lord. This is closely related to Spenser's signal naming of his heroes, a naming that challenges naming itself, much as the naming at Little Gidding does. Spenser's knight of holiness, Red Crosse, is remarkably unholy. Rather, he demonstrates rashness and pride, together with incompetence. Spenser's point is that those imputed holy by the saving action of Christ must yet become holy through sanctification. Holiness cannot be possessed but must be lived. Naming in the *Faerie Queene*, then, serves a heuristic function rather than a labelling one, which is also the case with naming in the Little Academy, in which at least some of the members were named according to their weaknesses: the Patient, the Submisse, the Cheerful. They were named not as they were but as they might become.[15]

The conversations of the Little Academy ever guard against easy arrival. Rather, as Reid Barbour points out, not only do the dialogues repeatedly say that stories of "perfectly saintly" virtue are less helpful than those of the "struggling wayfarer," but also that fallenness itself is "a condition for religious heroism" (791). The members are alert to—among other concerns—idleness and pride, both of which involve an insufficient resting place, a faith in oneself that fixes one's present situation as having arrived at the destination. The story books of Little Gidding are filled with narratives

of surprise: many of them involve wise spiritual leaders who have their downfall in hidden possessions, or possessiveness, such as the early church leader Sapritius, who refuses to worship the emperor and so is taken to be martyred (Sharland 22–28). As he is processed through the town, a younger Christian and former disciple, with whom Sapritius has had a prideful falling out, comes on his knees, stopping the procession to ask forgiveness. He does this three times, and each time the would-be martyr Sapritius refuses him until, finally, Sapritius recants his faith altogether. As the story makes clear, he has been ready to surrender everything except his "enraged Affections" (25), and so fails. This story demonstrates in an astonishing way the working nature of holiness, both in that it works moment by moment, and that it works between people. It cannot be secured by prior action or reputation but must always be in the process of happening. This working holiness is evident in the story books themselves, in which the members of the community take turns addressing common topics—liturgical feast days and then, later on, virtues—by telling stories about them, such as the story of Sapritius. The women often introduce their stories with musical terms such as *harmony* and *descant*, explaining that the intention is to expand upon the topic of the day by adding to the former stories in a harmonic way, through difference that makes up fullness. The story books, then, are conversations, the product of a group of people who have submitted themselves to a common discipline, one enacted only in common. And the entire conversation is conditioned by the goal of making actions match words: as the reconstituted "academy" put it, "euery one should be bound to the performance of what they spake, Making their practizes keep equall pace to their Discourses" (Blackstone 110).

The "Concordances"

Because the Ferrars' pattern was Christ, it was necessary to know the story of Christ. To this end, Nicholas introduced the project—continued for about ten years—of making gospel harmonies. In this project, Nicholas copied the harmony model of Cornelius Jansen, one that combined the four gospels into one story of 150 chapters. The community named their books not *harmonies* but *concordances*, presumably for the way that they brought

the four gospels into concord. This single story the members of the community learned through continual repetition and memorization, aided imaginatively through the addition of illustrations of gospel scenes. The gospel concordances of Little Gidding were, like the story books, a project of the women, imagined and directed by Nicholas as exercises in their spiritual development. The unique characteristic of the concordances was that they were made almost entirely by cutting apart printed books—New Testaments and biblical illustrations—and pasting those pieces of paper onto a large sheet to form a new page.[16] This they referred to as "a new kind of printing" (Muir 76). They started making these books in the early 1630s as a help to the discipline of the community: by doing, in that they kept away idleness while keeping the makers' minds on scripture, and by using, in that the books were used by all of the community members to memorize scripture for recitation during times of prayer. Joyce Ransome has recently made the persuasive argument—based on evidence from the community's letters—that they planned to have their concordance printed, until they discovered that another harmony had beaten them to the market in 1632.[17] By 1633, though, the books were known in court, and King Charles I himself "borrowed" one, reading it and annotating it over the course of several months, and then giving it back on a promise that they would make one for him.[18]

The effect of the Little Gidding concordances is remarkable. Each opening (or pair of pages), through its size and variety, invokes a biblical story that is reasonable and affective: its texts and images are arranged compellingly, in conversation with each other. Typically, pages have illustrations on top and text below, though, in the book made for the king, more complicated combinations of text and image occur frequently.

While the concordances had started out as what Joyce Ransome calls "source books for reading aloud" at family devotions, they now, starting with the book made for the king in 1635, also became books for the serious student ("Monotessaron" 32). The earliest books present the four gospels harmonized into one coherent, readable story—the fullest story possible. This one harmonized account still forms the basis of the later books but with a key difference. In addition to this harmonized story, the community added all of the texts left out, and all the cases of overlap, in which a story is told by more than one evangelist. One problem with the presentation

of the overlapping material is readability: how does one present all of the texts while avoiding incoherent repetition? The Ferrars addressed this problem by constructing the harmonized account—which they called the *context*—by pasting words from a large-typeface Bible, while constructing the "extra" accounts—which they called the *supplement*—with words from a small-typeface Bible. In addition to type size, they further distinguished the context from the supplement by using different typefaces. In the king's book, the text presents a composed narrative (the context) in black letter, but it also includes, in a smaller roman letter, all of the extra material that such a composition normally leaves out (the supplement), so that the entirety of the gospels is on the pages of the book, with the harmonized account standing out in large black-letter type.[19]

Strikingly, while the context is, in theory, seamless, the combination of context and supplement is not—and, importantly, the page is not. In fact the page is all seams. The page, as much as it presents concord, also reveals the construction of that concord. Even while the book smoothes over the differences between the gospels, it makes plain the difficulty of such smoothing. In this way, it lays out its resources to the reader: it is not so much an achievement as a demonstration. The introduction to the book makes clear that the book's composition is not meant as a fixed settlement of the relationship of the four gospels but is meant to encourage the reader to conduct a similar kind of comparison and assessment in order to read the parts together in a complex but coherent whole.[20] The book invites one to read dialogically, listening to more than one voice at a time.[21] This sense of multiple voices was also established by the pictures pasted on the page. In my experience of working with these books, the pictures act as memory anchors, vividly locating a gospel story in two ways: both in a biblical geographical location, the place depicted within the picture, and in a bookish location, a place within the book. The place within the book, though, may be constituted by many and disparate biblical places. While the pictures accompanying the text usually illustrate the story being told, they often illustrate other biblical scenes, drawn from the Old and New Testaments. Chapter 40, "The Beatitudes," for example, contains a series of prints after Martin Heemskerck, placing images of Job learning of his misfortune and Abigail bringing a peace offering to David alongside images from the gospels such as Mary Magdalene wiping

Jesus's feet with her hair.[22] The page, then, invokes several stories at once, bringing a rich sense of biblical history to bear on the wisdom being preached by Jesus. As with the method of the Little Academy, the concordances explore truth through multiplicity.

The concordances both recognize the particularities of individual gospels and imply that these individual texts yield their fullest meaning in conversation with the others. It would be a mistake, I think, to understand this harmonization as a solution to difference, because it is precisely about difference. Difference here, though, is harmonic. It does not always resolve as neatly as in this example, and sometimes it does not resolve at all. At Little Gidding, though, there was a frankness about these differences, one grounded in a faithfulness: a faith that difference was part of God's loved, created order.[23] Notably, the idea of the marginal itself is brought into question by the book's arrangement. The biblical apparatus that would normally be located in the margin of the page occupies a more dynamic position here: though the supplement signifies a parallel passage in a smaller typeface, that passage is nonetheless fully represented on the page (rather than as a marginal reference). As soon as one begins to read it, it is no longer marginal but is the main text.

Two distinct methods, or orders, direct this book: the spatial and the temporal—that is, the ordering and categorizing of the text, and the text's free movement, its story telling. These might also be called the scientific and the liturgical, though the two are not mutually exclusive, for liturgy itself is the product of careful ordering. The distinction I am drawing, though, is between the ordering of knowledge so that it might be mastered, and the telling of a story that might master the hearer. The physical arrangement of text on the page has everything to do with this. The 150 chapters were read through by the community once a month; the members took turns reciting them, five times a day, from memory. The arrangement worked like a lectionary, liturgically arranging the story not in space but in time, as a way to be followed rather than as a truth to be established. The addition of the supplement satisfies a different need: the need to know sources, and to know the differences between sources. The early concordances present a straightforward text, suggesting its own authority, while the concordances of the mid-1630s present a text that makes its authority complex through its multiplicity. These books present text as dialogical.

Many voices speak, and in the complex interplay of these words spoken together, and through the hard work of the reader, a story emerges.

It is important to recognize that at Little Gidding the book was always a placeholder, a temporary store for material that properly belonged in the heart and mind.[24] The concordance set out the pattern of Jesus: a pattern of love to be followed in life. Notably, books could be produced out of this thinking, even the extraordinarily labour-intensive gospel concordances. Especially these books, though, must be read as produced by a practice, a practice that they were meant to cultivate in the reader. The bits of paper glued to the page were not meant as an impressive fixity but as an engaging pattern of movement. They do not establish any final reading of the gospels, but rather testify to the impossibility of any such final reading, giving witness to the hand-weary and heartfelt, but also astonishingly rich, labour of reading scripture as an act of living. Text here is not fixed but has been liturgically unhooked from its steady place on the page. It marks out, in the contingent harmony of four voices and many hands, the flow of a life, the life that gives life to all who follow. The good old way is exactly that: a way. The life of Christ told communally, in harmony, then reassembled by a family of friends out of pan-Christian materials, acts as a compelling witness of a vision of the world in which nothing is ever, finally, marginal.

Notes

1 Two studies that have influenced this article particularly are Joyce Ransome's "Prelude to Piety: Nicholas Ferrar's Grand Tour" and Reid Barbour's "The Caroline Church Heroic: The Reconstruction of Epic Religion in Three Seventeenth-Century Communities," later reworked as part of his *Literature and Religious Culture in Seventeenth-Century England*. The two have significantly different emphases: Ransome charts Nicholas's experience of religion, education, medicine, and other aspects of European culture across doctrinal and political divides, reconstructing the probable influence of these experiences on Nicholas's development of Little Gidding practices. Barbour explores the experimental nature of Little Gidding, understanding its goal as "heroic" religion, one that includes both certainty and scepticism. The first study gives the impression of Little Gidding as drawing upon well-established

resources; the second gives the impression of the community as something of a precarious—even existential—outpost. I do not find the two contradictory in substance; rather, they together capture the complexity I refer to above: that Little Gidding was catholic and particular.

2 Carbone's book is also known by the Italian title *Dello Ammaestramento de' Figliuoli nella Dottrina Christiana* (J. Ransome, "Prelude" 9).

3 Herbert translated Luigi Cornaro's *Treatise of Temperance and Sobriety*, which was published together with Lessius. John Ferrar characterized the two friends' co-operation this way: "as N.F. communicated his heart to him, so he made him the Peruser, & desired the approbation of what he did, as in those three Translations of Valdezzo, Lessius, and Carbo. To the first Mr Herbert made an Epistle, To the second, he sent to add that of Cornarius temperance, & well approved of the last" (Blackstone 59). Because the translator's introduction to Lessius has been signed "T.S.," it is not entirely clear whether Nicholas actually did the translation or just initiated the work. Barnabus Oley, who wrote a commendatory verse for the book, wrote elsewhere that Nicholas "help'd to put out Lessius" (Hutchinson 565). In either case, Nicholas was personally and centrally involved in the production of the English *Hygiasticon*.

4 Because of the polarization of church politics in the 1630s, the devotional images and stories used at Little Gidding shifted in their larger social meanings even as the community employed them. J.F. Merritt observes the changing significance of church furnishings in England in the first half of the seventeenth century. For instance, a pulpit cloth embroidered with "IHS" (standing for Jesus, but prominently used by and thus potentially associated with the Jesuits) was given to and received by the London puritan parish of St Bartholomew Exchange. In 1642, as a response to the Laudian emphasis on the sacredness of exactly such furnishings, the parish had the embroidered letters removed (957). The cloth went from being a "thing indifferent" to being a contentious object.

5 According to Susanna's memorial plate in the Little Gidding church, she and John were parents to eight boys and eight girls.

6 See the chapter "The Spiritualization of the Household" in Christopher Hill's *Society and Puritanism in Pre-Revolutionary England*.

7 Hill's argument opposes the family and the parish as sites of spiritual authority. While this was no doubt how some people saw the relationship, for many others family and parish were mutually beneficial. The Ferrars' rare circumstance was that their family essentially formed their parish, the manor and parish being coextensive (J. Ransome, "Monotessaron" 23).

8 However, as Malcolm Smuts observes, through most of the 1630s, courtly power groupings cut across ideological lines. Thus, the ideological breadth of the Ferrars' circle may not have been unusual (219).

9 These three series of conversations have been passed down in a somewhat
 confusing fashion. Williams has sorted it out as follows: 1631 included Sharland,
 Story Books, Part 1, and Williams, *Conversations,* "On the retirement of Charles V";
 1632 included Sharland, *Story Books,* Part 2, and Williams, *Conversations,* "On the
 Austere Life." The conversation of about 1634 is recorded in Blackstone as "The
 Winding Sheet" (Williams xxvi–xxix).

10 As the *Hygiasticon* makes clear, the body and the soul are profoundly connected
 in their daily workings: the problem of gluttony, which seeks the delight of the
 body, is that the resulting surfeit of food dulls both the body's ability to taste
 and the soul's ability to pray. Thus the careful diet has everything to do with the
 spiritual life.

11 In his introduction to Valdesso, Nicholas specifically identified the value of that
 author's comments on "justification and mortification" (*2).

12 Clarke notes that Ferrar was quite willing to tolerate Valdes's antinomianism
 when he translated the *One Hundred and Ten Considerations,* chiefly because
 Valdes, like Calvin, emphasized the sovereign will of God. Antinomianism
 (literally "against law") posits a direct causal relationship between God and
 human action, thus identifying human nature as something to be put to death
 in order that the divine nature might flourish. The true Christian, then, is that
 person under the control of the Holy Spirit, free of intermediaries and free of
 the temptations of sin. While Herbert and Nicholas Ferrar are careful to insist
 upon the importance of Scripture as a sacred and reliable intermediary of
 God's will, their reformed theology has much in common with that of Valdes
 (180–89).

13 The difficulty and delay in taking up the "Academy" is recorded at the beginning
 of "The Winding Sheet" dialogue in Blackstone.

14 Note, though, that books were at this time sold unbound. The Ferrars were
 unlikely to have cut apart bound books.

15 The reconstituted "academy" later abandoned this practice: "their intents were
 not, at least as they themselves thought, when they took those specious Titles
 of vertues & Abilities, wth wch they were first stiled, to procure honor in others
 Esteeme, but rather to animate themselues in the pursuite & practize of those
 things, wch were most Necessarie & proper for them, Yet finding a secret kind
 of complacencie arising in their Hearts vpon the sounding of such magnifique
 Attributes in their Eares; & feeling a manifest Failing, yt I may not say, flatt
 contradiction in their dispositions & Actions to them, They began to be afrayd
 in good Earnest, least they should by the vse of them, though it were not indeed
 in earnest[,] incurre not only the vnpardonable Guilt of vrsurpation of that, wch
 they had no right vnto, but ye irreparable dammage of Empayrement & happily
 [haply] of the vtter ouerthrow of that Humilitie, wch they ought aboue all other
 things to pursue." They decided rather to "suit themselves with such Names &

Titles, as might exactly agree with truth & modesty which they conceiued these last chosen did" (Blackstone 111-12).

16 Each page of the four British Library concordances is about 14 × 19 inches [35.6 × 48.3 cm]. Two of these are gospel concordances, one made for Charles in 1635, the other dating from about 1636. The others are a harmony of Kings and Chronicles, and a grouping of Acts and Revelation, both of which were made for royal use. For an account of all extant concordances, see J. Ransome, "Monotessaron." On the concordance made for Charles I, see Dyck, "A New Kind of Printing." For images from the king's book, see Dyck and Williams, "Toward an Electronic Edition."

17 "Monotessaron" 28-29.

18 The full title of the king's book is as follows: "THE ACTIONS & DOCTRINE & Other PASSAGES touching Our Lord and Saviour IESUS CHRIST, as they are Related by the FOURE EVANGELISTS, Reduced into one Complete Body of HISTORIE, wherein That, wch is SEVERALLY Related by them is Digested into ORDER; And that, wch is IOINTLY Related by all or any two or more of them Is, First Expressed in their own words by way of COMPARISON, And Secondly brought into one Narration by way of COMPOSITION, And Thirdly Extracted into one clear Context by way of COLLECTION.

 "Yet so, as whatsoever is Omitted in the Context, is Inserted by way of SVPPLEMENT in another Print. In such manner as all the FOVRE EVANGELISTS may be read SEVERALLY from First to Last+ To wch are added Sundry PICTVRES Expressing Either the FACTS themselves Or their TYPES & Figures Or other MATTERS appertaining thereunto An° M,DC,XXXV+." The British Library shelfmark is C23e4.

19 Uniquely, the king's book presents not only the context and supplement, together named the *composition,* but also the original passages, in columns, called the *comparison,* as well as a third version of the relevant gospels, a composition cut and reordered out of yet another book, displaying a rough equivalent of the context, a harmonized account uninterrupted by supplemental material. This multiple presentation of the text was almost certainly a response to the king's interest in the particulars of gospel harmonizing. He had made marginal notes on the book that he borrowed, questioning whether a verse had been left out. It had not, but the book made for the king clearly lays out not only the harmonized account, but all of the textual resources that were used to make the harmony.

20 The audience of this particular book must be kept in mind. The following instructions occur only in the king's book, explaining that the "comparison" (the gospel texts placed side by side) has been included so that the reader may harmonize them in alternate ways. How much this was to encourage further harmonizing and how much it was to defer to royal privilege is a matter of

speculation: "As for ye COMPARISON wee need say nothing, but that besides it will giue Satisfaction to see the ORIGINAL Relations of ye EVANGELISTS: So ye ADDITION of it to these other serues both for proof of ye truth of ye COLLECTION & COMPOSITION, & may happily minister occasion of other Composures in both kinds. For these are not to infringe ye* Liberty of any others judgement; but to be Directions & Helps for them, who cannot intend the doing it themselues" (5).

21 Whether the first Little Gidding harmonies—those that did not include the supplement—presented a dialogical or a monological text would have been a matter of the reader's awareness. The Harvard concordance, the earliest extant, lists gospel sources in its margins. The text thus gives a somewhat abstracted sense of multiple voices rather than the strikingly typographical sense of the king's book. Notably, the community ultimately went back to the simpler presentation of the text, without supplement, in its last harmonies (see J. Ransome, "Monotessaron" 35). For more on the Harvard concordance, see Craig.

22 Digitized forms of this series of prints are available through the website of the Hill Museum and Manuscript Library (Heemskerck). See both Henderson and Cabot for a general discussion of the illustrations used in the concordances.

23 As I have pointed out elsewhere, the chapter entitled "The Baptism of Christ" uniquely features two differing accounts that are both in the large black-letter typeface of the "context." These are the words of God the Father regarding Christ, which Matt. 3:17 has as "This is my beloved Sonne, in whom I am well pleased," whereas in Mark 1:11 and Luke 3:22 the voice says, "Thou art my beloved Sonne, in thee I am well pleased." In this case, the Ferrars' refusal to choose context and supplement itself indicates the limits of their method and some comfort with an equivocal text. See Dyck, "So rare a use" (73-74).

24 [Cf. Mary Carruthers, *The Book of Memory: A Study of Memory in Medieval Culture* (Cambridge: Cambridge UP, 1990), on medieval representations of reading in terms of the "consuming" of texts in order to incorporate them into one's "heart and mind." (Ed.)]

Works Cited

The Arminian Nvnnery; or, A Briefe Description and Relation of the Late Erected Monasticall Place, Called the Arminian Nvnnery at Little Gidding in Hvntington-Shire: Humbly Recommended to the Wise Consideration of This Present Parliament: the Foundation Is by a Company of Farrars at Gidding. London: Thomas Underhill, 1641.

Barbour, Reid. "The Caroline Church Heroic: The Reconstruction of Epic Religion in Three Seventeenth-Century Communities." *Renaissance Quarterly* 50 (1997): 771–818.

Blackstone, B., ed. *The Ferrar Papers*. London: Cambridge UP, 1938.

Cabot, Nancy G. "The Illustrations of the First Little Gidding Concordance." *Harvard Library Bulletin* 3 (1949): 139–42.

Cambers, Andrew, and Michelle Wolfe. "Reading, Family Religion, and Evangelical Identity in Late Stuart England." *Historical Journal* 47 (2004): 875–96.

Clarke, Elizabeth. *Theory and Theology in George Herbert's Poetry: "Divinitie, and Poesie, Met."* Oxford: Clarendon P, 1997.

Craig, C.L. "The Earliest Little Gidding Concordance." *Harvard Library Bulletin* 1 (1947): 311–31.

Dyck, Paul. "'A New Kind of Printing': Cutting and Pasting a Book for a King at Little Gidding." *The Library* 9.1 (September 2008): 306–30.

——. "'So rare a use': Scissors, Reading, and Devotion at Little Gidding." *George Herbert Journal* 27 (2003–2004): 67–81.

——, and Stuart Williams. "Toward an Electronic Edition of an Early Modern Assembled Book." *Computing Humanities Working Papers* (June 2008), A44. <http://www.chass.utoronto.ca/epc/chwp/CHC2007/Dyck_Williams/Dyck_Williams.htm>.

Eliot, T.S. *The Four Quartets*. London: Faber and Faber, 1944.

Ferrar Family. *The Actions & Doctrine & Other Passages Touching Our Lord and Saviour Jesus Christ....*Little Gidding, 1635.

Heemskerck, Martin van, Herman Jansz van Müller, and Claes Jansz Visscher the Elder. "Beatitudes." [Antwerp?, c. 1585]. Available online from the Hill Museum and Manuscript Library. See Arca Artium 1049 and 1085–1091. <http://www.hmml.org/arca/cataloguesearch.asp>. Accessed 22 May 2007.

Henderson, George. "Biblical Illustration in the Age of Laud." *Transactions of the Cambridge Bibliographical Society* 8.2 (1982): 173–216.

Herbert, George. *Herbert's Remains; or, Sundry Pieces of That Sweet Singer of the Temple, Mr George Herbert, Sometime Orator of the University of Cambridg. Now Exposed to Publick Light.* Intro. Barnabas Oley. London: Timothy Garthwait, 1652.

Hill, Christopher. *Society and Puritanism in Pre-Revolutionary England.* 1964; London: Penguin Books, 1991.

Lessius, Leonard. *Hygiasticon; or, The Right Course of Preserving Life and Health unto Extream Old Age.* Cambridge: Roger Daniel, 1634.

Merritt, J.F. "Puritans, Laudians, and the Phenomenon of Church-Building in Jacobean London." *Historical Journal* 41 (1998): 935–60.

Muir, Lynette R., and John A. White, eds. *Materials for the Life of Nicholas Ferrar.* Leeds: Leeds Philosophical and Literary Society, 1996.

Ransome, D.R. "John Ferrar of Little Gidding." *Records of Huntingdonshire* 3.8 (2000): 16–24.

Ransome, Joyce. "Monotessaron: The Harmonies of Little Gidding." *The Seventeenth Century* 20 (2005): 22–52.

———. "Prelude to Piety: Nicholas Ferrar's Grand Tour." *The Seventeenth Century* 18 (2003): 1–24.

Sharland, E. Cruwys, ed. *The Story Books of Little Gidding: Being the Religious Dialogues Recited in the Great Room, 1631–2.* New York: E.P. Dutton, 1899.

Smuts, R. Malcolm. *Court Culture and the Origins of a Royalist Tradition in Early Stuart England.* Philadelphia: U of Pennsylvania P, 1987.

Williams, A.M., ed. *Conversations at Little Gidding: "On the Retirement of Charles V," "On the Austere Life."* Cambridge: Cambridge UP, 1970.

The Seductive Serpent

EVA MARIA RÄPPLE

In the measure to which images give a body, a contour, a shape to
meaning, it is not confined to a role of accompaniment, of illustration,
but participates in the *invention* of meaning.
　　—Paul Ricoeur ("Function of Fiction" 123)

The dynamic role of images in inciting the imagination and in "the inven-
tion of meaning" has frequently been a contentious issue. Endeavours to
control the power of images have been recurrent and varied throughout
the history of Western thought. Among the critics of the power of images,
Plato is famous for his assault against paintings, which he calls imitations
of phantasms, far removed from the original. In search of the best society,
Plato is concerned with the deceptive influences that paintings might exert
on human beings (*Republic* X.598b). Ricoeur, using Immanuel Kant's theory
of schematism (*Critique of Pure Reason* 180–87), contends that the work of
the creative imagination is an operation in which language and visuality
converge. As in the metaphorical use of language, the tensions between
text and image engender a restructuring of discourse in which meaning
emerges. In the creative, imaginative response that schematizes metaphor-
ical attribution, "seeing as" is an act of grasping similarity in dissimilarity
(Ricoeur, *From Text to Action* 173). Yet images do not function only on the
level of cognition. In addition to cognitive innovation, sense perception and
language skills are also intrinsically interwoven in the visual dimension.
As Maurice Merleau-Ponty argues, the body plays a key role in the percep-
tion of visual imagery, since sense experience allows for the possibility "to
live" (*erleben*). Through visual experience the body is intricately involved in
a process of objectification, constituting the world that is already presented
in the picture. While communication generally presupposes a linguistic
vehicle, perceiving requires an apparatus that synchronizes visibility

and experience. This apparatus, which actively engages the viewer in the interpretive process, Merleau-Ponty calls "the gaze" (363). This distinctive, complex characteristic of visual experience, which includes immediate perception as well as the possibility of cognitive conceptualization, is an important reason why images have played a significant role in the discourse about the body and the self in the Western tradition. Moreover, in the gaze, the space for creative response may enable "seeing as" to become the basis for lived experience and, ultimately, to culminate in action.

Tracing exemplary iconographic images in diverse historical contexts opens a space for investigating discursive formations that are part of the processes that give rise to values and beliefs, thus disclosing a particular character of the visual in cultural contexts (Shapiro 9–10). At the centre of this investigation will be representations of Genesis 3, the story of the Fall, a biblical text particularly influential and controversial in Western culture. The goal is to examine unique and paradigmatic works that provide a sketch of changing visual practices that are often in conflict with the text and commentary on Genesis 3. Visual discourse here is thus not the static component of a manifested expression, but the potentially effervescent, dynamic phenomenon, the engaged eye of an active gaze, that plays a role in the enactment of beliefs, expectations, and values. I argue here that the sketch of artistic interpretations of Genesis 3, as represented in a few exemplary pieces of art, bears witness to the dramatic role that images play in a multiplicity of discourses that have been shaping the ways in which descendants of Adam and Eve ought to conduct themselves in the Western world. Visual representations of biblical texts provide particularly poignant examples for such an analysis because these images necessarily require a certain typification while concomitantly initiating immediate sense experience in the gaze. In addition, visibility frequently heightens awareness of certain aspects of the text, often in accordance with traditional interpretations. How does the visual interpretation of religious texts influence the maintenance of values, the perception of the body, and the debate about good and evil? I will discuss this question through the analysis of several examples of artistic representations of the story of the Fall.

A paradigmatic selection of four unique works from the Middle Ages and the Renaissance will serve as the focus in this study, with the goal to determine certain discontinuities in the manner that the story of the Fall

is visualized. I am interested in particular changes apparent in visualizations of the story of the Fall and how these are suggestive of ways that knowledge is communicated and gives rise to diverse interpretations of the human body. The study cannot attempt a comprehensive analysis of art's historical or cultural contexts. Of primary interest here, then, are certain fissures that unsettle the congruence between the textual and visual representations of Genesis 3, and the discontinuities between the sign and its resemblance to a supposed anterior that are revealed in the selected works.

During the medieval period, knowledge is generally sought in the fundamental relation between text, world, image, and sacred truth. The sign as symbol is the key to knowledge. This profound relation between word and truth also governs the resemblance between textuality and visuality. Yet the relation is not a static one. The tension between textuality and visuality offers a play on different levels of resemblance and is evident in discontinuities arising from visual interpretations of the biblical story of the Fall. As Michel Foucault argues in his work *The Order of Things*, the sign that had always been the "very language of things,…a language which God had previously distributed across the face of the earth," takes on a different signifying function during the seventeenth century (59). Yet certain conditions that support the event in which knowledge ceases to reside in an enigmatic, sacred area of signs, I contend, are embedded in the tension between textuality and visuality and may be examined in the works discussed here. If imagination is the bond between sign and resemblance, changes in perceptions regarding the unity between resemblance and designation, between textuality and visuality, significantly influence systems of knowledge and beliefs. By focusing on these changes in the context of resemblance, I have selected the images for this essay because of the ways that visuality evokes imaginative response, while still linked to the biblical text. The works here speak of complex tensions between textuality and visuality, in which a compelling appeal to sense experience carries the potential to move the discourse far beyond the words of the biblical text. The image is at the centre of the imaginative creation of meaning. The evocative spur to imagine ultimately gives rise to diverse understandings of the role of the body in historical contexts.

The iconography of the Fall in the Escorial "Beatus," a tenth-century illuminated Spanish manuscript, permits a glance at an early traditional

visual exegesis (Williams, *Early Spanish Manuscript* 31). The link between text and image is firmly referential, suggesting the figures as typology foreshadowing the future of humanity unable to follow God's law. The illuminated page (Fig. 1), showing Adam and Eve, the tree, and the serpent in the Garden of Eden, is found in a Commentary on the Apocalypse written by an Asturian monk, Beatus of Liébena (composed c. 776 CE). Spain between the tenth and the thirteenth centuries produced a rich series of illuminated codices. Among these, the Beatus commentary is the most important and influential illuminated manuscript of medieval Spain (Williams, *Early Spanish Manuscript* 24). Of the more than twenty illustrated manuscripts of the work known today, the vibrant, colourful image of the Fall in the Escorial manuscript occupies the place of a map of the world that is included in other copies of the Beatus commentary. The prominent location of the image at the beginning of the commentary highlights the theological significance of the illustration as a typology of humanity in its fallen state. The composition of the illumination eliminates unnecessary decorative elements. The figurative elements remain clearly referential, binding text and image through an almost abstract schematization that redirects the viewer to the biblical text. In the play of contrasting dark colours set apart from the bright yellow background, and the flat patterns, free from any semblance of plasticity, what is to be recognized is the sign, not the figures. The image affirms the truth of the biblical text. The tree of knowledge, with the serpent surreptitiously twisting herself around its trunk, looms large over Adam and Eve, as if dividing the two. Organized according to geometric patterns, the schematized figures dominate the illuminated manuscript, symbols of the first couple and its place in the sacred order of the cosmos. Adam and Eve, realizing their nakedness, look at each other suspiciously; ashamed, they carry fig leaves (Gen. 3:7). The serpent almost touches Eve's face as if to whisper into her ear. The eyes of Adam and Eve meet, uncertain regarding their newly gained knowledge. For the monks of the scriptorium at San Millán de la Cogolla (Rioja), the presumed place of origin of the manuscript, the image set the stage for a book that exhibited apocalyptic visions (Williams, *The Illustrated Beatus* 29–31). The desolate consequences resulting from the sinfulness of Adam and Eve provided the exposition of the end time, colourfully exhibited in the remainder of the work. Hence, visuality not only served as a reminder

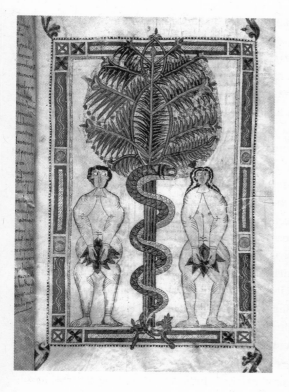

Figure 1 *The Fall of Adam and Eve.* An illustration to the Commentary on the Apocalypse by Beatus of Liébena; 33.5 × 22.5 cm. Spanish; c. 975–1000. San Lorenzo, Real Biblioteca del Escorial, Cod. lat. d.I.1 ("Codex Aemilianensis"), fol. 18. [Photo Copyright © Patrimonio Nacional; reproduced by permission.]

of the original Fall but also of humanity's failures in general, and of the pain and suffering to come before the end.

In its static composition, the image highlights the role of the body and desire in the game of life and temptation, locating sinfulness in the flesh. The visuality of the text here is formative for a religious discourse that accentuates the links between flesh, Christian morality, sin, and the body. Although colour and form offer a visual experience, the symbolic typology largely confines the reader to the world of the biblical text and its commentary, accentuating the close relation between text, world, and sacred truth. In the Escorial "Beatus," the sign as symbol is the key to knowledge, enhancing memorization through the referential link between the illustration and the biblical text. The bodies in the image, including the serpent, provide a medium for the illuminator visually to communicate the

abstract concepts of evil, sinfulness, obedience, and desire, strictly bound to the text.

As evident in the above example, medieval aesthetic perception is distinctly different from later sensibilities with respect to iconography and figurative art. As argued by the Pseudo-Dionysius, the symbol and sign are generally assumed to be analogous to essences as expressions of the harmonious divine order (108). Texts such as the Beatus commentary clearly served to enfold iconography in the canons of theology. Yet figurative art, even in its most emphatic denial of plasticity, opens spaces for artistic practices to take on a certain unmediated sphere of autonomy. These discontinuities between the text and visuality, in spite of all attempts to limit the power of images, have always been known to evoke imaginative responses. The enduring debate about the role of figurative art and the struggles against iconographic representations attests to a perceived incongruence between the sensual appeal and religious content. The power of artistic practices to incite the imagination caused concern among some of the most influential medieval theologians (Besançon 109-64; Freedberg 317-44). Particularly famous is the Abbot of Clairvaux, St Bernard, for his invective against Cluniac splendour and sensuality in their decoration of the monasteries (Davis-Weyer 168). St Bernard castigates the marvellous varieties of diverse shapes that tempt Christians rather to "read the marble than the books, and to spend the whole day marveling over these things rather than meditating on the law of God."

St Bernard's invective against the fascination with shapes might well have been addressed to the bishop and chapter who commissioned the artist Gislebertus to exhibit his lavish, extraordinary craftsmanship for the twelfth-century Cathedral of St Lazare in Autun, France. Among the many sculptural decorations carved by Gislebertus over a decade, the particular one of interest here is the sculpture of a beautiful female body originally placed above the north transept. This seductive Eve formerly whispered to Adam, who was located on the opposite side of the tympanum (Grivot and Zarnecki 146). Gazing longingly onward, she picks the forbidden fruit (Fig. 2). Akin to the serpent wrapping itself around the tree in many representations of Paradise, Eve's delightfully moulded body curls between branches of the tree of knowledge as if she were a serpent herself. Visuality intrinsically interweaves feminine beauty and animalistic characteristics.

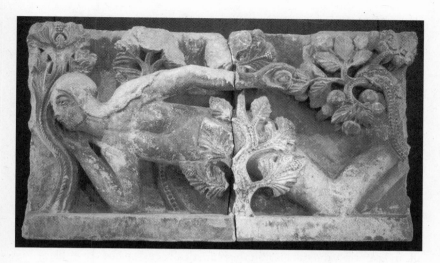

Figure 2 *Eve as Temptress*. Fragment of a lintel sculpted (according to an inscription) by Gislebertus; originally part of the portal of the north transept, Cathedral of St Lazare, Autun (Saône-et-Loire, Burgundy), now in the Musée Rolin, Autun. French; Romanesque (c. 1125-1135). [Photo courtesy of Allan T. Kohl / Art Images for College Teaching; reproduced by permission.]

Eve's prominent place, reclining above the north transept, visually marks her position in medieval moral discourse. The veneration of St Lazarus as the patron saint of lepers began in the eleventh century. The Cathedral therefore was a destination chiefly for lepers who performed a pilgrimage to find relief from their sickness. Traditionally used as the principal entrance, the central tympanum carried the scene of the raising of Lazarus, an apt focus since the relics of the saint were buried inside the Cathedral. For a society in which faith was "fixed in images" and "salvation depended on a system of signs," the seductive Eve symbolizes the fallen flesh, warning Christians of Judgement Day, the topic marvellously carved in stone above the west façade of the Church (Camille xxvi). Eve takes centre stage as a symbol of seduction and lust, marking the boundaries between the world of sinful pleasures outside and the realm of spiritual holiness inside the Cathedral. Only the ones who enter, willing to follow the divine law promulgated by the Christian Church, await the powerful promise of salvation. The stone above the entry, although in reality only a material analogue, speaks eloquently, allocating Christians to their

places in this medieval society in which one was frequently made aware of one's demarcated position in the web of human sinfulness. The transept, therefore, visually outlines the body politics of a society that distinguishes between brute animalistic elements, frequently commented upon by doctors and theologians, and the spiritual human being set apart by moral purity (cf., e.g., Thomas Aquinas, *Summa theologica* I, q. 75, a. 3, res.). Eve, above the portal in Autun, evokes forces of sexual attraction and lust not controllable by the rational mind, and this is suggestive of a role that was frequently attributed to her.

The work of Gislebertus exerts a perplexing appeal. Given that Eve's role on the tympanum was to warn of the Fall, the allure of the carved body is multi-faceted. Remarkable sensuality speaks through an illusion of flesh in stone. Large-scale nude sculptures were not common in medieval art overall, and certainly did not exhibit the realistically curved body or opulent breasts pilgrims faced in Autun (Grivot and Zarnecki 145-52). Although a vivid memento of the Fall was meant to be evoked, one might as well imagine the sick, stricken by their debilitating illnesses, captivated by a disturbingly alluring Eve, finding a healing of a different kind. Highly accentuated in its focus, beauty here wields an almost irresistible attraction. The carved stone unveils Eve's body to the senses, enlivening the material for those who are willing to imagine a world beyond the fallen flesh.

The invitation for the gaze to be delighted is all the more surprising if cast against a tradition in which theological interpretation served to bind iconography closely to the text. During the Middle Ages, imagery as well as architecture had key places in the education of Christians, and various passages in the writings of the Church Fathers provide crucial insights regarding precepts that strongly determined the didactic role that imagery played. In recent years, numerous studies have appeared analyzing these texts and their roles in the shaping of the early Christian world view (Brown 1988; Prusak 89-116; Salisbury 1-54). It is impossible in a short space to revisit the many excellent arguments, yet I will briefly refer to some important voices that have influenced the role of Eve in the Christian interpretation of the biblical text of the Fall. Since Philo of Alexandria (20 BCE-50 CE), Genesis 3 has been a key source for expounding theories about the problem of evil. Subsequently, Eve's nature became an important topic of discussion among the Church Fathers. The nature of women as defined

as subject to their body was significantly shaped by authoritative writers like Tertullian, Cyprian, Ambrose, Jerome, and Augustine, who understood spirit and flesh as distinct, abstract entities on earth. Control over the body had been lost after the Fall, resulting in a constant struggle between the spirit and the flesh. The sexual relation between Adam and Eve essentially bound them to the world of carnal desire. The spiritual state that Adam and Eve inhabited in paradise was lost. In a society in which women were frequently considered to be weak by nature (e.g., 1 Peter 3:1-6), the interpretations of Eve's role as bearer of sinfulness called attention to a custom that had long been established. Yet to designate Eve, and with her all women, as the "devil's gateway" who destroyed "God's image, man," as for example Tertullian infamously claims, adds an ontological dimension to the understanding of the nature of woman (Tertullian, *De cultu feminarum* 1.1). Not her physical deficiency alone, in comparison with the more active male, characterizes woman and distinguishes her from man, but her weakness allows the penetration of evil into humanity.

Joyce E. Salisbury explores the sensual metaphors in the writings of the Church Fathers. Their voices by and large considered physical sensuality, including touch, smell, and taste, as an essentially sexual experience (Salisbury 18). Among these experiences the sense of vision was perceived as particularly threatening, because it allegedly incited fantastic images of sexual desire. Augustine ponders the exceptional role of the visual experience of sense perception. He argues that seeing is the means to experience, including the experience of lust. Seeing is vital for remembering, which he defines as "inner seeing" (Augustine 10.8.1). The visual attractiveness of women, perceived to carry imminent sensuality, hence posed a great danger of inciting the fallen flesh. Thus, in order to gain control over the elusive character of sensual attractiveness, women were commonly advised to wear modest clothing and to remove themselves from the gaze of men (Tertullian, *De cultu feminarum*). In addition, women were often considered to be of a significantly more passionate nature than men. Accordingly, their natural inclination was often interpreted as the cause of sexual temptation. Women, seducing men, time and again repeated the original sin of Eve, luring Adam into sinfulness. Sensual experience thus required serious control, since after the Fall the flesh had lost its state of innocence. In a society that generally viewed men as more closely connected to the

spiritual world, Jerome summarizes the nature of the lustful temptress Eve: "Woman's love in general is accused of ever being insatiable; put it out, it bursts into flame; give it plenty, it is again in need; it enervates a man's mind, and engrosses all thought except for the passion which it feeds" (1.28). If the act of reproduction in these interpretations was identified with moral dangers inherent to the nature of humans, renunciation of their nature was the path to salvation, an honourable path that many Christian women would take (Brown 259–84).

While there were more moderate positions than the one taken by Jerome regarding the role of the descendants of Eve in Christian society, the patristic tradition generally enforced a definition of woman as a disorderly sensual body that needed to be subordinated to male control. It was Augustine's task to reshape dramatically the teachings regarding the role of the body in early Christian society. Augustine rejects the notion that the flesh is evil; therefore, he discards the dualistic distinction between the flesh and the spirit that the early Fathers had proclaimed as the consequence of the Fall in the West. While Augustine considers the sexual drive as a deeply unruly force, disturbing humankind after the Fall, he vindicates the sexual act as part of God's plan, places the sexual act into the context of marriage and, thus, gives it, alongside virginity, a status of social acceptance. Yet lust Augustine declares to be a most harmful vice, because lust excites the sexual organs and causes a loss of control over the body. Lust aroused by visual beauty is a powerful force. Reason is absent from this human condition in which desire and yearning for the opposite sex become sinful stirrings:

> It convulses all of man when the emotion in his mind combines and mingles with the carnal drive to produce a pleasure unsurpassed among those of the body....But surely any friend of wisdom and holy joys, who lives in wedlock but knows, as the Apostle admonished, "how to possess his bodily vessel in holiness and honour, not in disease of lust like the gentiles who do not know God," would prefer, if he could, to beget children without this kind of lust. (*City of God* 14.16)

Augustine's interpretation of the story of the Fall securely situates the sinfulness in lustful thought, and it shapes future perceptions of the

role of the body, an influence that does not recede after the discovery of Aristotelian ethics during the thirteenth century. A central focus of theological interpretations of Genesis 3 is the question of how evil could have penetrated the world. If God's creation is good by nature, what is the cause of evil? Augustine's answer to this central theological question in the *City of God* is that evil is a privation of good (12.3); therefore, evil is not a reality that requires a causal principle. Eve, accordingly, is described as the weaker part, attacked by the serpent in the Garden of Eden:

> And this animal [serpent] being subdued to his wicked ends by the presence and superior force of his angelic nature, he abused as his instrument, and tried his deceit upon the woman, making his assault upon the weaker part of that human alliance, that he might gradually gain the whole, and not supposing that the man readily give ear to him, or be deceived, but that he might yield to the error of woman. (*City of God* 14.11)

In his commitment to Aristotelian philosophy, Thomas Aquinas attempts to reconcile the Augustinian teaching that man had been without lust in Paradise (*City of God* 14.15), enjoying the naturalness of the sexual act of reproduction. Thomas argues that physical pleasure in paradise would have been moderated by reason and thus not become immoderate pleasure (*Summa theologica* I, q. 98, art. 2).

The voices of theologians and doctors certainly were of importance in the discourse about the role of the body. Yet textual visuality offers a dynamic environment, carrying the viewer beyond the Word in the process of imagining the complex relation between traditional theology and image. With the dawn of the Renaissance, the iconography of Genesis 3 is transformed gradually into a new discourse. As foreshadowed in the Autun Eve, the evocativeness and sensuality of the work of art, suggestive of a seductive Eve in the context of Genesis 3, takes an audacious turn in late medieval and Renaissance representations. Bodies pretend to come alive in the image.

The female head of the serpent that frequently appears in the iconography of Genesis 3 in later medieval representations is a visual extension, suggestive of the seductiveness of the serpent, which accentuates the allure of the female body and of the sinfulness rooted in lust and the

graven sin of idolatry (Camille 90). Paolo Uccello (1397–1475), in a fresco in Santa Maria Novella, Florence (Fig. 3), portrays a seductive serpent with an attractive female head. Adam and Eve, attentive to each other with the snake winding around the tree between them, exude a reticent solemnity. The aura of beauty and fragile appeal of the flesh stand in stark contrast with the gravity of the sin referred to in this picture. In this Renaissance work, ideal beauty and fallen flesh create a delicate paradox, conceivably the cause of agitation among those viewers who perceived the divergence between visuality and the textual tradition. Uccello's famous fresco is located in the Green cloister, the secluded part of one of the most prestigious Dominican monasteries in Italy during the fifteenth century. In the walls of this important place of study for Thomist doctrine, monks probably contemplated the Doctor's warning against the role of sensuality in bodily pleasure, which corrupts the incorporeal principle of the human being: "The serpent not only showed and proposed sin, but also incited to the commission of sin. And in this, sensuality is signified by the serpent" (*Summa theologica* I, q. 81, a. 1, res. 3). Uccello's serpent portrays seductive beauty, reminding the viewer of the power of sensuality and the danger of falling into sinfulness. In contrast to the symbolic serpent in the Escorial "Beatus," Uccello designs a creature that leaves the reference to the biblical text far behind. The pale serpent face, framed in flowing yellow hair, exerts an almost discreet attractiveness as she appears in the garden. Subtle changes in the colours of red and green, rather than the dazzling contrasts in the manuscript illumination, imitate nature. Textuality and visuality are still closely linked, yet the symbol has lost its exclusive bond to the text, as is clearly evident in the serpent's female head. Instead of the close referential link between symbol and sign, Uccello transforms the traditional figures in the story, striving to imitate the world as it appears to the senses. Knowledge, sought after in the fundamental relation between text, world, and sacred truth, changes via the brush stroke of artists like Uccello, who initiate a different kind of discourse. The beauty of the body warns as it seduces. The dramatic change from symbol to a visualized sense experience of the world leaves a significant impact on the gaze. As soon as visuality begins to set itself free from its profound kinship with the sacred text, the gaze is freed to engage in a creative act. Considering the power of images to engender imagination, one can only speculate whether the

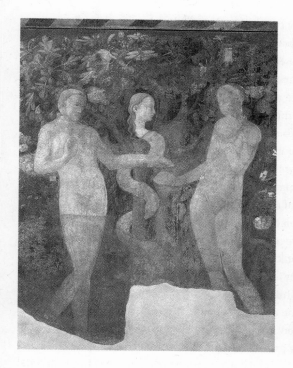

Figure 3 Paolo Uccello, *Creation of Eve and Original Sin* (detail). Fresco; 244 × 478 cm (size of full fresco). Green Cloister, Santa Maria Novella, Florence. Italian; 1432–1436. [Photo courtesy Scala / Art Resource, New York; reproduced by permission.]

beautiful serpent face in Uccello's fresco was perceived as a stark warning or as one that perhaps evoked desire among some of those who lived a life of chastity.

Uccello's painting appears at a transitional moment in history, following a new Renaissance sensibility in painting that has been called a "dogma of aesthetic theory," namely that a work of art needs to represent the natural object as realistically and directly as possible (Panofsky, *Life* 243). Painters such as Uccello change dramatically the Genesis 3 discourse, since the illusion of the real bodies of the first human couple is also a call to understand the nature of Adam and Eve given in sense experience. The symbolic tradition that has been the dominant motif for images of Genesis 3 during the Middle Ages is referred beyond the visibility of the flesh. Evil as bestial force is implanted in the female nature of the human being, and it is no longer an outside motion "mingled with the good to deceive the lustful affections of the carnal senses," as argued, for example, by Eriugena

(4.259). Of course, one may contend that medieval images also merged the animal with the human body, and that Eve above the portal in Autun also exudes seductiveness. However, merging the female head with the serpent's body marks a remarkable visualization of Genesis 3. The artist strives to achieve a most realistic representation of the natural world still permeated by the traditional symbolic dimension. The serpent's body and human flesh become one, accessible to the gaze. In Uccello's fresco, the playful illusionary character that makes the symbolic dimension an obvious characteristic of medieval representations of the Fall changes into an illusion of the real body in painting. The beautiful female head seals the nature of Eve as carrying the seed of the serpent's seductive character. The symbolic dimension and an illusion of the real world merge effortlessly. Certainly, the transformation in the context of artistic expression is a subtle one in Uccelo's painting, and yet it remains a very important modification of the biblical story of the Fall. It is consistent with an overall transformation of a changing concept of humanity during the Renaissance. The female body, providing an illusion of reality in painting, radically transforms the visual experience. New techniques, such as insights regarding proportion and perspective, not only provided important artistic measures, they also enabled the artist to pretend the real where the medieval craftsmen set the symbol (Panofsky, *Meaning* 26–54). The focus of this essay, however, is not on the techniques but on the ways in which painting here gives rise to a new discourse about bodies and the ways in which human beings may conduct themselves. There is apparent a paradoxical dynamic between imagery and traditional interpretations of the text of Genesis 3. The disturbing allure of beauty is detested as temptation—hence the female serpent's head—but Eve herself remains attractive to the viewer, an incentive for imagination.

The vibrant, realistic body surfaces even more dramatically about a hundred years later in the next example, a painting by the German painter and graphic artist Hans Baldung Grien. The body speaks eloquently in the painting *Eve, the Serpent, and Death* (Fig. 4). The image is no longer securely entwined with the biblical text. The story of the Fall is not readily recognizable in the painting, and the title of the work is needed to readjust and extend the context to the suspended recollection of the biblical text (Hieatt 297). The tension between reminiscences of the biblical tradition and Baldung's painting opens a dramatic space for the imaginative

response. Figures, emulating the illusion of the human body, evoke an intricate play between viewer and image. In her stunning move, the first woman seduces viewers with the radiance of her gorgeous body. Strict adherence to the biblical text is unreservedly replaced by artistic playfulness in which a visual discourse discloses life and death beyond the Garden of Eden, forcing the gaze to be engaged in the deadly play between attraction and seduction. For the first time in the history of monumental panel-painting, Death, personified, encircled by the snake, grips Eve's flesh (Koch 5). The boundaries between the sacred and secular seem to have disappeared in a world in which a beautiful shining body and flying hair do not allow the gaze to rest on the sinister side, where evil forces lurk under the forbidden tree to implement punishment. Baldung gives a body to Augustine's interpretation of death as the condemnation of the sinfulness of Adam and Eve, the consequence of a human body and soul that has surrendered its will to temptation (*City of God* 13.3).

Physical charm, stepping into the foreground, exerts a fascinating force beyond the sacred realm. The artist presents an interpretation of the Fall in which a sensuously audacious Eve, a delicate nude, has taken centre stage as the protagonist. Adam has no role in the drama of perdition. Without shame, Eve steps confidently forward, her head enticingly tilted sideways as if to invite the characters of darkness to join her. Although Baldung's expressive, rotten, flesh-like skeleton instils abhorrent fear, the observer cannot but rest the eye on the illusionary beauty of Eve, encompassed by the gaze of the viewer who delights in her body. The paradox of beauty as allegory for ultimate failure does not prohibit attraction, but, quite the contrary, extends a dangerous invitation to enter the realm of the nude body, as if the self-confident Eve had finally loosened the grip of the serpent and the legacy of Paradise lost. Baldung's works are notorious with respect to their potential to provoke divergent interpretations among scholars. In this painting, *Eve, the Serpent, and Death*, textual visuality of the Fall not only restructures the connection between word and image, it also provides incentives for the imagination that involve the human being in its personal history. The tension between the biblical story and the artistic image becomes the field in which the viewer perceives the image, reconstitutes it, and experiences its place in the world. Hence, via the reflective gaze, imagination not only participates in the creation of meaning but generates

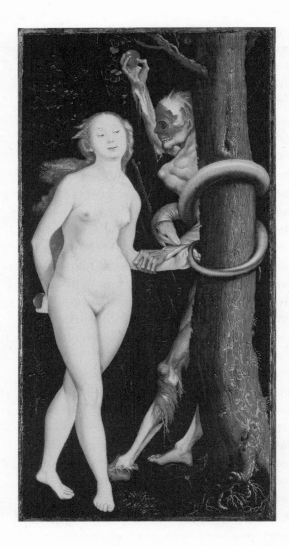

Figure 4 Hans Baldung (called Grien), *Eve, the Serpent, and Death*. Oil on panel; 64 × 32.5 cm. German; c. 1510–1515. [Photo Copyright © National Gallery of Canada, Ottawa; reproduced by permission.]

human behaviour in a world opened through the image (Merleau-Ponty 451). In other words, the theological interpretation of the Fall masks an understanding of the female body that has already claimed pleasure in the gaze.

Baldung, playing with Eve's self-confident charm, delights the gaze, while the textual discourse ascribes seductiveness to the female gender.

The gaze is invited to reflect upon Eve's appeal and the perfected, enticing illusion of a visual representation of reality. Looming up out of the darkness, death personified consigns the flesh to the mortal consequences of sinfulness. Baldung's painting thus dramatically transforms the story of the Fall. In contrast to early medieval representations of Genesis 3, the work provokes an increasingly objectifying gaze to engage in an illusion of the real. In consequence, the real manifested in the painting resonates with the world alive in the gaze. As Thomas Puttfarken argues, the Renaissance artist understood the picture as a lively enactment of the order and harmony of the universe: "In Renaissance theory and criticism the 'picture' has no ontological status apart from that of its figures and objects....The paradigm of all order and disposition, the distribution and arrangement of the world by God, was accessible to the artist...in the composition of the human body" (98). Within these boundaries, Eve's body no longer alludes to a symbolic dimension of sinfulness but to a real body dangerously engaging the gaze and her own role in a changing society. Flesh imperils moral constraints and delivers the body into the grip of death.

The few images here sketch bold lines in what are, in fact, most complex historical contexts. Yet the distinctly different roles that the diverse female bodies take on in their respective traditions not only mirror important, historically located perspectives on the flesh and sexuality, in which imagery of the body plays a central role in the tradition of the biblical story of the Fall, but also reveal evocative ways that humans perceive themselves. "One of the essential factors in imaging consciousness is belief," Jean-Paul Sartre claims (116). What is of importance is the intricate interplay between principles based on the biblical textual tradition and images that sometimes only remotely refer to those traditions while also recreating them. This interplay is decisive in establishing what a society holds to be true. In Baldung's painting, the observer is no longer visually taken into the Garden of Eden, but faces an immediate encounter with the reality of evil in seductive beauty. Ecstatic physical beauty effectively replaces the medieval symbolic dimension, and yet the images of the serpent and death loom large, forcefully recalling the grave detriment that is believed to have its origin in the Fall of humanity.

The most dramatic transformation of historically constituted experience is visualized in Eve's role. "Seeing as" is no longer strictly tied to the

symbol carrying the divine truth. Instead, in the optical illusion, the gaze begins to detect a world and its alleged nature. In the beauty and ugliness of the figures, life and death emerge as concepts because the viewer experiences the "illusion of being immediately present everywhere and being situated nowhere" (Merleau-Ponty 369). The image, restructuring traditional resemblances to the biblical story of the Fall, opens a space to realize the limit of experience for the body in its actuality.

In this sequence of images, the focus has shifted from the serpent symbolizing the abstract notion of evil, looming outside the human body, to visualizations in which the gaze experiences the spectacle of evil itself in its beauty. Lost is the unidentified source beyond the control of human beings symbolized by the serpent in the Beatus commentary. Responsibility for evil almost exclusively rests in the hands of the human being who carries the capacity for evil. Baldung's work offers a pre-taste of an imaginative gaze, beginning not only to restructure the bond between word and truth, but entering a creative process of a free play of possibilities in which values and being in the world can be explored. The body is in the centre of this changing discourse about the sources of evil, a body that is simultaneously object and subject of the gaze. In this process of "seeing as," which reconstitutes reality via the imagination, the legacy of the Fall lingers beyond conscious realization in a tradition in which the distinction between good and evil has moved into the realm of the body veiled in the illusion of beauty and ugliness. Baldung's interpretation of the biblical text is thus fundamentally different from the medieval goal of linking directly the sign and divine truth. Instead, the image offers a dynamic incentive to the imagination via the engaging eye of an active gaze that ultimately re-describes reality.

Works Cited

Augustine (St). *The City of God against Pagans (De civitate Dei contra paganos).*Trans. Philip Levine. Loeb Classic Library. 7 vols. Cambridge, MA: Harvard UP, 1957–1972.
———. *Confessiones.*Trans. Joseph Bernhart. Darmstadt, Ger.: Wissenschaftliche Buchgesellschaft, 1984.

Bernard of Clairvaux (St). *Apology* (excerpt). Trans. David Burr. <http://www.fordham.edu/halsall/source/bernard1.html>. Accessed 1 August 2006.

Besançon, Alain. *The Forbidden Image: An Intellectual History of Iconoclasm.*Trans. Jane Marie Todd. Chicago: U of Chicago P, 2000.

Brown, Peter. *Body and Society: Men, Women, and Sexual Renunciation in Early Christianity.* New York: Columbia UP, 1988.

Camille, Michael. *The Gothic Idol: Ideology and Image-Making in Medieval Art.*1989; Cambridge and New York: Cambridge UP, 1995.

Davis-Weyer, Caecilia. *Early Medieval Art, 300–1150: Sources and Documents.*1971; Toronto: U of Toronto P, 1986.

Eriugena, Johannes Scotus. *Periphyseon (De divisione naturae) IV.* Ed. E.A. Jeauneau. Trans. J.J. O'Meara. Dublin: Colour Books, 1995.

Foucault, Michel. *The Order of Things: An Archaeology of the Human Sciences.*Trans. A. Sheridan. 1971; New York: Vintage, 1994.

Freedberg, David. *The Power of Images: Studies in the History and Theory of Response.* Chicago: U of Chicago P, 1989.

Grivot, Denis, and George Zarnecki. *Gislebertus, Sculptor of Autun.* New York: Orion P, 1961.

Hieatt, A. Kent. "Hans Baldung Grien's Ottawa Eve and Its Context." *Art Bulletin* 65 (1983): 290–304.

Jerome (St). "Jerome Against Jovinianus." *Post-Nicene Fathers of the Christian Church.* Vol. 6. Ed. Philip Schaff and Henry Wace. Edinburgh: T. & T. Clark. <http://www.ccel.org/ccel/schaff/npnf206.html>. Accessed 1 August 2006.

Kant, Immanuel. *Immanuel Kant's Critique of Pure Reason.*Trans. Norman Kemp Smith. London: Macmillan, 1958.

Koch, Robert A. *Hans Baldung Grien: Eve, the Serpent, and Death.* Ottawa: National Gallery of Canada, 1974.

Merleau-Ponty, Maurice. *Phenomenology of Perception.*Trans. Colin Smith. 2002; London: Routledge, 2005.

Panofsky, Erwin. *The Life and Art of Albrecht Dürer.* Princeton: Princeton UP, 1955.
———. *Meaning in the Visual Arts.*1955; Chicago: U of Chicago P, 1982.

Prusak, Bernard P. "Woman: Seductive Siren and Source of Sin?" *Religion and Sexism: Images of Woman in the Jewish and Christian Traditions.* Ed. Rosemary Radford Ruether. 1974; Eugene, OR: Wipf and Stock, 1998. 89–116.

Pseudo-Dionysius the Areopagite. *The Complete Works.* Trans. Colm Luibheid. New
York and Mahwah, NJ: Paulist P, 1987.

Puttfarken, Thomas. *The Discovery of Pictorial Composition.* New Haven, CT: Yale
UP, 2000.

Ricoeur, Paul. *From Text to Action: Essays in Hermeneutics II.* Trans. Kathleen Blamey
and John B. Thompson. Evanston, IL: Northwestern UP, 1991.

_____. "The Function of Fiction in Shaping Reality." Trans. David Pellauer. *A Ricoeur
Reader: Reflection and Imagination.* Ed. Mario J. Valdés. Theory/Culture 2. Toronto:
U of Toronto P, 1991. 117-36. (Rpt. from *Man and His World* 12.2 [1979]: 123-41.)

Salisbury, Joyce E. *Church Fathers, Independent Virgins.* London: Verso, 1991.

Sartre, Jean-Paul. *The Imaginary.* Trans. Jonathan Webber. London: Routledge, 2004.

Shapiro, Gary. *Archaeologies of Vision.* Chicago: U of Chicago P, 2003.

Thomas Aquinas (St). *Summa theologica.* Trans. Fathers of the English Dominican
Province. 3 vols. New York: Benziger Brothers, 1947-1948.

Tertullian. *On the Apparel of Women (De cultu feminarum).* Trans. Rev. S. Thelwall.
<http://www.tertullian.org/anf/anf04/anf04-06.htm>. Accessed 16 May 2007.

Williams, John. *Early Spanish Manuscript Illumination.* New York: George Braziller, 1977.

_____. *The Illustrated Beatus: A Corpus of the Illustrations of the Commentary on the
Apocalypse, 3: The Tenth and Eleventh Centuries.* London: Harvey Miller, 1998.

Two Discovering the Present

Contemporary Configurations

Memoirs of Byzantium

MYRNA KOSTASH

As I have travelled through eastern, central, and southeastern Europe, wherever there is an Orthodox church I have found myself in it. I take a kind of rest in the homely peace that settles over me; I sniff the remnant whiffs of incense and beeswax, gaze at the icons who gaze back at me, and mumble the lines of text I know from the hymns and prayers of the Orthodox liturgy.

I had been baptized Orthodox, and all these churches—in Bulgaria, Macedonia, Serbia, Romania, and Greece—were open to me, as were their prayers, their feast days, their saints.

St Demetrius, for example. On the icons, he is young and pretty-faced, beardless, with thick hair tucked behind his ears. He wears the green tunic and red cloak of a Byzantine army officer and holds a round shield and long-armed cross. He died young, speared through his right breast, in the basement of the Roman baths in the northern Greek city of Thessalonica, for the crime of preaching the Gospel of Jesus Christ. This was the year 304, his name was Demetrius, and he was going to become a saint.

As Demetrius of Thessalonica, he would be one of the most powerful saints in all of Christendom. But he had been hastily buried in the red earth of the baths; then the little shrine marking the spot fell into ruin, the relics disappeared, and, after a time, the details of his life and death vanished from living memory. But he came back three hundred years later to perform miracles, and the greatest of these was the defence of his beloved city, Thessalonica, from the repeated assaults of the barbarians at the gates. The barbarians tried over and over again to crash through the walls and gates but to no avail. Demetrius appeared miraculously on the ramparts and saved the day. He and the Thessalonians had thrown back the enemy, which is to say the Slavs. Which is to say me.

Then the barbarians became Christians and embraced the saints, including Demetrius, patron and guardian of Thessalonica.

In one of the numerous religious bookshops in Thessalonica I bought a comic book. St Demetrius is displayed on the cover as a warrior saint in Roman breastplate and halo, mounted on a sturdy steed on the crest of a hill, with an expression of beatific resignation to his task, which is the defence of the city laid out below. Inside the book, however, Demetrius is something like the Incredible Hulk of Orthodoxy: he stands up in his stirrups, with his stallion pawing the air above the ramparts, to give an almighty shove to the scaling ladder from which the barbarians, brandishing battleaxes, fall like so many fleas off the back of a dog. A few panels further on, they are back at the city walls, this time with formidable catapult machines and a supply of enormous boulders against which the terrified Thessalonians can marshal only a procession of priests bearing icons and swinging censers until—lo!—St Demetrius appears hauling a boulder of his own. On it is inscribed a cross and the text of the very message that had flared in the midday sky on 28 October 312, the day of St Constantine's victory over his enemy at the Milvian Bridge north of Rome. *In hoc vinces* (conquer by this), Constantine read, there above a cross of light in the heavens. Demetrius's boulder is inscribed in Greek but carries the same effect: the Thessalonians load it in their catapult and BOOM! KRAK! it hurtles over the walls and into the barbarians' infernal siege machine, blowing everything to smithereens.

In another miracle, the Saint, impatient for the thick of battle, and in order to be seen as well as felt by the faithful, clambers over the ramparts as light as a bird, his shield and sword and Roman armour weighing no more than the cape clasped at his throat. FRAP! he swings his sword. OOG! UGH! he spears a barbarian who slithers down the ladder, spraying his blood all over the battlements.

Demetrian scholar Paul Lemerle concludes, "The great city remained impregnable, and this alone doomed the successive assaults of the Avars, the Slavs, the Bulgars. This is the deep meaning of the Demetrian legend" (162).

Yes, but what did it mean to the Slavs?

In 253, Goths had vainly attempted the capture of Thessalonica; in 479, Theodoric of the Ostrogoths approached the city walls and turned away in hopelessness; over the winter of 550–551, barbarians formerly settled on the far shore of the Danubian frontier spent their first winter on Byzantine soil; in 581, the assault came from northern barbarians who were over-running all of Greece, capturing, devastating, and burning cities and enslaving their populations. They even brazenly settled down in the Greek countryside "and dwelt in it as though it had been their own without fear," to quote John of Ephesus, a Syriac historian (qtd. in Obolensky 51). These ones will not go away. Although they will repeatedly attack Thessalonica, they will not take it, and for generations ever after their descendants in Macedonia will long for this lost city of their hopeless dreaming even as they put down roots in the country all around. Thessalonica would never be theirs, for it was under the protection of St Demetrius.

These are, by remote but sure connection, my people. They swarm around the Balkans, driving south from the Danube; mere plunderers and looters and rapists, they terrorize the Greek world and enter its texts. Probably they wear animal skins and drag cudgels along the ground.

A medieval pilgrim to the Basilica of St Demetrius in Thessalonica would have made the rounds of the aisles of the nave, pausing at each votive icon or pillar mosaic to make the sign of the cross and to kiss its frame, perhaps to light a candle, perhaps just to stand there awhile, con-templating the story told by the image. For example, the mosaic panel of St Demetrius with his arms around the shoulders of Bishop John and Eparch (governor) Leontius, founders of the church, all three in splendid, voluminous robes. The pilgrim looks more closely: underneath the picture is an inscription, a flourish to the literate Greek viewer: "You are looking at the builders of this famous house from where the martyr Demetrius is the one who turns back the barbarian wave of barbarian ships and redeems the city."

What exactly is my "point of view" as I gaze at the mosaic inside a church that represents the faith I was raised in, and named for a saint who has his feast day duly celebrated in the Ukrainian Orthodox Church of Canada, and whose exploits celebrated here in Thessalonica amount to the repulsion of the Slavs, which is to say of the forebears of me?

In the third century, the Goths cross the Danube; in the fourth, the Huns. Finally, in the sixth century, it is the Slavs' turn. It was a passage as portentous for European cultures as that of the Germanic barbarians who had poured out of quarantine over the frozen Rhine in 406 CE into Gaul and never went back.

The Slavs destroyed Roman cities and moved on, through watered plains of wheat to the northern limits of the olive tree, past battle sites, below wooded hillsides, and between mountain ranges. Barbarians that they were, they nevertheless made use of the superb Roman highway system—to spread out from inland cities such as Naissus (Nis) and Serdica (Sofia)—and their own dugout canoes, to cross even to the Peloponnese, densely slavicizing the territory they had chosen as their new home.

And there, at the mouth of the Vardar, where it spreads out into the sea from its descent through the mountains behind Skopje, is Thessalonica, commanding the northern Aegean with a massive citadel: if the Slavs moved by easy stages, they could reach it in eight days from Singidunum (Belgrade) on the Danube. When they got there, they would call it Solun.

And so the Slavs stand at the gates and gawk. Inside are stone mansions and gardens of pomegranates, wagons laden with amber, olive oil, and plush brocades, and bales of airy cotton; there are tent-makers, mariners, and scribes who ply their trade for merchants and travellers journeying to the City, the King's City, Constantinople. The Slavs stand and gawk, and want it all. Fine tunics embroidered with gold, slaves pouring rose water in the bath, cooks in the kitchen, barrels of wine in the cellar. What they don't yet see, for they mean nothing, are the tiled roofs and the frescoed piers in the narthex of the basilicas, and they can't hear the chants in the monasteries nor smell the musk of the incense in the crypts, but eventually they will want these, too, and one day also they will want St Demetrius. They will call him Dimitri Solunsky.

The immemorial destination: "Sloboda ili smrt! Od Koruna do Soluna!" It is the slogan, in October 2000, of the farmers of Cacak, Serbia, marching to Belgrade to oust President Slobodan Milosevic from power. "Freedom or death! From Kordun [a historically Serbian town in Croatia] to Thessalonica!" From the Adriatic to the Aegean, this great swath of Slavic longing.

In 1988, a young Yugoslav Macedonian man scribbled on a napkin a rough map of the southern Balkans: it was my first lesson in what constitutes, in his vivacious mind at least, Greater Macedonia. It comprises three parts—Vardar (a squiggle of his pen), named for the river as it flows in then-Yugoslavia; Pirin, for the mountain in western Bulgaria; Aegean, for the sea rimming the unrequited, lost home harbour. The salt water laps at Macedonia, but the Greeks threw the Slavs back from the shore. The Slavs would build their cities elsewhere, on Balkan plains, in Balkan valleys, and on the shores of Balkan lakes they would call seas.

The brilliant, tragic Bulgarian king Samuel moved his capital to Ohrid. My Macedonian friend and I climb up the crag to the old, monumental gate and the remnants of ramparts from which Samuel lorded his authority over southern Serbia, Albania, Macedonia, Thessaly, and Epirus, between the Black Sea and the Adriatic. Unopposed, up and down valleys and across plains he marched his armies to the Isthmus of Corinth in southern Greece. The Byzantines finally stopped him on his way back, at Thermopylae in 997.

He had built himself a palace of towers ornamented with stone and fresco, and churches of marble and copper, silver and gold, in a kingdom of mud-caked hovels. He hung a mantle around his neck, embroidered with pearls, and slid gold bracelets on his wrists, and he wrapped his hips with velvet, and slung a sword in a jewelled scabbard. His boyars sat in ranks before him.

He would throw himself repeatedly at Thessalonica, too, but didn't he know? It was under the protection of St Demetrius, and the seawater was his.

Ohrid, 1988: I watch Goce across the café table, his dark face disappearing into the shade of the chestnut tree, and around us dark men drink red wine while pieces of lamb, jasmine and garlic, lemon and salt, sizzle on the grill. On Goce's face I watch the aggrieved expression of an ancient disappointment: the Slav who was thrown back by Greeks from the salt sea at the mouth of the Vardar, and who now stands with his back to the lake at Ohrid, which, to comfort himself, he calls the Macedonian Sea.

Goce has been turned away at the Greek border. What are they afraid of? "Write this down!" he shouts at me. "The Greeks force the Slav

Macedonians within their borders to write the epitaphs of their tomb-stones in Greek!" I write this down, swallowing a large mouthful of wine to stop my protest that Cyrillic is after all based on Greek letters, so...."And this! Marshal Tito, super-partisan of partisans, scourge of fascists—may his memory be eternal—directed his partisans at the end of the war to head north in pursuit of the retreating Germans instead of unleashing them to go south. South! South all the way to Solun...to get it back." Back?

Goce did live there once, or may as well have done, so intensely can he taste the dust off the red Byzantine brick and the salt of the gulf. He had a garden and cultivated gourds and vines, combed the fleece of his sheep, and built a stone altar to his gods. Then a Greek saint threw him out.

Slavs Come Down to the Balkans

In 1912 the French Byzantinist Alfred Rambaud surveyed the ethnographic maps of the Balkans. Setting aside the Turks for the purpose of his argu-ment, he saw there on the maps no "uniform hue consecrating the tri-umph of Hellenism," but, rather, "the strangest hotchpotch of colours." If it weren't for the Greeks of Thessalonica and the Macedonian coast, those in Constantinople and Athens would be "completely isolated" (Rambaud 264). British Byzantinists weighed in, too, as late as the 1960s, when Romilly Jenkins mused on the decline of the Hellenic creative genius since Alexander of Macedon, due mainly to the decline in the *biological* stock of the Mediterraneans (Vryonis, "Recent Scholarship" 238).

But what was more striking to me was the degree of Greek indignation at the very thought that they might have crossed bloodlines with the Slavs. After all, the barbarians did settle down and live alongside them, and even-tually became Hellenized and Christianized and practically indistinguish-able from their neighbours. Byzantine was not an ethnicity but a culture, "quite accustomed to the situation in which the Empire had become, since late Roman times, an ethnic mixture on an enormous scale" (Cheetham 13). At least until its late period, its name for itself was *Roman/Romaioi*, indifferent to its racial antecedents.

If any culture had been exterminated, it was the Slavs'. What was so intolerable in the notion that there is no such thing as a racially pure

Greek? To quote a British-Russian-Jewish traveller to Monemvasia in 1995, "the idea of ethnic or genetic homogeneity in societies which have lived through centuries of movements of population, of immigration, emigration and re-migration, let alone invasion and occupation, is bogus and dangerous romantic twaddle" (Kark 88).

Engineers of the great Byzantine emperor Justinian (483–565 CE) had constructed a string of fortresses across Macedonia precisely to keep the Slavs out, and away from the Thessalonian prize (Cheetham 15). The repair of the ancient wall across the isthmus that connected the Peloponnese to the Greek mainland was futile labour, however, and the destruction of the Justinian walls was so complete they are now unlocateable. The Slavs poured through, and in 581, according to the ecclesiastical history of John of Ephesus, Slavs overran the whole of Greece, "captured the cities and took numerous forts and devastated and burned and reduced the people to slavery, and made themselves masters of the whole country" (qtd. in Cheetham 16).

Byzantine culture was overwhelmed in the greater part of the southern Balkans. And "when the darkness begins to lift from the peninsula" in the ninth century, the Roman names for places have vanished, replaced by Slavic; Greek replaces Latin as the official language of the state; the Byzantine populations have been reduced to "murmur indignantly and endure." The Roman historian Polybius, in the second century BCE, had asked, "What is more dreadful than a war with barbarians?" (qtd. in Obolensky 52).

Where the barbarians settled on Byzantine territory was called Sclavinia. In 581 John of Ephesus called them Slavonians and "an accursed people" (qtd. in Obolensky 51). The countryside had become a wasteland abandoned by its farmers, turned now into a "Scythian" (Slav) wilderness of pestilence and famine. Bishoprics were uprooted and administrative machinery collapsed. Highways fell into disrepair. When God is angry with humankind, it was said, He sends signs: plagues, earthquakes, floods, shipwrecks, civil wars, enslavement, and barbarians. Four thousand people in Patras were buried by an earthquake in 561; in 542 a great bubonic plague consumed whole villages and towns.

The long stretch from the sixth to the ninth century is sometimes called Byzantium's Dark Ages—or, at least, obscure times—from which the

Christian, Greek-speaking world centred on Constantinople in the eastern Mediterranean emerged forever differentiated from its former identity as *Roman*—in direct lineal descent from the glories of the empire centred on Rome—by the two centuries of Slav barbarism that intervened. Unlike the Latins, however, who had succumbed to the Goths and Vandals, the Byzantines gradually began a reconquest of their territory, by stationing troops in coastal cities such as Thessalonica, Patras, and Monemvasia, and by settling Greek farmers in the Balkans, then enserfing the Slavs, pressing them into the army, and evangelizing them. One scholar calls this the "reconquista" (Vryonis, "Review Essay" 423).

The gradual transformation of Slavic pastoralists who worshipped a god of thunder into Christians who paid tax to Constantinople was underway, and a new Byzantine character type pops up in the literature: take Pervund/Perbundus, for example, the Slav chieftain in the neighbourhood of Thessalonica who spoke fluent Greek and enjoyed parading about in Byzantine robes; or the comic bishop Niketas who mispronounced Greek; or the rich landowner in Constantinople who, boasting of his Peloponnesian origin, was given away by his Slavic cheekbones (Cheetham 22).

How was it possible for such unsophisticated barbarians as the Slavs, without political organization, to have wreaked such havoc on the Byzantines as to bring down a "Dark Age" upon them? They had lived peaceful, indeed monotonous, lives in forests and marshes, an economic niche "underexploited by their more sophisticated neighbours" (Whittow 49–50), beyond the gaze of the ancient world until they reached the Danube, until they were finally mentioned at the beginning of the sixth century by Pseudo-Caesarius Nazianus.

The remains of their material culture found in excavations are unprepossessing in the extreme, the early Slavs having built their shelters halfsunken into the earth. As herdsmen, they knew neither ploughing nor slash-and-burn agriculture; as hunters and fishers, they lived in marshlands and along rivers, and hollowed out their boats from trees. They did not try to inhabit the Greek towns in the Balkans, such as remained, but set up their own villages organized around family groups. Later Romantic historians had them as beekeepers and diligent cultivators of grain, fruitgrowers and brewers of mead, with an aptitude for commerce, but this was not the culture they arrived with.

Why, then, the Greeks' historic sense of having been terrorized, and polluted, by such people? They were historically, after all, the more "cultivated and dynamic race" (Stratos 157).

Emperor Nicephorus I crushed a massive Slav siege—some sources say a riot—in Patras in 805, which was under the protection of St Andrew. Nicephorus enserfed them all, men, women, and children, and handed them over as property to the church. By this time the Slavs had been on Greek territory for more than two hundred years, pushed around by Greek colonists forcibly settled from Asia Minor. "Their [the Slavs'] back was broken," writes Peter Charanis of the campaigns of Nicephorus. "Nicephorus saved Greece from becoming slavonicized" (86). By his feat the Slavs were then absorbed into Christianity, and discharged into the great currents of history, their gods and their names for things exhaled as effluvia of cultural failure.

There are two Ukrainian Orthodox churches in Saskatoon: the original one, located in what is called here the Core Neighbourhood and which used to be East European working class but is now mainly Aboriginal (Good-bye Dnipro Cafe, Hello White Buffalo Youth Lodge); and a suburban one beautifully done in wooden Carpathian style. I picked the first one because it was closer to where I live and I got hooked. The congregation is middle-aged and elderly with a sprinkling of young and fertile Ukrainian immigrants, it is working and lower middle class, it has a pretty darn good choir, beautiful Byzantine-style frescoes, and a young priest who grew up on a Manitoba farm and decided to join the priesthood the day his boss on the oil rig in Alberta wouldn't let him go home for Ukrainian Easter. I was immediately welcomed into this community and have got into the spirit of the thing: I've driven a carful of women around to sing Ukrainian Christmas carols at people's homes, laid tables and cleaned up after community lunches, sung with the choir (once and never again), joined a short-lived group learning to sing the Liturgical chants. We were five: me, my friend Elaine, cantors Wally and Ernie, and Stefan, the church caretaker. Well, the men already knew how to sing, in all eight tones of the Byzantine chant. Me, I couldn't hear the difference, and sat abashed.

I wrote this in a notebook, then wondered: Were Ukrainian-Canadians all pious once upon a time? All of us—from the women in fantastically-flowered Easter hats to the men on the farms who took wives and children to church but themselves stood outside the building, leaning on their wagons, smoking, and talking about grain prices? From the Ukrainian-speaking

priest who threw his stole over my head to hear my confession and wondered how to get through to me, to the tiny old woman, bent over at a right angle from her waist, in permanent paralysis, kissing and stroking the icon laid on the lower altar? I am told my paternal Baba was a woman of great piety, although I have no memory of any particular instance of it, unless it were her remark that her one wish at the end of her life was to die when it was not winter, for how were the poor gravediggers to dig her grave in the blasted heath that is the Canadian parkland in the winter? (She died in a February.) My paternal grandfather died before I was born, but I did come across, in the cigar box with the hinged lid that so fascinated me, the small black and white photograph of his funeral: it was taken outside the church somewhere near the farm, my father was one of the pallbearers, hatless though stout with a winter coat (another winter funeral), my grandfather laid out in the open coffin, his hands crossed over his dark-suited chest, his face bearing a large moustache. Fortunately, Baba had borne a family of sons; she did not have to sell the family farm.

Is this what constituted Ukrainian-Canadian piety: a church for the rites of passage, the twelve dishes of Christmas Eve for the twelve Apostles, a bowl of painted Easter eggs on the coffee table, and a prayer at the end of life not to be a burden to anyone, not even in one's coffin?

My maternal grandparents were something else altogether. What I know of their attitudes to the Ukrainian, or any Christian, church I know from my mother's familiar anecdotes, as well as from what I sensed when I was in their home: they never went to church and hung no icons. Arguments between my father and Dido were as often as not provoked by the brandishing of their respective newspapers, *The Ukrainian Voice* vs. *Farm and Life*. Dido was not my biological grandfather—that man had died in his early thirties, from pneumonia contracted from one walk too many on the long, dark, cold walk home from the rendering plant in east Edmonton. Dido was his brother, a thin, bug-eyed, gristly bearded man in coveralls and long johns who spoke no English, and who had married, as was expected, the widow of his brother. As the story goes, he forced his new wife to give up her Bible and placed it in the outhouse—Baba, whose best subject in four years of school in Galicia had been religion—and made a fuss whenever mum was invited by the daughters of "English" neighbours to join them in going to a Sunday service at the neighbourhood United or

Anglican church. For this was the same householder who spat invective against priests ("blood-suckers") and hung large portraits of Lenin and Marx in the front room.

When I have supper with my mother in a restaurant now, with its luxury of time, I know I can always count on her revisiting her young womanhood. I have heard some of these stories many, many times, but now I listen alert to the meanings they might hold for my own narrative.

For example, the tale of the surprise suitor, one Bill M. He was a fellow student at Normal School but otherwise she had no acquaintance with him. "Imagine how I felt," she invites me, meaning that I should share the shock of her surprise when Bill M. showed up unannounced at her parents' home in east-end Edmonton. Mum was studying in the little vestibule/porch. "I was a serious girl," she says, "I studied hard and helped my mother with the cows and chickens, and there was certainly no money for hair cuts or new dresses, and I had no time for boys," but here was one, asking her to go out with him that very evening. At least, she assumed that was his intention; but, having caught a glimpse of the imposing portrait of Lenin on the front room wall, he made his excuses and departed. He never approached her again.

I had always found this anecdote mildly amusing. Mum always tells it with a tone of reproach, both toward Bill M. for his fecklessness and toward her parents who should be so unhelpful in her social life as to hang such pictures on a Canadian wall. But now I want to know more. Why is it that she did not align herself with the politics or at least the community of the Ukrainian-Canadian left? "I just felt there was something wrong about it." I think I am meant to understand her as admirably her own woman in such a milieu, but now I am irritated and regretful, for by never associating with the "goings-on" at the Hall (the socialist Labour Temple), she has effectively deprived me of an interesting legacy: that of a parent who marched in May Day parades or learned labour songs or heard speeches by Ukrainian-Canadian Communist militants or memorized proletarian verses by Ukrainian poets or saluted the hammer-and-sickle flag or...whatever subversive or at least alternative culture was incubated away from the churches.

"Oh, leave her alone!" said Baba in mother's defence. "Let her go to church if she wants to." And off mama went, a few times, and to this day

longs for the hymn-singing of those Protestant immigrant and working-class congregations who sang their hearts out, the minister's wife joyfully banging away at the rickety upright piano, singing texts that were *normal*—everybody knew them, even if they themselves weren't "English," from song books and glee clubs and school recitals: *Rock of Ages, cleft for me, and let me hide myself in thee....Glory, glory, halleluiah, His truth goes marching on....*

I see now that I was more my Dido's granddaughter than my mother's daughter. I have spent most of my conscious life as a secular humanist, receptive to movements that followed on my adolescence: the New Left, the counterculture, feminism, Canadian cultural nationalism, environmentalism, Soviet and East European dissidence. I was overwhelmed by wave upon wave of distress and outrage at the iniquities of the powerful and ruthless around the world, and I found solace, not in spiritual practices (as others did in Buddhist meditation and Native American peyote ceremonies and Liberation Theology, anywhere but in a church), but mainly in political texts. I pored over Marx and Lenin in Sunday morning (!) reading circles and Germaine Greer and Kate Millett in feminist reading groups and Malcolm X, Regis Debray, and eventually the entire library of New Left Canadian critiques of the world order in the books I was piling into my own library. If that's what we mean by *modernity*, there was a very good reason why I spent most of my life inside it, namely my conviction that the human heart is a capacious enough organ to enable me to live life as a good person.

And I suspected that faith in the transcendent was some kind of luxury for the lucky few who know how to pray.

"The illusory importance and autonomy of private life," wrote German philosopher Theodor Adorno, "conceals the fact that private life drags on only as an appendage of the social process" (qtd. in Rose 21). All through the decades of my intellectual maturation and beyond, even as the idealized models collapsed—the Left into a dustbin of history, feminism into post-feminism, the "peace dividend" into perpetual war—I believed passionately in the possibility of human solidarity.

But as I stood in the Basilica of St Demetrius in Thessalonica, surrounded by images of his ineffable beauty, and venerating them, I can see now that I was struggling for a "self" that was neither reducible to some private psychodrama nor dismissible by an ironic, despairing flourish of postmodernism. I was admitting to myself, icon by icon, that my "self" was

embedded in the matrix of spirit, as well as in history, politics, culture. And even as I began to thresh about for a spiritual vocabulary for my desires, I knew that *salvation* was not personal but would still somehow be a communal struggle, as *liberation* and *revolution* had been. That it might be taking on the form of the Ukrainian Orthodox Church of my childhood was not yet an issue; the struggle was.

> It is fitting for Greeks to rule barbarians.
> —Euripides, *Iphegenia in Aulis*

December 2001. As I made my way back to my hotel in Monemvasia, in the Peloponnese in Greece, I heard the bells pealing from the church in the next street. Vespers? I slipped inside, and stood at the back along with several women and a couple of men. There were two cantors at the front, an old man leaning on a cane and warbling weakly, and a young man I recognized from the old town in the afternoon, still in his windbreaker and sneakers. I stood, hands at my sides, and tried to recognize "in the name of the Father and the Son and the Holy Spirit" so that I could make the sign of the cross—*I am Orthodox, see me sign!*—but I remained baffled. The little altar in front of the iconostasis (I know there's a word for it) consisted of a simple folding table dressed with a white cloth on which had been placed a bowl of *kolivo* (cooked wheat, the food of the dead) impaled by three burning tapers. The white-bearded priest, big-bellied under his black cassock and gold stole, gestured perfunctorily. Well, he was a civil servant, after all, and wanted to be home. *This is how I become one of those Slavs at the furthest reaches of the Peloponnese: I stand motionless in front of an iconostasis, my hands by my sides, bewildered by the goings-on, and become a Christian.* It will be ages and eras before I believe, but I will show up in Orthodox churches because it is my memory of the gods.

I want to understand what happened at that moment of transformation of the Slavic world by the Christian Gospel, and how the Byzantines felt about these very same barbarians—from whom they so recently had had to save themselves—now that they too were in possession of the Word. When I returned to Thessalonica, I put the question to Byzantinist Dr Antony-Emil Tachiaos. He offered the notion of "transplantation," not "assimilation," to account for what happened—as in "transplantation of

Byzantine cultural elements into the Slavonic world." The Slavs found Byzantium irresistibly attractive because, argued Tachiaos, "they could not produce Byzantine culture themselves,...could not say the Liturgy as such, the readings of the Holy Scriptures as such, even make the movements of the priest during the Divine Service. The Slav Christians did not *imitate* these, they *transplanted* them" into the quiescent humus of their souls.

In the Cathedral Church of the Holy Trinity in Saskatoon, there hangs the iconic representation of the Baptism of Ukraine. Saint and Prince Volodymyr in Byzantine court dress looks Mongol, high-cheeked and mustachioed, as he supervises the rite. His people throng waist-deep in the river while priests lean over from the riverbank, blessing the waters while soldiers stand in disciplined ranks before them. Here, then, are all the social orders. From Volodymyr's hand spills a scroll: *God Almighty who created heaven and earth, look now upon these new people, and grant, Lord, that they acknowledge you the true God as the Christian nations have done.*

There's one in every Eastern rite Ukrainian-Canadian church I've been in, in vestibule, nave, or basement—a depiction of the Christian baptism of Rus' in the waters of the tributary Pochaino River. The entire population of Kyiv has been assembled on the river shore and some are already knee deep in the stream while Prince Volodymyr, dressed as a Byzantine knight in long white tunic and bejewelled belts, sternly directs this compulsory conversion of his people. Until this moment, they have been satisfied with a cosmology peopled by forces—Hors, the sun god; Volos, god of cattle; Striboh, wind god; Dazhboh, god of abundance and fertility; and, mightiest of all, capped with silver, Perun, god of thunder—whose veneration and conciliation they had shared universally with all peoples who have not yet become "historic."

Marriage had forced Volodymyr's hand. The Byzantine emperor, Basil II, would betroth his sister to this barbarian chieftain on condition that the bridegroom convert to Christianity, baptized by a Byzantine bishop. Anna walked solemnly out the gates of Constantinople accompanied by a retinue of priests and a loud and eloquent lamentation that she was being married to no better than an idol worshipper and slave trader. With the ardour of the newly-converted, Volodymyr ordered that the idols should be overthrown. His people fell upon them with axes—they tilted woefully on the riverbank,

awaiting their fate—and built a pyre of them and burned them. Almighty Perun was tied to a horse's tail and dragged about the city, bashed pitilessly by citizens wielding sticks seeking vengeance on the Fiend who had chosen this attractive form—the silver cap, the golden moustache—to walk among them, before being tossed ignominiously into the river and disappearing over a waterfall. Then Volodymyr sent the children of the noble families to school, to learn to read Greek and Slavonic, fulfilling the prophecy of Isaiah: "In that day shall the deaf hear the words of a book, and the tongue of the dumb shall be clearly heard."

A few months ago, away from home, I picked up the copy of the Gideon's Bible discreetly shelved in the hotel cupboard drawer, and let it fall open. The passage I read there was from James 3:6. "And the tongue is a fire, the very world of iniquity; the tongue is set among our members as that which defiles the entire body, and sets on fire the course of our life, and is set on fire by hell."

It's still a shock, that Biblical language of harsh judgement, yet so vivid and stirring. I had "left the church" (that is, stopped going to Sunday services) in order to go out into the world of ideas and argument, my tongue on fire. I will never agree that such fiery speech could ever "defile" the entire body of the community.

One hot July afternoon in Saskatchewan's Qu'Appelle Valley, the air so stilled from heat that even the flies could not be bothered lifting themselves off the window panes, I sat with a friend, also a writer, who had bought this land we were sitting on, a sere and undulating landscape shaped by the meandering ribbon of water in the valley bottom. We talked about ambivalence and anxiety, that peculiar state of people who have experienced themselves all their lives as rational beings (we two, for example), only to be sabotaged, blind-sided, shaken, upended, by what my friend called "a longing for the holy" that arrives seemingly out of the clear blue heaven, but that also, if you think about it, makes perfect sense. I was listening to him with mounting agitation, for I guessed where this was heading.

My friend, an environmentalist and amateur ornithologist, is a practising Roman Catholic (after a long lapse) who was unafraid, to judge from his books, to speak publicly as a man of faith, and to interrogate that faith. The "sense" to be made of this was that not everything could be known by the exercise of logic and judgement (a modesty lost to us since the Enlightenment). Considering all the materials I had gathered in my "Demetrius project," did I not feel, he asked, the urge to go beyond

the narrative and intellectual limits of history, ethnology, and what I was calling my deep, personal, cultural grammar? Did I not want to push the boundaries of what I already knew from intellectual experience, a push from my religious heritage, not to mention from a certain saint of Byzantium? Saints are our intercessors with God, and here was one who was tapping me on the shoulder. God may or may not be out there (or in here), but we certainly aren't going to find out one way or another by the application of our reasoning alone. We are likelier to find Him through the slippages offered by uncertainty and ambivalence, what he called *the anxious threshold experience* of travelling between *rationality and faith, doubt and spiritual longing.*

"Think of what happens in the act of creativity," my friend invited me. "That mysterious arrival out of nowhere of a thought or image you did not know you were thinking or seeing? St Paul said to the Romans, 'And do not be conformed to this world but be transformed by the renewing of your mind, that you may prove what is that good and acceptable and perfect will of God.'"

Mind, yes, but mind renewed, transformed into the highest faculty of human nature—the eyes of the heart, "the eyes of your understanding," as Paul explained it to the Ephesians.

"Illumine our hearts," Orthodox Christians pray before the reading of the Gospel begins. The triumph of Christian thought in the first centuries, writes Orthodox theologian Vladimir Lossky, "was not the rationalization of Christianity but the Christianization of reason" (38). "I believe," we begin, and perhaps from the believing proceeds a new understanding of who and where we are, and not the other way around, as my lonely, rational self has believed.

Cyril and Methodius of Thessalonica
How the Slavs Got an Alphabet

It is told that in 862, Rastislav, Moravian prince, sent messengers to the Byzantine emperor Michael III, saying, "Our nation is baptised, and yet we have no teacher to direct and instruct us and interpret the sacred scriptures. We understand neither Greek nor Latin. Some teach us one thing

and some another. Furthermore, we do not understand written characters nor their meaning. Therefore send us teachers who can make known to us the words of the scriptures and their sense" (*Russian Primary Chronicle* 62–63). Michael heard them out, then sent for Cyril the Philosopher (born Constantine in Thessalonica) and had him listen to the matter:

And he said: "Philosopher, I know that you are weary, but it is necessary that you go there. For no one can attend to this matter like you."

And the Philosopher answered: "Though I am weary and sick in body, I shall go gladly, if they have a script for their language."

Then the Emperor said to him: "My grandfather and my father, and many others have sought this but did not find it. How then can I find it?"

And the Philosopher answered: "Who can write a language on water and acquire for himself a heretic's name?"

And together with his uncle, Bardas, the Emperor answered him again: "If you wish, God may give you this as He gives to everyone that asks without doubt, and opens to them that knock."

The Philosopher went and, following his old habit, gave himself up to prayer together with his other associates. Hearing the prayer of His servants, God soon appeared to him. And immediately Constantine composed letters and began to write the language of the Gospel, that is: "In the beginning was the Word, and the Word was with God, and the Word was God," and so forth. (Kantor 111)

What Cyril employed was the Glagolitic script, from Old Slavonic *glagol*, "word," or, as the *Macedonian Times* has it, "called Glagolitic because its miraculous signs could speak." If speak they once did (and into Croatia and along the Dalmatian coast as well as in Moravia), they do so no more, for it is a most peculiar-looking script—although an improvement on the scratches and glyphs with which Slavs had had to make do until then— even "outlandish," for in its sequences of what I think of as dipsy-doodles it resembles no known alphabet. Scholars have come forward to claim its origins in Georgian, Hebrew-Samaritan, Syriac, and even Byzantine alchemical symbols, but to the biographer of Cyril it was God-given. And at its arrival through his prayer, "the Emperor rejoiced, and together with his counsellors glorified God" (Kantor 68).

Certainly Cyril had heard all about the history of the Slavs in the Homilies thundered against them in the Basilica of St Demetrius, in the cautionary texts inscribed in the mosaics, and in the account of his miracles assembled as a single text in the seventh century. And it is generally agreed that he and his brother were familiar with the Slavonic speech of Macedonia, perhaps were even born to a Slavic mother. As he and his brother Methodius walked about the city and its marketplaces, they would have spoken with Slavonic-speaking peasants selling their produce from the Macedonian countryside. "Each morning, when the great gates in the city walls opened—the Golden Gate, the Letaea Gate, and the Cassandria Gate—groups of Slavs would enter the city and pursue their affairs there," including buying and selling among the Greeks in verbal exchanges of broken tongues (Tachiaos 16).

So, Cyril gathered his brother Methodius and other monks, and together with them set off in the Spring of 863 for the court of Rastislav.

Once they were in Moravia, the missionaries taught their flock Matins and the Hours, Vespers and the Compline, and the Liturgy in Slavonic—the *Vita* of Methodius recounts how he and Cyril placed their translation under the patronage of St Demetrius, who surely took no offence—and "the ears of the deaf were unstopped, the words of the Scripture were heard, and the tongue of stammerers spoke clearly. And God rejoiced over this, while the devil was shamed" (Kantor 69).

This, at least, is how the Byzantine world saw matters. In the Latin-speaking West, where German clergy held sway in Moravia in direct competition for souls, these two pious, long-bearded, ascetic monks speaking Greek and dragging parchments of new-fangled Slavonic scriptures around with them were bordering on a heresy. In defiance of a doctrine of Trilingualism (ignored in the East), that held that there were only three languages in which the name of God could be praised, Hebrew, Greek, and Latin (the three languages of Pilate's text nailed to Christ's cross on Golgotha), sacred texts in Slavonic might be blasphemous.

Bishops, priests, and monks of the Latin church fell upon the Greek missionaries "like crows upon a hawk," saying, "Tell us, man, how is it that you have created a script for the Slavs, and teach it to them, a script such as none other has ever found before, neither apostle, nor Pope of Rome, nor yet Gregory the Theologian, Jerome or Augustine?" (Kantor 71). The problem did

not lie in the Slavonic language as such, but that it was used in the texts of the Liturgy and Sacraments: the Slav was free to preach and pray in Slavonic but not to be baptized or prepare the Eucharist in the barbarian tongue.

The brothers were forced to defend their work before synods and symposia in Rome. Cyril's reply has been recorded by his biographer in Slavonic, although it is certain he addressed the Latin clergy in Greek. With this masterful stroke, to all future generations of Slavic Christians this little treasure of spiritual and moral compassion, this gesture to the Slavs of recognition of their dignity before the face of God if not of the Western church, was given. He said, "But does the rain not fall equally upon all people, does the sun not shine for all, and do we not all breathe the air in equal measure?...Tell me, do you not render God powerless, that He is incapable of granting this?...For David cries out, saying, 'O sing unto the Lord, all the earth: sing unto the Lord a new song'" (Kantor 71).

And so the Slavs came into Byzantium, singing.

Listen now, all Slav peoples, listen to the words coming from God, which feed human souls, words that heal our hearts and minds.
—Constantine's *Prologue to the Scriptures*

Pope Hadrian in Rome, happily, looked on the Byzantine missions with favour and, taking the books of Slavonic translation that Cyril and Methodius brought him, laid them on an altar in the church of Santa Maria Maggiore, consecrating them, and celebrated Divine Liturgy over them. The next day and the day after that and the one following, the Slavonic liturgy was celebrated all over Rome, approved and accepted as sacred.

"And his many labours overtook him and he fell ill" (Kantor 77). Constantine/Cyril died in Rome in 869, saying from his deathbed that he was "neither a servant of the Emperor nor of anyone else on earth, but only of God Almighty. I was not, and I came to be, and am forever. Amen."

And forever to us, who regard his iconical aspect in the churches of the Slavonic liturgies, he is a saint in the softly-folded garment of a priest, white-bearded with a wavy fringe of hair on his forehead, haloed, the Gospel resting on his left arm: serene and immensely dignified as is fitting for a great teacher and scribe of a whole new world. Slavs harkened to the word inscribed for them by a monk who dreamed in Byzantium.

Works Cited

Charanis, Peter. "Nicephorus I, the Saviour of Greece from the Slavs." *Byzantina-Metabyzantina* 1 (1946-1949): 75-92.

Cheetham, Nicolas. *Mediaeval Greece*. New Haven, CT: Yale UP, 1981.

Kantor, Marvin. *Medieval Slavic Lives of Saints and Princes*. Ann Arbor: U of Michigan, Dept. of Slavic Languages and Literatures, 1983.

Kark, Austen. *Attic in Greece*. London: Little, Brown, 1994.

Lemerle, Paul. *Les plus anciens recueils des miracles de Saint Démétrius et la pénétration des Slaves dans les Balkans*. 2 vols. Paris: Éditions du Centre national de la recherche scientifique, 1979-1981.

Lossky, Vladimir. *Orthodox Theology: An Introduction*. Crestwood, NY: St Vladimir's Seminary P, 1978.

Obolensky, Dimitri. *The Byzantine Commonwealth: Eastern Europe, 500-1453*. 1971; London: Phoenix P, 2000.

Rambaud, Alfred. "Hellènes et Bulgares: La guerre des races au Xe siècle." *Études sur l'histoire byzantine*. Paris: Armad Colin, 1912. 255-317.

Rose, Jacqueline. "A Use for the Stones." *London Review of Books* 28.8 (20 April 2006): 20-23.

The Russian Primary Chronicle: Laurentian Text. Trans. Samuel Hazzard Cross and Olgerd P. Sherbowitz-Wetzov. Cambridge, MA: Medieval Academy of America, 1953.

Stratos, Andreas N. *Byzantium in the Seventh Century*. Vol. 4 of 5. Trans. Harry T. Hionides. Amsterdam: Adolf M. Hakkert, 1978.

Tachiaos, Anthony-Emil. *Cyril and Methodius of Thessalonica: The Acculturation of the Slavs*. Crestwood, NY: St Vladimir's Seminary P, 2001.

Vryonis, Speros. "Recent Scholarship on Continuity and Discontinuity of Culture: Classical Greeks, Byzantines, Modern Greeks." *The "Past" in Medieval and Modern Greek Culture*. Ed. Speros Vryonis. Malibu, CA: Undena Publications, 1978. 236-56.

——. "Review Essay." *Balkan Studies* 22 (1981): 405-39.

Whittow, Mark. *The Making of Byzantium, 600-1025*. Berkeley: U of California P, 1996.

"The Writing on the Wall"

Rembrandt, Milton, and Menasseh ben Israel
in Ken McMullen's R

DAVID GAY

My approach to the concept of marginality emphasizes the transmission of religious ideas and influences across spatial and temporal borders formed by juxtapositions of different art forms produced in different nations, cultures, languages, and historical periods. The medium of film is uniquely equipped to foreground these juxtapositions. As a dominant contemporary art form, film separates us from previous generations that had no experience of the photographic image or motion pictures; at the same time, film recovers and recombines many of the art forms of the past. Two basic categories comprehend these forms: image and text. Film can replicate fixed images from sculpture, painting, or architecture. Film also moves in time, emphasizing text as the flow of narrative. In *The Strange Encounters and Timeless Wanderings of a Man Named R*, a short film produced for television in 1992, British filmmaker Ken McMullen makes his debt to the images and texts of the past explicit by combining the paintings of Rembrandt with the poetry of Milton.[1] Through his technique, McMullen foregrounds film's relation to painting and poetry in order to make the past visible as an influence on the present.

My title, "The writing on the wall," refers to Rembrandt's *Belshazzar's Feast* (Fig. 5), a work that presents an image and a text. Belshazzar, son of King Nebuchadnezzar, orders a feast for "a thousand of his lords" (Daniel 5:1). He serves his guests with "the golden vessels that were taken out of the temple of the house of God which was at Jerusalem" (5:3). In the midst of the feast, Belshazzar sees a hand inscribing writing on the wall. He calls for soothsayers to interpret the message, but only the prophet Daniel can read the words: "MENE, MENE, TEKEL, UPHARSIN" (5:25):

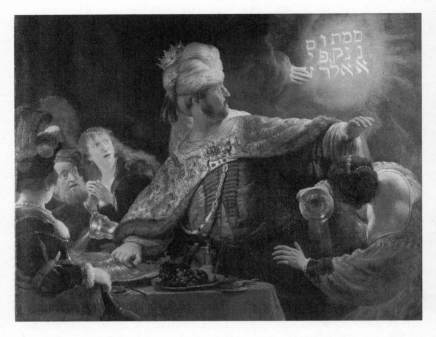

Figure 5 Rembrandt van Rijn, *Belshazzar's Feast*. Oil on canvas, 167.6 × 209.2 cm. Dutch; 1636–1638. National Gallery, London. [Photo courtesy National Gallery Picture Library; reproduced by permission.]

This is the interpretation of the thing:
MENE; God hath numbered thy kingdom, and finished it.
TEKEL; Thou art weighed in the balances, and art found wanting.
PERES; Thy kingdom is divided, and given to the Medes and Persians.
(Daniel 5:26–28 [KJV])

Belshazzar loses both his life and his kingdom that night.

Belshazzar's Feast is an apt emblem of marginality. The story of Daniel is set in the period of Israel's exile in Babylon. Belshazzar summons Daniel from the margin to the centre of his royal court to read and interpret the text. Similarly, while painting *Belshazzar's Feast*, Rembrandt turned to Menasseh ben Israel, a friend and a prominent Rabbi in Amsterdam, to explicate the text. McMullen, in turn, uses Menasseh ben Israel to connect Rembrandt and Milton, recalling that Menasseh tried to persuade Oliver

Cromwell to readmit Jews to England in 1655. McMullen speculates that Menasseh met Milton and described Rembrandt's paintings of Samson to him, thereby influencing *Samson Agonistes*, published in 1671. Menasseh ben Israel is the marginal figure that makes meaning visible; like Daniel, he conveys texts and images across national, cultural, religious, and linguistic borders, making his readings influential from his marginal position within a larger Christian society. McMullen explores the persistence of such marginal influences as they shape the ancient world of Daniel, the early modern period of Rembrandt, Milton, and Menasseh ben Israel, and our present moment. While Belshazzar's encounter with writing on the wall is extraordinary and terrifying, our encounters with marginal influences in the present are often unconscious, unrecognized, and invisible. Art makes the marginal articulate and visible.

A Synopsis of Ken McMullen's The Strange Encounters and Timeless Wanderings of a Man Named R

McMullen's film is about a man named Dominique who admires Rembrandt. Disturbed by the misattribution of certain paintings to Rembrandt, and by the use of a Rembrandt painting in a televised cigar advertisement, he takes the name "R" out of his "profound identification" with "the ghost of the great painter." With his friends Sarah and Rachel, R sets out to verify Rembrandt's existence. He begins in Leiden, Rembrandt's birthplace. McMullen presents two witnesses who pose motionlessly in seventeenth-century dress, evoking Rembrandt portraits, while their remarks on Rembrandt are heard as voice-overs. The first is Cees Goekoop, Mayor of Leiden in 1992, author, archaeologist, and the "discoverer of Ithaca."[2] Goekoop confirms the existence of Rembrandt's grave and of a surviving signature. He connects Rembrandt's fixation on blindness to biography: "our records" show that Rembrandt's father "lost his sight for the last eight years of his life." The second witness is Bartlomeu Dos Santos, the distinguished Portuguese artist, printmaker, and Professor of Fine Art at the University of London.[3] His affirmation of Rembrandt's existence focuses on his art rather than his life; specifically, he affirms Rembrandt's ability to transmit emotion, comparing this transmission to a "cobweb of lines" or filaments of feeling.

R and his friends escape to Greece, "but the ghosts went with them." One "late afternoon in Ithaca," as R works on the canvas of *Belshazzar's Feast*, the "ghost of Milton passed by." Walking invisibly through the room, Milton recites "On Time," establishing the temporal in images of measurement, mortality, and consumption:

Fly envious *Time*, till thou run out thy race,
Call on the lazy leaden-stepping hours,
Whose speed is but the heavy Plummet's pace;
And glut thy self with what thy womb devours,
Which is no more than what is false and vain,
And merely mortal dross;
So little is our loss,
So little is thy gain.
For when as each thing bad thou hast entomb'd,
And last of all, thy greedy self consum'd,
Then long Eternity shall greet our bliss
With an individual kiss;
And Joy shall overtake us as a flood. (1–13)

Why Ithaca? Ithaca is the home of Odysseus and is origin and terminus for Odysseus's wanderings in Homer's epic. Rembrandt's *Aristotle Contemplating a Bust of Homer* is a prominent image in this scene. Milton's *Paradise Lost* is in the epic tradition of Homer, while his *Samson Agonistes* engages Aristotle's theory of tragedy in the *Poetics*. Ithaca is therefore an ideal site for the ensuing dialogues on art and history between R and Milton, with Rembrandt's *Belshazzar's Feast* and the *Blinding of Samson* and Milton's *Samson Agonistes* serving as focal points.

In the final section of the film, R's friend Rachel travels to Assyria "armed" with a hat and "ten pages of the Bible." Assyria is the setting of the apocryphal Book of Tobit, a story of blindness and exile. Indeed, ten pages would be roughly the length of the Book of Tobit in most Bibles. Tobit, a righteous Jew, is healed of blindness by his son Tobias through the help of the angel Raphael, whose name means "medicine of God." Raphael is a major character in *Paradise Lost*; he offers guidance and friendship to Adam before the Fall. Rembrandt sketched many scenes from the Book of

Tobit. The final image in *R* is a tableau of his painting *Tobias Returns Sight to His Father*, with Milton in the position of the blind Tobit, and R in the position of Tobias.

Samson and the Theme of Blindness

Belshazzar, Samson, and Tobit develop a central theme in McMullen's film: the interplay of sight and blindness. Identifying with Milton and Rembrandt, McMullen considers the implications of blindness for his own art. For McMullen, sight occurs in the recognition of the artistic and critical categories that film combines. Several theorists of painting and film demonstrate these combinations. Film has a unique ability to "combine elements from the various arts into its own synthesis" (Durgnat 73). As Durgnat remarks, the "cinema's only 'purity' is the way in which it combines diverse elements into its own 'impure whole.' Its 'essence' is that it makes them interact, that it integrates other art forms, that it exists 'between' and 'across' their boundaries" (73). McMullen makes us see the boundaries in their constituent elements, which include motionless figures evoking Rembrandt's portraiture, printed messages advancing the narrative, and *tableau vivant* imitations of narrative paintings. The result is similar to the distancing effects developed in drama.

In *How to Read a Film*, James Monaco remarks that these effects "recreate the relationship between actor and audience as a dialectic," turning the "spectator into an observer" while arousing his or her "capacity for action" (36). In *Visual Pleasure and Narrative Cinema*, Laura Mulvey suggests that the breaking down of the gaze of the camera into its separate looks resists verisimilitude, in which the camera can become a focalizing surrogate, or a "mechanism for producing an illusion of Renaissance space, flowing movements compatible with the human eye, an ideology of representation that revolves around the perception of the subject" (166). As she further remarks, the "first blow against the monolithic accumulation of traditional film conventions...is to free the look of the camera into its materiality in time and space and the look of the audience into dialectics and passionate detachment" (166). The dialectics McMullen explicates engage the viewer by separating narrative time in Milton and pictorial space in

Rembrandt while exploring the attention both artists give to the theme of blindness.

In *Reading Rembrandt*, Mieke Bal reads blindness in Rembrandt's paintings on three interconnected levels: postmodernism[4] relates blindness to self-reflexivity; feminism relates it to voyeurism; psychoanalysis relates it to castration (11). While Bal reads Rembrandt as a "cultural text, rather than a historical reality," McMullen portrays R's search for proof of Rembrandt's historical existence as a process mediated by texts and images. At the same time, McMullen engages in Bal's three levels: his film is intensely self-reflexive in its use of painting and poetry; it examines voyeurism from a feminist perspective in Rembrandt's *Susanna and the Elders*, as Sarah and Rachel observe the "randy" men who spy on Susanna; it evokes castration in the shearing of Samson's hair and the destruction of his eyes. Bal remarks that the domains of the visual and the verbal are "constantly intertwined" (5), adding provocatively that, in order "to assess what a work means for the culture in which it circulates, we...need to overcome the artificial boundaries that form the basis of academic disciplines" (5). She overcomes such boundaries through "interpretive juxtapositions." These juxtapositions impel dialogue between critical categories and artistic media.

The Strange Encounters and Timeless Wanderings of a Man Named R is a sequence of interpretive juxtapositions. The primary juxtaposition consists of the dialogue between Rembrandt and Milton and dialogues between R and his friends. In one dialogue, Rachel dismisses Rembrandt as a "money-grubbing capitalist who exploited the blind and the poor." R counters that Rembrandt was a "genius whose paintings possess the only things that make painting worthwhile: sight and blindness, action and truth, speech and silence, in one word—emotion." At this point, the ghost of Milton recites the prologue from *Samson Agonistes*:

> O loss of sight, of thee I most complain!
> Blind among enemies, O worse than chains,
> Dungeon, or beggary, or decrepit age!
> Light the prime work of God to me is extinct,
> And all her various objects of delight
> Annull'd, which might in part my grief have eas'd,

Inferior to the vilest now become
Of man or worm; the vilest here excel me,
They creep, yet see; I dark in light expos'd
To daily fraud, contempt, abuse and wrong,
Within doors, or without, still as a fool,
In power of others, never in my own;
Scarce half I seem to live, dead more than half.
O dark, dark, dark, amid the blaze of noon,
Irrecoverably dark, total Eclipse
Without all hope of day!
O first created Beam, and thou great Word,
"Let there be light, and light was over all";
Why am I thus bereav'd thy prime decree?
The Sun to me is dark
And silent as the Moon,
When she deserts the night
Hid in her vacant interlunar cave.
Since light so necessary is to life,
And almost life itself, if it be true
That light is in the Soul,
She all in every part; why was the sight
To such a tender ball as th' eye confin'd?
So obvious and so easie to be quench't,
And not as feeling through all parts diffus'd,
That she might look at will through every pore? (67–96)

Samson's deepest suffering comes from his sense of exile from God's "prime decree" of light. Reciting this lament, McMullen's Milton passes an image of Homer and arrives at a tableau of Rembrandt's *The Blinding of Samson*, thus constructing interpretive juxtapositions of visual and verbal art. Sarah and Rachel lean on some old books, which might suggest texts ranging from Homer to the Bible to Milton's epics; R poses beside a white plaster replica of Rembrandt's *Aristotle Contemplating a Bust of Homer*. An image of a bust of Homer appears on a white wall. As in *Belshazzar's Feast*, the wall represents film as projection onto a screen; moreover, we become conscious of Homer's blindness while viewing his image. The figure of

Aristotle, meanwhile, evokes the *Poetics* with its attention to *anagnorisis,* or recognition, illustrated by Aristotle in Oedipus's self-blinding at his moment of greatest self-knowledge. The term *identification,* initiated in R's primary identification with Rembrandt, here becomes a function of the interpretive juxtapositions McMullen creates. Milton identifies with Homer in *Paradise Lost,* as he asks to be equal in renown to Homer or "blind Mæonides" (3.35). As a central focus of identification in the film, Milton's Samson conveys the abject condition of blindness, aggravated by the thought of being exiled from God's "prime decree" and a spectacle for his enemies, and the frustration of revolutionary energy.

The ghost of Milton moves past the image of Homer and arrives at a tableau of *The Blinding of Samson* (Fig. 6). The *tableau vivant* calls attention to actors who animate scenes in both drama and film. This scene conveys the horror and violence of Samson's blinding; however, the Philistine soldier who forces the stake into Samson's eye is strangely calm and methodical. We might see the stake as a phallic symbol,[5] but the soldier, in his deliberate detachment, suggests a technician or artist at work with a pencil or a brush, perhaps reflecting Rembrandt's awareness of his own skill in capturing a moment of horror. The opening to the left, towards which Dalila retreats, represents the aperture of the human eye admitting light. McMullen's film intensifies this self-reflexivity, as both screen and camera become metaphoric aspects of the human eye, with the tableau creating a disconcerting reciprocity between the image and the viewer.

The scene leads Milton and R to compare the attributes of painting and poetry. Milton recreates the action as narrative, while Rembrandt creates a "vantage point outside the action." Rembrandt depicts the blinding of Samson with a graphic literalism, while Milton treats the scene "as metaphor" for the failure of the republican revolution in seventeenth-century England. When R asks Milton about the outcome of his revolution, he replies that the English must "salvage" what they can of its principles.

The dialogue opens the aperture of English history. The restoration of the monarchy in 1660 frustrated Milton's republican hopes and religious ideals, although he continued to transmit those ideals to future generations of readers. Milton's enemies at the time of the Restoration referred to him derisively as an "image breaker," recalling his tract *Eikonoklastes,* an attack on monarchs as political idols. Samson's destiny

Figure 6 Rembrandt van Rijn, *The Blinding of Samson*. Oil on canvas, 236 × 302 cm. Dutch; 1636. Städelsches Kunstinstitut, Frankfurt. [Photo courtesy Artothek; reproduced by permission.]

is iconoclastic when he pulls down the Philistine temple at the moment of his death. When R queries Milton's personal and political identification with Samson, Milton remarks, "I too am exhibited in the house of the Philistines. If I could I would pull down the pillars upon mockery and lies."

The Marginalized Reader
Menasseh ben Israel, Rembrandt, and Milton

McMullen shifts the identification of Milton with Samson from the personal to the national level of typology: "The Puritans identified with the lost tribes of Israel, and found great beauty in the apocalyptic texts. England is the lost paradise of Eden refound." While these metaphoric identifications may be familiar to viewers, their origin in the marginal

figure connecting Milton and Rembrandt is not. The dialogue between R and Milton begins with this printed text on the screen: "'R' discovered that it was a man called Ben Israel who had interpreted the writing on the wall for Rembrandt,...that Ben Israel had talked to Rembrandt and Milton about Samson." Milton recalls that Menasseh ben Israel appealed to Cromwell for the readmission of Jews to England. This remark is subsumed into Milton's identification of the Puritans with the "lost tribes of Israel" and with his failed revolution. As this dialogue unfolds, the figure of Menasseh ben Israel stands behind and between R and Milton. He remains silent, and exits to the right without speaking at any time.

Menasseh ben Israel is at once the most marginal and the most influential presence in the narrative, given his interpretations of Belshazzar and Samson. He is a type of Daniel, having the wisdom and erudition to interpret the texts and images central to the art of Rembrandt and Milton. His appearance is brief, silent, and minimal. In what ways can we read his presence in McMullen's film? First, we note that Menasseh ben Israel is yet another tableau, one that alludes to Rembrandt's sketches of Menasseh, whom he knew, and to his practice of sketching Jewish neighbours and basing biblical figures on local Jews. In *Rembrandt's Jews*, Steven Nadler recalls the vicious visual stereotyping of Jews in some medieval art, and notes how stereotyping made Jews "foils to the message of the Gospels" in early modern painting (64). In Rembrandt, however, there is a difference:

> Still, what is striking is how the celebrated Dutch artistic eye for the natural—the predilection for seeing rather than conceiving—accomplishes for Holland's Jews what it does for its domestic interiors and flower settings. Rembrandt painted, etched, and drew his Sephardic and Ashkenazic neighbours, sometimes for the sake of their biblical potential. Yet even when his compositions have their source and inspiration more in his literary imagination than on the Breestraat, the face and figures are drawn from familiar acquaintance, not prejudice. (64)

Rembrandt's portraits of Amsterdam Jews document and affirm their existence.[6] McMullen—whose film, we recall, concerns R's need to verify Rembrandt's existence—furthers this affirmation of identity in his choice of words: his Milton refers to a "*man* called Ben Israel."

What insights did Rembrandt gain from Menasseh ben Israel as he painted *Belshazzar's Feast*? As Nadler shows, rabbis found Belshazzar's inability to read the writing on the wall perplexing: the "biblical text itself gives no indication of the format of the words; it just says that the king could not read them" (125). In Rembrandt's painting, the reader must read the letters vertically, not horizontally, to understand them. While many Christian artists either "ignored or rejected various rabbinic solutions to Belshazzar's perplexity," either omitting the message or making it plainly legible, "Rembrandt alone showed an interest in the Jewish tradition" (Nadler 126). Through his knowledge of early rabbinic sources and commentaries, Menasseh conveyed the vertical format—the marginalized influence—to Rembrandt (Nadler 126). Menasseh eventually published his account of the writing on the wall in a book called *De termino vitae*, the end of life (Nadler 126). Significantly, McMullen's R tells his friends that he knows the secrets of painting, especially of how to paint "the moment of speech" and the "terminal term." As an ekphrastic moment, the writing on the wall in *Belshazzar's Feast* presents the viewer with a complete identification of image and text, since the writing is both at once.

Menasseh ben Israel encounters Milton through the debate over the readmission of the Jews to England, centuries after their expulsion by a decree of Edward I in 1290. Cromwell convened a conference on readmission at Whitehall in 1655. While Menasseh and Rembrandt were neighbours and friends, Milton's direct contact with Menasseh is hard to verify. Milton had lost his sight completely by 1652, three years prior to the Whitehall conference, and had begun to retire from his duties in Cromwell's government where he served as Latin secretary. While Rembrandt's art reveals a literal, human dimension in his Jewish subjects, the Whitehall conference was a nexus for more figurative Christian attitudes to Jewish learning and identity. As Linda Munk has shown, many Puritans viewed the conversion of the Jews to Christianity as a necessary precondition of Christ's second coming. These expectations entailed prognostication: "Influenced by Rabbi Menasseh Ben Israel, the Baptist preacher Henry Jessey said the Jews would be converted before 1658" (48). Hence, the debate on readmission galvanized the Puritan "identification" with Israel, which was motivated by millenarian expectations and self-interested philo-Semitism more than by humanitarianism.

Two attitudes to rabbinical learning are visible in this debate. As Jeffrey Shoulson remarks, where "the Jewish tradition was threatened by a Pauline rejection of carnal Israel and what it literally embodied, and by a thorough allegorization of the Scriptures, the humanistic respect accorded to the ancients from philological, historiographical, and philosophical perspectives was commuted to a renovated respect for Jewish learning" (83). Allegorization can, as Thomas Luxon has argued, entail the rejection of the otherness of Judaism: "After 1655, it became clear that orthodoxy was more interested in the Israelite and the Jew as two alternating fantasies instrumental to the Protestant work of self-reading than it was in any actual Jews, especially Rabbi Menasseh Ben Israel, who died debt-ridden and disappointed" (109). An erudite poet, Milton's respect for rabbinic traditions was immense. Hence there is no complacent presumption of Christian typology or national election in *Samson Agonistes*. As Shoulson argues, in "both rabbinic literature and Milton's drama, Samson comes to embody an intense ambivalence concerning the distinctiveness—the chosenness—of ethnic or national identity" (259). The conflicted, self-interrogating speeches of Milton's Samson are as emotional and humanizing as Rembrandt's representation of living Jewish people.

In his appeal to Parliament for the readmission of the Jews, Menasseh ben Israel asserted the integrity of Jewish identity "contrary to Christian millenarian beliefs. The coming of the Messiah does not require the conversion of the Jews. They will remain God's chosen people and will be the primary beneficiaries of Israel's sovereignty" (Nadler 135). In *The Hope of Israel*, Menasseh summarizes his vision of the return of the lost tribes of Israel from exile:

> I prove that the ten Tribes never returned to the second Temple, that they yet keepe the Law of Moses, and our sacred Rites; and at last shall return into their Land, with the two tribes, Judah, and Benjamin; and shall be governed by one Prince, who is Messiah the Son of David; and without doubt that time is near, which I make appear by divers histories worthy of memory, and many Prophecies of the old Prophets opened with much study, and care. I willingly leave it to the judgement of the godly, and learned, what happy worth there is in this my Book and what my own Nation owes me for my paines: It is called, *The Hope*

of Israel; which name is taken from Jerem. 14.8. O the hope of Israel, the Saviour thereof. For the scope of this Discourse is, to show, that the hope in which we live, of the coming of the Messiah is of a future, difficult, but infallible good, because it is grounded upon the absolute Promise of the blessed God. ("Menasseh Ben Israel to the Courteous Reader" Av3–Ar4)

Given that the book is addressed to the Parliament of England, Menasseh's careful exposition of the Messiah and his hope for a reunion of Jews in exile supports Nadler's description of him as a "pillar of scholarship and interfaith understanding" (223). Menasseh's influence has important implications for the concept of national identity in McMullen's film. First, Menasseh links two artists of different languages and nationalities through their respect for rabbinical learning. Second, exile is prominent in the film: R and his friends leave Holland for Ithaca, Sarah journeys to Assyria, and Samson is "exil'd from light" (98). As McMullen's characters traverse national and cultural borders, they challenge the concept of national identity by comparing the persistence of texts, images, and religious influences to the transience of the empires that marginalize them.

Tobit and the Healing of Blindness

Seeking the intersection of their readings of Samson, R remarks to Milton, "Your poem begins where my painting ends." Milton intended *Samson Agonistes*—a "closet drama"—to be read and not seen. Narrative report is the medium of violent spectacle. Milton follows Aristotle's precept on the superiority of hearing over seeing for the transmission of emotion: "Pity and fear, then, may be aroused by the spectacle, and also by the arrangement of the events; the latter is preferable and the mark of a better poet, because it is necessary for the plot to be so put together that, without seeing, one who hears what has been done is horrified and feels pity at the incidents" (87). In particular, Samson's final destruction of the Temple of Dagon takes place "off stage." A Messenger, who witnesses the horror of the scene, narrates the event for Samson's father and the Chorus of Hebrews. For Milton the priority of the verbal over the visual makes reading and

interpretation the imperatives for all who hear the story. As R remarks, "When I think of Homer or Samson or Christ himself, seeing was the least of them."

McMullen explores the opposition of seeing and telling by placing biblical texts within the vanished civilizations that marginalized Jews. Rachel journeys to Assyria "armed" with a hat and "ten pages of the Bible." The word *armed* suggests a weapon that prevailed over empires. The ten pages may be the Book of Tobit, a story that attracted Rembrandt. Tobit, a Jew living in exile, suffers blindness late in life. He sends his son Tobias to claim a debt in a distant city. The archangel Raphael accompanies Tobias. Raphael travels in disguise and teaches Tobias to drive out evil spirits and to cure blindness using the liver of a fish. Tobias returns and cures his father's blindness at the close of the story, which entails a larger recognition scene as the angel also discloses his identity.

Rembrandt painted Tobit's healing in 1636, the same year as the *Blinding of Samson*. In the Tobit painting, as Julius Held observes, the figures "watch intently as Tobias performs...a medically perfect rendering of a [seventeenth-century] cataract operation" (128). The calm, surgical, and technically correct manner in which the healing is performed invites comparison with the dispassionate, methodical action of the soldier in the *Blinding of Samson*, although the operation here induces sight rather than blindness. The painting also shows an aperture of light in the window to the left, suggesting the mechanism of human sight. The blindness from which Tobit suffers is characterized in scripture as a white screen. Raphael says of the cure, "it is good to anoint a man that hath whiteness in his eyes, and he shall be healed" (6:8), and, later, he assures Tobit's son that "the whiteness shall fall away, and he shall see thee" (11:8).

Whiteness was a symptom of Milton's blindness in its early stages. He describes this as a "universal blanc" in *Paradise Lost* (3.48). In the final tableau in McMullen's film, Milton takes the position of Tobit, while R plays the role of Tobias, the son who performs the cure. In the final frame of the film, the actors in the tableau make eye contact with the viewer by looking directly into the camera. The axis of this eye contact traverses the white projection screen, creating a heightened self-consciousness in the viewer in this final moment. The viewer's eye becomes the point of convergence for all lines of sight. While no single "reading" of this final frame can be

privileged, I argue that it reverses the perspective of the viewer, who can no longer watch comfortably from her "vantage point outside the action," and produces a moment of recognition for the viewer, who attains a different relationship to the action by becoming the object of sight at the moment that blindness is healed. In these respects, the tableau is the reverse of *The Blinding of Samson*, which depicts the moment at which sight is lost.

How does this final image instruct us in relations among religion, culture, and marginality? In the final segment, McMullen conveys us to a setting in the ancient world, but also presents his characters consuming the artefacts of past cultures and civilizations in galleries and museums. *Belshazzar's Feast*, coincidentally, is housed in London's National Gallery, while the British Museum contains many objects from the ancient Middle East. This interplay of times and places creates a final interpretive juxta-position in the film. Civilizations once central in their own eyes decline, leaving fragmentary proofs of their existence in stone or monument. Texts endure as they are recreated and interpreted in successive art forms and media, from painting to poetry to film. The writing on the wall simultane-ously evokes words printed on paper (Milton), images painted on canvas (Rembrandt), and films projected onto screens (McMullen).

The writing on the wall in *Belshazzar's Feast* is an important emblem of marginal influence. It appears to the side of Belshazzar, who occupies the centre of the canvas. Its meaning is unknown to him, though it foretells his demise. The text requires a marginal figure, a Daniel or a Menasseh ben Israel, for meaning. Similarly, marginality in our time is not simply a matter of what we exclude or ignore. The marginal consists of those texts and images that we cannot read or decipher but that continue to shape or influence our present. McMullen's use of "ghosts" as guests or presences makes the same case for marginal forces that are invisible. McMullen raises marginal influences like Menasseh ben Israel into our field of vision and collective memory through his juxtaposition of two central figures in Western art and literature. Like Menasseh ben Israel, McMullen teaches us how to read in the margins of the past.

Notes

1 Ken McMullen's brief biography is found at <http://www.facebook.com/pages/
 Ken-McMullen/121203244062?v=info>; his filmography is found at <http://www.
 imdb.com/name/nm0573427/>.
2 For Goekoop's exploration of the location of Ithaca, see <http://srs.dl.ac.uk/
 people/pantos/IST-POSTER/who-cares.html> and his book, *Op zoek naar Ithaka*.
3 See the artist's work and collaboration with McMullen at <http://www.arts.
 ac.uk/infinite/english/signatures/popsignbds.php>.
4 A helpful definition of the postmodern is found in Linda Hutcheon's *A Poetics of
 Postmodernism*. Hutcheon emphasizes self-reflexivity, parody, and metafiction as
 elements that call attention to knowledge and history as human constructs.
5 Mieke Bal suggests that Derrida's theory of dissemination replaces the phallus
 as signifier with the concept of the hymen as canvas on which "meaning
 circulates without fixity" (19). Derrida is a strong influence on McMullen's art
 and appears in his feature film *Ghostdance*.
6 In addition to Nadler, see Jonathan Israel, "The Dutch Sephardic Colonization
 Movement."

Works Cited

Aristotle. "Poetics." *Literary Criticism: Plato to Dryden*. Ed. Allan H. Gilbert. Detroit:
 Wayne State UP, 1982. 63–124.

Bal, Mieke. *Reading Rembrandt: Beyond the Word–Image Controversy*. Cambridge:
 Cambridge UP, 1991.

Durgnat, Raymond. "The Mongrel Muse." *Film and Literature: Contrasts in Media*. Ed.
 Fred H. Marcus. London: Chandler, 1971. 71–82.

Goekoop, C.H. *Op zoek naar Ithaka*. Weesp, Neth.: Heureka, 1990.

Held, Julius. *Rembrandt Studies*. Princeton: Princeton UP, 1991.

Hutcheon, Linda. *A Poetics of Postmodernism*. London: Routledge, 1988.

Israel, Jonathan. "The Dutch Sephardic Colonization Movement." *Menasseh ben Israel
 and His World*. Ed. Yosef Kaplan, Henry Méchoulan, and Richard Popkin. Leiden,
 Neth.: E.J. Brill, 1989. 139–63.

Luxon, Thomas H. *Literal Figures: Puritan Allegory and the Reformation Crisis in
 Representation*. Chicago: U of Chicago P, 1995.

McMullen, Ken. *The Strange Encounters and Timeless Wanderings of a Man Named R*.
 BBC TV, Cine Bobillot Paris, Epico / Acao Studios de Lisbon, Magnum Crown
 Communications, 1992.

Menasseh ben Israel. *The Hope of Israel*. London, 1652.

Milton, John. *John Milton: Complete Poetry and Selected Prose*. Ed. Merritt Hughes. Indianapolis: Bobbs-Merrill, 1984.

Monaco, James. *How to Read a Film: The Art, Technology, Language, History, and Theory of Film and Media*. New York: Oxford UP, 1977.

Mulvey, Laura. From "Visual Pleasure and Narrative Cinema." *A Critical and Cultural Theory Reader*. Ed. Antony Easthope and Kate McGowan. Toronto: U of Toronto P, 1992. 158–66.

Munk, Linda. *The Devil's Mousetrap: Redemption and Colonial American Literature*. New York: Oxford UP, 1997.

Nadler, Steven. *Rembrandt's Jews*. Chicago: U of Chicago P, 2003.

Shoulson, Jeffrey. *Milton and the Rabbis: Hebraism, Hellenism, and Christianity*. New York: Columbia UP, 2001.

7 | Marginality, Martyrdom, and the Messianic Remnant
Reflections on the Political Witness of Saint Paul

CHRIS K. HUEBNER

It might reasonably be argued that no concept is more prevalent in the contemporary West than that of marginality. The media never seems to tire of casting its gaze upon those who are deemed to be marginal in some way. The eye of the academic, too, is trained to be on the lookout for such figures, and one of her chief tasks, as of late, seems to be that of providing the marginalized with the voice of which they have somehow been stripped. Witness the rise of the ethnographer and the phenomenon of cultural studies. It is at the margins where all the most interesting and significant artistic and literary activity is said to be located. And it is to the margins that we look when searching out practices of resistance to various hegemonies. Lately, even conservatives have hopped on the marginality train. It is a plea of marginalization that animates the cries of those who identify themselves with the "neo" in neo-conservative.

In light of all this, it is worth considering why it is that the notion of marginalization appears to be so prevalent. How is it that the margins have come to occupy such a central place in the contemporary imagination? What leads us, continually, to seek out the marginalized and to identify those said to be responsible for their marginalization? What accounts for the continued need to assert the meaningfulness of marginalities? To whom are we speaking when we make these assertions? And what if this rush to the margins masks a kind of violence that is somehow associated with the very valorization of marginality itself? What if marginalities are not so much meaningful as meaningless? Then again, what if, in the apparent meaninglessness of marginality, we might be able to identify a different sense of the meaning of marginality? Or rather, what if the problem is the implied assumption that we must somehow choose between

meaningfulness and meaninglessness? Might it be possible to identify a meaning of marginality that names what Giorgio Agamben calls a "zone of indistinction" (*Remnants* 120), in this case a zone of indistinction between meaningfulness and meaninglessness?

In the discussion that follows, I draw on Alain Badiou and Slavoj Žižek in order to suggest that the recent popularity of the concept of marginality might be situated in the logic of global capitalism. Against this background, I weave together Agamben's notion of the witness as messianic remnant, Rowan Williams's observations on martyrdom, and reflections on the work of the German novelist W.G. Sebald in an attempt to gesture toward some different ethical and political possibilities. More specifically, I shall suggest that a reading of the martyr as messianic remnant might offer some resources for moving beyond the unhelpful stalemate between triumphant meaningfulness and meaningless resignation in which the contemporary figure of the marginalized is inscribed. In short, I shall suggest that the logic of martyrdom is that of a messianic remnant that interrupts and cancels the very distinction between the meaningless violence and oppression suffered by victims, and heroically meaningful narratives of survival and resistance. Exploding the dialectic of victim and hero, martyrdom names a politics in which what is usually meant by meaning and marginality is radically transformed, and a new vision of life emerges.

Let me begin to unpack these all-too-schematic and grandiose claims and questions by looking briefly at a recent backlash against the popularity of marginality, specifically that of Alain Badiou and Slavoj Žižek. Badiou and Žižek are particularly interested in exposing the extent to which allegedly liberating discourses of marginalization can actually contribute to a politics of self-imposed captivity. The name they give to this situation is global capitalism. For Badiou and Žižek, global capitalism names a new kind of empire in which power is notably not concentric. Capitalist power does not proceed by banishing its subjects from the centre to the margins. Rather, it is thoroughly decentred and turns upon the differential fragmentation of identities characteristic of marginality itself. As Badiou, echoing Deleuze, argues,

> Capital demands a permanent creation of subjective and territorial identities in order for its principle of movement to homogenize its

space of action; identities, moreover, that never demand anything but the right to be exposed in the same way as others to the uniform pre- rogatives of the market. The capitalist logic of the general equivalent and the identitarian and cultural logic of communities or minorities form an articulated whole. (10–11)

Or, as Žižek more provocatively puts it,

> today's critical theory, in the guise of "cultural studies," is performing the ultimate service for the unrestrained development of capitalism by actively participating in the ideological effort to render its massive presence invisible....The price of this depoliticization of the economy is that the domain of politics itself is in a way depoliticized: political struggle proper is transformed into the cultural struggle for the rec- ognition of marginal identities and the tolerance of differences. (*The Ticklish Subject* 218)

In short, Badiou and Žižek claim that a world of marginal identities con- stitutes an ideal situation for the proliferating power of capital. To put it bluntly, each marginal identity offers a new market possibility. The con- cept of marginality is not merely bereft of critical purchase, it actually functions to undergird contemporary discourses of capitalism and their attendant forms of injustice.

According to Badiou and Žižek, then, the problem with marginality is the extent to which it is so thoroughly entwined with the mechanisms of the capitalist mainstream. Global capitalism, they suggest, is all the more powerful because we willingly participate in it even as we claim to enact strategies of resistance in the name of marginal identities. Like Augustine, they argue that a response to this situation calls for the transformation of such a deformed will, a rethinking of the subject, perhaps even a desubjec- tification of the subject. And it is worth noticing that they follow Augustine in finding resources for theorizing this transformation of will in the figure of St Paul. Theirs is clearly not the same old Nietzschean Paul—Paul the architect of the "institutional church" that wields the solidity of institu- tional authority as a weapon of mastery against the marginal. Rather, in the hands of Badiou and Žižek, Paul is deployed to demonstrate the extent

to which marginality can express the same violent lust for social stability and solidity that Nietzsche associated with the institutional church. Far from defending the stability of institutions and identities, Paul is here a figure of disruption. In the hands of Badiou and Žižek, Paul is a radically militant political figure dedicated to the explosion and interruption of institutional and identitarian commitments.

According to Badiou, the significance of Paul is that he enjoins us "not to put our trust any longer in any discourse laying claim to the form of mastery" (43). He argues that Paul's assertion, "no longer Jew or Greek" (Gal. 3:28 [NRSV]), is just such an attack on an identitarian conception of mastery. Paul seeks neither a new, all-encompassing meta-identity, nor an assimilation of marginal fragments drawn from the larger essences named Jew and Greek. Rather, he sets out to interrupt and explode all identitarian forms of association. In other words, he seeks the very over-coming of a preoccupation with identity as a ground of some sort. For Badiou, Paul names a subtraction, a "detachment from every particular-ism" (42). For Žižek, Paul calls for a difficult work of uncoupling or unplug-ging that "interrupt[s] the circular logic of re-establishing balance" (*The Fragile Absolute* 125). For both of them, the significance of Paul is his ges-ture of a diagonal cut—a dispossessive gesture that is neither vertical nor horizontal—that crosses out and suspends the desire for balanced order and unified social holism that they see reflected in the politics of both the majority and the marginal.

Put differently, and returning to the question of the transformed will, Badiou and Žižek argue that Paul gives us a glimpse of a new kind of sub-ject, a subject whose identity does not coincide with itself. He also offers a vision of a new kind of community—the *ekklesia*—whose being is inter-nally divided against itself. In Badiou's terms, Paul inaugurates the "desti-tution of established differences and the initiation of a subject divided in itself by the challenge of having nothing but the vanished event to face up to" (58). Or, in Žižek's conception, *ekklesia* names a body that appears simul-taneously as community and anti-community, a body that is constituted by the disrupting work of love, "the hard and arduous work of repeated 'uncoupling' in which, again and again, we have to disengage ourselves from the inertia that constrains us to identify with the particular order we were born into" (*The Fragile Absolute* 128-29). In general, they argue that the

name of Paul stands neither for a politics of mastery or victory, nor a resig-
nation to defeat at the hands of another. Rather, they see Paul as enacting a
discourse of non-mastery, a radical messianic politics of fragile charity and
vulnerable love.

This turn to Pauline messianism as an alternative to the politics out
of which the discourse of marginality emerges is developed further in
the work of Giorgio Agamben. Whereas Badiou and Žižek are particularly
concerned with the possibility of interrupting the fragmentary and dif-
ferential logic of global capitalism, Agamben turns his attention to the bio-
political logic of sovereignty in which politics has come to be preoccupied
with the very phenomenon of life itself, and of which capitalism is but a
single, albeit significant, episode. Whereas politics was once understood as
an exercise of the formation and cultivation of a qualified or particular way
of life, Agamben argues that modern politics, whether democratic or totali-
tarian, has become increasingly invested in what, following Benjamin,
he calls "bare life," pure biological life or life exposed to death (Agamben,
Homo Sacer 1–5, 88; Benjamin, "Critique of Violence" 251). As Agamben him-
self puts it, "the politicization of bare life as such…constitutes the decisive
event of modernity and signals a radical transformation of the political-
philosophical categories of classical thought" (*Homo Sacer* 4). Another way
to articulate this is to suggest that the biopolitical investment in bare life
names a situation in which political techniques of power become increas-
ingly focused on and seamlessly interwoven with the very lives of its sub-
jects. The nature of this process has been captured most forcefully by the
work of Foucault.

Agamben's most significant contribution to contemporary political
philosophy is reflected in his attempt to develop this Foucauldian claim
about the biopolitical proliferation of power through a reflection on Carl
Schmitt's account of the logic of sovereignty in relation to the state of
exception. According to Schmitt, sovereign power is—crucially—not to
be identified too closely with the juridical application of the law. On the
contrary, he defines sovereignty as a limit concept that stands paradoxi-
cally both inside and outside the law. Sovereignty is defined in terms of the
capacity to suspend the rule of law by declaring a state of emergency. Or,
as Schmitt asserts, "the sovereign is he who decides on the exception" (5).
Unlike the law, the sovereign exception cannot be codified or subsumed in

any general ordered system (Agamben, *Homo Sacer* 15-16). Rather, it is the sovereign who creates the conditions for possible order precisely by standing outside it.

Bringing together these suggestions drawn from Foucault and Schmitt, Agamben claims that the exceptional logic of sovereignty is such that it finds itself increasingly invested in the politicization of bare life, discussed above. Or, rather, the state of exception and bare life intersect to form the very basis of contemporary politics. Agamben clarifies: "the inclusion of bare life in the political realm constitutes the original—if concealed— nucleus of sovereign power. *It can even be said that the production of the bio-political body is the original activity of sovereign power*" (*Homo Sacer* 6). In the most general sense, it might be suggested that the concept of bare life can be understood as a tragic mirror image of sovereign power, in that it is brought decisively under political capture just to the extent that it is excluded from the very possibility of meaningful political discourse (7). In other words, the biopolitical preoccupation with bare life is, like the concept of sovereignty itself, structured by the logic of exceptionality in that it is paradoxically both inside and outside the political realm.

Moreover, this intersection of bare life and sovereign exceptionality is such that it gives rise to a kind of violence that is entirely "unsanction-able" (*Homo Sacer* 82). Agamben claims that "the sovereign is the point of indistinction between violence and law, the threshold on which violence passes over into law and law passes over into violence" (32). And he suggests that this violence opens up a new "sphere of human action that is only ever maintained in a relation of exception" (83). Elsewhere, he suggests that the name for this new sphere of activity is that of "survival" (*Means Without End* 8). Biopolitical and sovereign power thus coalesce to erase the capacity to speak that is implied by the notion of a qualified, particular "form-of-life"; together, they foster a preoccupation with mere survival. Agamben claims that "the decisive activity of biopower in our time consists in the production not of life or death, but rather of a mutable and virtually infinite survival....Biopower's supreme ambition is to produce in a human body, the absolute separation of the living being and the speaking being,...[that is] survival" (*Remnants* 155-56).[1] Whereas Foucault describes biopower in terms of a transition from a political formula of "letting live and making die" to that of "making live and letting die," Agamben argues

that contemporary biopolitics is better understood in terms of the formula of "making survive" (*Remnants* 155).

Among other things, Agamben's analysis of biopolitical sovereignty is part of an attempt to lay the basis for a critique of the inevitable and extreme intensification of power he considers characteristic of modern politics. Echoing Benjamin, Agamben claims that we live in a time when the exceptional suspension of law has increasingly become the rule, the "fundamental political structure" of contemporary social reality, a situation that he believes is exemplified most clearly in many of the responses to the events of 11 September 2001 (*Homo Sacer* 20; Benjamin, "Theses" 257; with respect to 11 September, see Agamben, *State of Exception* 3–4). In such a context, Agamben argues that it is no longer the city but the concentration camp that represents the paradigm of the political. For not only does the concentration camp represent an absolutization of power, of pure exceptionality and unsanctionable violence, but this absolutization turns on the possibility of life being stripped of any qualities—particular ways, acts, or processes—that might be said to give it some sort of particular social or political form (*Means Without End* 4). Against the background of these apocalyptically chilling claims, Agamben's work is a call to "return thought to its practical calling" (*Homo Sacer* 5), that is, to a conception of politics that is concerned with the question of a qualified and particular form-of-life. Agamben states that

> until a completely new politics—that is, a politics no longer founded on the *exceptio* of bare life—is at hand, every thought and every praxis will remain imprisoned and immobile, and the "beautiful day" of life will be given citizenship only either through blood and death or in the perfect senselessness to which the society of the spectacle condemns it. (11)

This is not, however, a matter of instrumentally setting out to engineer different political realities, of seeking to cultivate and bring about new political ends. Claiming that a politics of the instrumental calculation and production of ends merely reproduces the survivalist urges characteristic of biopolitical sovereignty, Agamben speaks instead of a politics of "pure means" or "means without end" (*Means Without End* 57–59, 117–18). Here,

again, Agamben follows Benjamin in arguing that meaningful political thought and activity is far more radical than simply working to change the current realities with which we are presented. In short, Agamben calls for a politics of messianic interruption—what Benjamin calls a "real state of emergency" (*Theses* 257)—that changes the very landscape of political and ethical subjectivity (*The Time That Remains* 106-07). And, like Badiou and Žižek, not to mention Benjamin, Agamben develops his account of messianic politics by drawing upon the resources of Paul, particularly the Pauline notion of the messianic remnant and the corresponding notion of witness.

Perhaps the most significant aspect of this messianic politics, for the purposes of the present discussion, is that it is not to be construed numerically. Agamben argues that a messianic politics is founded neither on the concept of the part nor of the whole; instead, it transforms the very logic of part and whole by introducing the notion of a remnant. Pointing in particular to Paul's Letter to the Romans, Agamben claims that "Paul makes use of a series of Biblical citations to conceive of the messianic event as a series of caesuras dividing the people of Israel and, at the same time, the Gentiles, constituting them each time as remnants" (*Remnants* 163; see also *The Time That Remains* 50, 54). Like Badiou and Žižek, Agamben here gestures toward a conception of political subjectivity in which the subject is interpreted as somehow non-identical to itself.

This is perhaps most fully developed in Agamben's notion of the messianic remnant as witness. In short, Agamben claims that the messianic remnant is that which bears witness to the impossibility of witnessing. This suggests that the politics of witnessing is not final or in any way programmatic, but is rather a work of ongoing receptivity to the interruptive grace of the messianic event. Recalling the notion of a qualified, particular form-of-life, which he associates with the speaking subject, Agamben thus gestures toward a politics of speech that is capable of recognizing the extent to which speech is impossible. Such a politics is not grounded in a conception of pure biological life that cannot speak, nor does it reflect an understanding of linguistic activity that is unrelated to the natural. Rather, it names a zone of indistinction that somehow exists between them. As Agamben puts it,

What is expressed in [the witness] is nothing other than the intimate dual structure of testimony as an act of an *auctor*, as the difference and completion of an impossibility and possibility of speaking, of the inhuman and the human, a living being and a speaking being. The subject of testimony is constitutively fractured; it has no other consistency than disjunction and dislocation—and yet it is nevertheless irreducible to them. This is what it means "to be subject to desubjectification," and this is why the witness, the ethical subject, is the subject who bears witness to desubjectification. And the unassignability of testimony is nothing other than the price of this fracture,...of an impotentiality and potentiality of speaking. (*Remnants* 151)

Similarly, he suggests that the

testimony [of witness] takes place where the speechless one makes the speaking one speak and where the one who speaks bears the impossibility of speaking in his own speech, such that the silent and the speaking, the inhuman and the human, enter into a zone of indistinction in which it is impossible to establish the position of the subject, to identify the "imagined substance" of the "I" and, along with it, the true witness. (120)

Although he does not refer explicitly to the question of marginality, I want to suggest that Agamben can be read as extending the critique of the politics of marginality that I have associated with Badiou and Žižek. In Agamben's terminology, the discourse of marginality is problematic just to the extent that it remains premised on the numerical logic of whole and part. Far from offering a genuine alternative to the forms of violence it sets out to unmask, what we find instead is an interminable interplay between major and minor voices that might be said to leave us sealed within a circuit of endlessly shifting identitarian commitments, or what Agamben calls a "single planetary petty bourgeoisie" (*The Coming Community* 63; see also *Means Without End* 6-7, 10). The politics of marginality remains captivated by a construal of resistance and hope as instrumental calculation, and thus remains inscribed within a logic of means and ends, or at

least an ethos of survivalism. This is perhaps most clearly reflected in the sense that discourses of marginalization typically set out to secure a more effective capacity to speak against the voices that have hitherto sought to silence them. It equally plays into the hands of biopolitical sovereignty, just to the extent that it appeals to conceptions of dignity or of rights grounded in the very sanctity of life (Agamben, *Means Without End* 15-26). As Agamben asserts, "The sacredness of life, which is invoked today as an absolutely fundamental right in opposition to sovereign power, in fact originally expresses precisely both life's subjection to a power over death and life's irreparable exposure in the relation of abandonment" (*Homo Sacer* 83).

Agamben's account of the political witness of Paul might be further developed by way of an examination of the figure of the martyr. Another name for the Pauline subject is the martyr. And the *ekklesia* is, among other things, a community of martyrs. Put in terms of the desubjectification of the subject, martyrdom names an alternative to what may be called the standard metaphors of subjectivity and political agency, namely victory and victimhood. The Pauline subject, in other words, is neither the heroic victor nor the defeated victim, but rather the martyr whose very being signals the indistinction between the hero and the victim. While such an account of the martyr is occasionally hinted at by Badiou and Žižek, particularly in their respective critiques of a victimist conception of the subject (Badiou 6; Žižek, *The Fragile Absolute* 54-63), the figure of the martyr remains largely implicit in their work. If anything, their work displays a residual fascination with the heroic subject (see Badiou 7; Žižek, *The Ticklish Subject* 238). Agamben could hardly be said to valorize a conception of the heroic subject; yet he does not speak of martyrdom, even though he provides an account of messianic witness. In order to develop a reading of martyrdom as a fracturing of the apparent distinction between hero and victim, I move beyond Badiou, Žižek, and Agamben, to Rowan Williams.

According to Williams, contemporary North Atlantic cultural practices can be read in terms of an apparent inversion of the positions of the hero and the victim. In such a reading, the predecessor culture—often referred to by the labels "modernity" or "colonialism"—can be defined by the image of the hero. In a heroic culture, to be is to be victorious, to exercise power over, to overcome whatever challenges might stand in one's way. It is to inhabit

a position of sovereign power, to vanquish one's opponents—in short, to dominate. But whereas power used to reside in the hands of the powerful, it now often appears to be wielded by the powerless victim, the very subject of domination. From talk-show television to international tribunals, we are repeatedly presented with the message that to be is to be victimized, to suffer under the hands of one form of power or another. It has become customary to define oneself in terms of that by which one is afflicted, whether illness or anguish, overt physical abuse or subtle psychological manipulation. Identity is thus no longer understood as an expression of heroic power but as an experience of subjugation (Williams, *Lost Icons* 109).

This turn to the victim is often read as a story of liberation, a flight from captivity, and even a contemporary analogue to the story of Exodus. But, according to Williams, what is significant about the rise of the victim is not so much the liberation of the victim's voice, but the sense in which the posture of victimhood often expresses the same old mechanisms of power associated with heroic victory. The problem with the logic of victimization, Williams suggests, is its tendency to give rise to discourses that are self-confirming and entirely invulnerable to critique—that is, nobody has the right to call my experiences of suffering into question. And so the position of the victim circles right back to the conception of power exemplified by the hero.

According to one common story, then, the victim has been relieved from a life of suffering and subjugation at the hands of the victor and has achieved a sense of justice. But Williams argues that this alleged shifting of the balance of power from hero to victim is not so much of a shift at all. The victim has simply become the new face of the hero. The culture of victimhood reproduces the same logic of power as that of victory, namely a competition for security and control, a politics of mastery and survival. Put differently, the hero and the victim are both expressions of a desire to escape difficulty. They both reflect what Williams elsewhere describes as an attempt to "imagine an environment without friction" (*Lost Icons* 147). The hero seeks to overcome such friction in a kind of final utopian triumph, while the victim also lives a frictionless existence precisely because of his or her resignation to suffering and loss. In both cases, what is missing is an ability to put the self into question. The metaphors of victory and victimhood both present a vision of the subject as a fundamentally

closed and fixed entity. The figure of the martyr, by contrast, suggests the emergence of an entirely different model of culture and identity; whereas the hero and the victim both express forms of social control, martyrdom implies a conception of life lived out of control.

Among other things, stories of martyrdom give expression to an uncomfortable message of hope that saves us from the temptation to locate our hope in ourselves, to confuse salvation with survival. To turn once again to Williams, this is to suggest that martyrdom is essentially

> about something other than *heroism*. It has to do with freedom from the imperatives of violence—a freedom, in this instance, that carries the most dramatic cost imaginable. It is not the drama that matters, however, it is the freedom that is important. If we focus on the drama, if we long for the opportunity of heroism, we are in thrall to another kind of violence because we are seeking a secure and morally impregnable place for the self to be. We want to be *victims*, to enter a world where there are clear divisions between the forces of darkness and the forces of light. We want, in fact, to get back to that clear frontier between insiders and outsiders which is so comprehensively unsettled by the trial of Jesus in the Gospels. (*Christ on Trial* 107 [emphasis mine])

Stories of martyrdom, in other words, provide glimpses of a transformed subject and a new conception of political agency according to which the boundaries that separate inside and outside no longer have a determina-tive, identity-constituting function. Martyrdom names the possibility of thinking identity in terms of non-coincidence, as something internally differentiated from itself. The martyr is at once a subject and desubjectified. The community of martyrs is resolutely anti-communitarian. The very exis-tence of the martyr is a kind of testimony or witness to the difficulty of iden-tity, a difficulty that significantly complicates the concept of marginality.

As a way of illustrating these comments, I want briefly to point to the work of the German novelist W.G. Sebald, to suggest that his writings might be read as a way of putting some flesh on this all-too-thin picture of mes-sianic politics. Indeed, I want to suggest that the preceding discussion can be understood as a series of prefatory comments that set the stage for a

reading of Sebald—in particular, his haunting novel of fractured memory and ruptured identity, *Austerlitz*. Sebald's characters are everywhere expressions of marginality and accounts of exilic existence, and yet his meditations on marginality are not susceptible to those critiques of the marginal that take it to be irretrievably linked with global capitalism and biopolitical sovereignty. Against the background of these arguments for the meaninglessness of marginality, Sebald's work can be read as a rethinking of the meaning of marginality that arises out of a reckoning with the appearance of its very meaninglessness. At the same time, while not explicitly articulated in terms of the logic of witness or the grammar of martyrdom, I think it is appropriate to read his work as an expression of the concepts of martyrdom and witness that I have developed through a reading of Williams and Agamben. Each of Sebald's key characters is an instance of life lived out of control, of subjects that are subject to desubjectivization. Sebald's writing is, perhaps more than anything, an attempt to provide an account of what it might mean to be a meaningful witness. His characters are gripped both by a responsibility to witness and by a struggle with the elusiveness of just such a task, an elusiveness that is bound up with a recognition that, as Austerlitz puts it, "the border between life and death is less impermeable than we commonly think" (*Austerlitz* 283).[2] One commentator has suggested that Sebald presents an image of the witness, not as one who is in possession of the truth, but who is rather "part of an ongoing quest for the truth, a quest that involves an audience able and willing to endure [in this case] the silences that accompany all Holocaust memory" (Garloff 77).[3]

Austerlitz recounts the harrowing work of memory undertaken by Jacques Austerlitz. Austerlitz is a figure of isolation and dislocation in search of a lost memory and identity and, perhaps even more importantly, a language or figure of speech that is appropriate to that memory. In an interview shortly before his death, Sebald claimed that "the moral backbone of literature is about that whole question of memory" (Sebald, qtd. in Jaggi), and he described *Austerlitz* as an attempt to "create an alternative Holocaust museum" (Sebald, in interview with C. Krauthausen, qtd. in Schlesinger 44). Indeed it is this question of the intimate yet complicated relationship between memory, identity, and the possibility of speech in the midst of marginalization and meaninglessness that drives all of Sebald's

work. At one point, in one of his many echoes of Wittgenstein, Austerlitz reflects that

> if language may be regarded as an old city full of streets and squares, nooks and crannies, with some quarters dating from far back in time while others have been torn down, cleaned up, and rebuilt, and with suburbs reaching further and further into the surrounding country, then I was like a man who has been abroad a long time and cannot find his way through this urban sprawl anymore, no longer knows what a bus stop is for, or what a back yard is, or a street junction, or an avenue or a bridge. (123-24)

But then the past comes to haunt him like a ghost, as Austerlitz speaks of "scraps of memory beginning to drift through the outlying regions of [his] mind" (136)—memories, for instance, of seeing himself as a boy with "white knee-length socks" holding a small rucksack on his lap while sitting on a bench in Liverpool Street Station. It was at this point, Austerlitz says, that "I became aware, through my dull bemusement, of the destructive effect on me of my desolation through all those past years, and a terrible weariness overcame me at the idea that I had never really been alive, or was only now being born, almost on the eve of my death" (137). Through a series of these fragmentary memory scraps, we listen in as Austerlitz slowly discovers that he is not the son of a Welsh Calvinist minister and his wife but, rather, that he was shipped away by his desperate Jewish mother on one of the *Kindertransporte* just prior to her internment in the Prague ghetto of Theresienstadt (Terezín). Austerlitz is compelled by the need to bear witness, to find a language and a voice adequate to speak the truth, and to relate his story to an appropriate listener. By the end of the story, Austerlitz has wandered with his rucksack to Prague and Theresienstadt, Paris, and the French Pyrenees. He learns to speak in his Czech mother tongue again. And he comes to be equipped with a handful of glimpses of both of his parents, an old lover, and some other lost companions. It is significant, however, that we are told all of this not by Austerlitz himself, for the voice of the martyr is by definition a silent one. Rather, the witness of Austerlitz is communicated by an unnamed listener who comes to share in the difficult responsibility of bearing witness, the unsettling work of martyrdom.

Austerlitz is often described as a story of recovered memory, a restoration of identity from the grip of a horrifying vortex of traumatic loss. But I think such a description of Sebald's writing instructively misses the mark. In the end, Austerlitz arrives at no final meaningful resolution; he reaches no sense of closure. "In one way," Austerlitz says, he feels "liberated from the false pretences of his English life, but in another oppressed by the vague sense that he did not belong in this city either, or indeed anywhere else in the world" (253-54). There is for Austerlitz no "emergence from the past" (218-19) and no sense of belonging. He is still gripped by a sense of marginality and the meaninglessness of his life. And he scorns those who are captured by a desire for monumentalism, a wish to perpetuate their memory in some way (276). Instead, he exists on the "far side of time" (258). And so we are left wondering as Austerlitz once again wanders off with his rucksack, leaving the keys to his house and, indeed, the burden of witness with his listening companion. According to Katja Garloff, the significance of Sebald is precisely that he does *not* attempt to "restore a voice to the voiceless," but rather "accepts the gap between the speechless and the speaking...as the irrevocable condition of his own literature" (88). "I came to the conclusion," says Austerlitz, "that in any project we design and develop, the size and degree of complexity of the information and control systems inscribed in it are the crucial factors, so that the all-embracing and absolute perfection of the concept can in practice coincide, indeed ultimately must coincide, with its chronic dysfunction and constitutional instability" (281). And so it appears that for Sebald the sense of not belonging, of being on the far side of time, is precisely the point of the witness of Austerlitz. The witness is the one who does not belong. The truth offered by the witness is the possibility of a freedom from the temptation to erect monuments, to preserve our own memories, and so to secure the meaningfulness of our identities. This has everything to do with the question of the meaning of marginality. Sebald has no interest in those marginalities that might be said to reflect a sense of belonging to any sort of marginal identity. For Sebald, marginality is in a sense constitutive of identity, but this is a transformed sense of identity that emerges only out of a serious reckoning with the meaninglessness of identity, a desubjectification of the subject. In other words, *Austerlitz* offers a sense of marginality that is

meaningful only insofar as it names a fracturing of identitarian forms of association, an interruptive sense of not belonging.

By way of conclusion, I want to return to the question of the Pauline subject. Near the beginning of this essay, I invoked Agamben's terminology of a "zone of indistinction." It is out of just such a zone of indistinction that the witness of Austerlitz might be said to emerge. Drawing upon the example of Austerlitz, I have tried to suggest that the significance of the martyr, the witness, is a kind of fracturing of the distinction between meaning and meaninglessness. In a similar way, the martyr interrupts the difference between the politics of the majority and that of the marginalized. In the words of Agamben, the witness, the martyr, is a remnant, a remainder, or a division of division. The significance of the martyr is that of being a witness that renders the very distinction between meaningfulness and meaninglessness, between majority and marginality, problematic. In doing so, the martyr offers a gesture, for there can be nothing more, of a transformed subject, a new kind of political agency. Such a politics is not preoccupied with the task of engineering specific ends, but gestures toward a form-of-life. Neither does it seek to secure identitarian commitments, let alone set out to ensure the survival of something called life itself. It is, rather, a politics of witness that involves both the linguistic articulation of a particular form-of-life, specific works of memory, and yet, at the same time, a recognition that it does not, of itself, contain the power to speak. So, in the spirit of this simultaneous possibility and impossibility of speaking that might be said to reflect the political witness of Paul, let me close by deferring the last word to Agamben, offering it up as a theoretical echo of the silent voice of Austerlitz:

> In the concept of the remnant, the aporia of testimony coincides with the aporia of messianism. Just as the remnant of Israel signifies neither the whole people nor a part of the people but, rather, the non-coincidence of the whole and the part, and just as messianic time is neither historical time nor eternity but, rather, the disjunction that divides them, so the remnants of Auschwitz—the witnesses—are neither the dead nor the survivors, neither the drowned nor the saved. They are what remains between them. (*Remnants* 163–64)

Notes

1 It should be noted that Agamben's notion of "mutable and virtually infinite survival" is similar to what Badiou and Žižek identify as the differential logic characteristic of global capitalism, discussed above.

2 I owe this observation to Peter Dula.

3 It is worth noting that Garloff explicitly draws attention to possible continuities between Sebald and Agamben, focusing specifically on Sebald's *The Emigrants*. More recently, Eric Santner suggests, in *On Creaturely Life*, that Sebald's work is indebted to Benjamin and, by extension, contains many significant resonances with Agamben.

Works Cited

Agamben, Giorgio. *The Coming Community.* Trans. Michael Hardt. Minneapolis: U of Minnesota P, 1993.

———. *Homo Sacer: Sovereign Power and Bare Life.* Trans. Daniel Heller-Roazen. Stanford: Stanford UP, 1998.

———. *Means Without End: Notes on Politics.* Trans. Vincenzo Binetti and Cesare Casarino. Minneapolis: U of Minnesota P, 2000.

———. *Remnants of Auschwitz: The Witness and the Archive.* Trans. Daniel Heller-Roazen. New York: Zone Books, 2002.

———. *State of Exception.* Trans. Kevin Attell. Chicago: U of Chicago P, 2005.

———. *The Time That Remains: A Commentary on the Letter to the Romans.* Trans. Patricia Dailey. Stanford: Stanford UP, 2005.

Badiou, Alain. *Saint Paul: The Foundation of Universalism.* Trans. Roy Brassier. Stanford: Stanford UP, 2003.

Benjamin, Walter. "Critique of Violence." Trans. Edmund Jephcott. *Walter Benjamin: Selected Writings; Volume 1, 1913–1926.* Ed. Marcus Bullock and Michael W. Jennings. Cambridge, MA: Harvard UP, 1996. 236–52.

———. "Theses on the Philosophy of History." Trans. Harry Zohn. *Illuminations: Essays and Reflections.* Ed. Hannah Arendt. New York: Schocken Books, 1968. 253–64.

Garloff, Katja. "The Emigrant as Witness: W.G. Sebald's *Die Ausgewanderten.*" *German Quarterly* 77 (2004): 76–93.

Jaggi, Maya. "The Last Word [An Interview with W.G. Sebald]." *The Guardian*, 21 December 2001. <http://www.guardian.co.uk/education/2001/dec/21/artsandhumanities.highereducation>.

Santner, Eric L. *On Creaturely Life: Rilke, Benjamin, Sebald.* Chicago: U of Chicago P, 2006.

Schlesinger, Philip. "W.G. Sebald and the Condition of Exile." *Theory, Culture, and Society* 21.2 (April 2004): 43-67.

Schmitt, Carl. *Political Theology: Four Chapters on the Concept of Sovereignty.* Trans. George Schwab. Cambridge, MA: MIT P, 1985.

Sebald, W.G. *Austerlitz.* Trans. Anthea Bell. Toronto: Alfred A. Knopf, Canada, 2001.

_____. *The Emigrants.* Trans. Michael Hulse. New York: New Directions Books, 1997.

Williams, Rowan. *Christ on Trial: How the Gospel Unsettles Our Judgement.* Grand Rapids, MI: Eerdmans, 2003.

_____. *Lost Icons: Reflections on Cultural Bereavement.* Edinburgh: T. & T. Clark, 2000.

Žižek, Slavoj. *The Fragile Absolute; or, Why is the Christian Legacy Worth Fighting For?* New York: Verso, 2000.

_____. *The Ticklish Subject: The Absent Centre of Political Ontology.* New York: Verso, 1999.

Shared Marginalization and Negotiated Identities
Religion and Feminism in Philosophy

JANET CATHERINA WESSELIUS

Most people who are philosophers and either feminists or participants in traditional religions are familiar with the struggle to integrate these two central aspects of their identities, particularly since feminism and religion are marginalized in mainstream Western philosophy. Feminist philosophers and religious philosophers know that it is expected that they will bracket their political and religious concerns, respectively, in their intellectual work, although many refuse to do so. In this essay I shall not adumbrate evidence that there are conflicts among these three identities; rather, the acknowledgement of these conflicts is the starting point for my analysis and for my proposal that the recognition of the marginalization shared by feminism and religion (in this instance, Christian) can be used as a resource for beginning to negotiate a hybrid identity as well as for problematizing some of the hegemonic identities. Both feminist philosophy and Christian philosophy are marginalized (to a degree) by mainstream philosophy, insofar as both are accused of being subjective and irrational; but feminist philosophy has developed some interesting and powerful arguments in defence against this accusation that have parallels in some Christian philosophy.

In the first section, then, I shall examine the logic of marginalization by looking at the similarities and differences between the marginalization of feminism and the marginalization of religion. Marginalization cannot be read simply as an absence or a lack; rather, the very structure of marginalization marks and shapes that which is marginalized. In the second section, I shall examine how the self-understanding of philosophy as a discipline leads to the marginalization of both Christian philosophy

and feminist philosophy. In the third section, I shall analyze the response of feminist philosophy to defend itself against charges of subjectivity and irrationality—namely, the argument that all theory is situated—followed in the fourth section with an examination of how a Christian philosophy might respond in a similar fashion. Finally, I shall argue that the shared marginalization can be turned to an advantage, insofar as a recognition of it can be the beginning for negotiating an identity rooted in and yet branching across differences.

There is enormous variation within all three identities that I discuss—philosophy, feminism, religion—so it would be inaccurate to homogenize these three groups as if they comprised seamless wholes without difference. Nevertheless, there are legitimate generalizations that can be made; hence, I focus on smaller sub-groups that are self-identified as members of the larger identity and are still recognizably representative of that larger identity. By *philosophy* I am referring to the mainstream analytic Anglo-American tradition that is dominant in the English-speaking academy. While my analysis will not be as pertinent to the continental tradition, this self-characterization of philosophy is an ancient and hegemonic part of the shared history of both sorts of philosophy, despite the existence of alternative conceptions of philosophy. As well, I have chosen to use Kant as representative of philosophy, since he is a central, modern figure equally important in both the Anglo-American and the continental tradition. By *feminist* I am referring to self-identified feminist philosophers who are trained mainly in analytic philosophy but who have been deeply influenced by continental French feminist scholarship. By *religion* I am referring to Christianity; I have chosen to focus on Christianity mainly because of the long and important relation between the discipline of philosophy (as delimited above) and Christianity.[1] More specifically, by *Christian* I am referring primarily to the school of neo-Calvinist, Reformational[2] philosophy developed in Amsterdam in the nineteenth and twentieth centuries; I choose this group because the Amsterdam School—although small—appears in various forms in both analytic and continental circles, and, more importantly, it is rooted in a tradition of Christianity that historically places a high premium on intellectual activity in general and on philosophy in particular.

Marginalization
Similarities and Differences

Prima facie, it might seem strange to claim that religion is marginalized in mainstream philosophy. After all, the Christian religion and Western philosophy have, in large part, a shared history. Indeed, the philosophical tradition has historically included the work of philosophers who have been explicitly religious (for example, Augustine, Aquinas, Maimonides, or Avicenna). Nevertheless, Hans-Georg Gadamer, for example, argues that since the Enlightenment, the discipline of philosophy has had a prejudice against religion (272). Any philosopher who attempts to be explicitly religious in her philosophy is looked at askance. At least within the contemporary philosophical realm, religious people who try to integrate their faith and philosophy are judged to be engaged in an irrational project, and contemporary philosophy can be justly characterized as secular. This situation of religious philosophy vis-à-vis mainstream philosophy seems to be similar to that of feminist philosophy. Significantly, in terms of traditional hierarchical dichotomies, both religion and women have been relegated to the private realm, whereas philosophy (as the discipline of reason) occupies the public realm. So both religious philosophy and feminist philosophy are suspect insofar as they claim to be part of the discipline of philosophy.

This is the nexus of what is interesting about this situation: the claims of some Christians and some feminists to be engaged in Christian *philosophy* or feminist *philosophy* are treated with scepticism—and sometimes derision—by the discipline. This is not a question about whether or not philosophy can or does deal with religion and religious concerns or with feminism and gender-related concerns. As far as the discipline of philosophy is concerned, it prides itself on not having a particular subject matter, but rather on offering a distinctive range of approaches to thinking about all sorts of things, including religion and gender. Not only have both Christians and feminists sometimes claimed that they have not received unbiased evaluation from the discipline, but when either presume to use their religious tradition or political commitments to shape and develop a philosophy, the discipline rules them out of order.

Although I contend that mainstream philosophy is generally sceptical of both Christian philosophy and feminist philosophy qua philosophies, their respective histories with the mainstream are far from identical. Christian philosophy has a much longer—and, in many ways, inter-twined—history. Unlike issues related to gender and feminism, there is a long history of discussion amongst philosophers about religion and religious concerns that continues unabated: philosophy of religion remains a recognized and respectable area of specialization in the discipline. In other words, the marginalization of religion in philosophy is not the result of being ignored; indeed, philosophy pays considerable attention to religion in general and Christianity in particular. Nevertheless, much of the attention directed toward religion is negative. In many of the philosophical conversations about religion, the focus is on the role of reason in religion (that is, on the reasonableness of religion), and Christian philosophy is accused of being subjective and irrational.[3] One thing that strikes me is the asymmetry in the debate between Christian and non-Christian philosophers in the following sense. For philosophers, charges of irrationality are among the most serious kind that can be made (although, I suppose, if one truly believes that any form of religious belief is irrational, it must be quite horrifying to be called "religious," perhaps akin to being accused of taking an irrational position). *Pace* those philosophers who believe that the discipline of philosophy no longer has hubristic pretensions, philosophy still seems to see itself as *the* discipline of reason *alone*, however relativized, historicized, or particularized that reason may be; in other words, Richard Rorty's criticisms of Philosophy (with a capital *P*) are still as pertinent now as they were in 1979 when he published *Philosophy and the Mirror of Nature*. In this context, then, the position of the non-Christian philosopher who champions a (however fallible) reason, and who insists that Christian philosophers face up to the "irrationality" of Christianity,[4] certainly seems to occupy a position with the full weight and authority of the tradition of philosophy (or Philosophy) behind it. The position of a Christian philosopher, on the other hand, as one who seeks to make room for religious commitments or faith in philosophy, seems to be the position of a petitioner, looking for recognition for equally worthy philosophic credentials. And, in this sense, the non-Christian position functions, in one aspect at least, as that of a gatekeeper to a professional association of philosophy that guards

the accreditation of philosophers and philosophy. To take up the common metaphor of a level playing field, the non-Christian has the home court advantage while the Christian is on the defensive.[5]

The second thing that strikes me about many of these discussions is the virtual absence of feminist perspectives or contributions, particularly because I suggest that feminist proposals for understanding knowledge as situated, including reason and objectivity and philosophy, can shift the focus of many of these discussions and can be helpful in moving these conversations forward. Like many Christian philosophers, feminist philosophers have often had to defend their credentials as philosophers, and they have had to argue for the validity of feminist philosophy qua philosophy.[6] The relation of feminist philosophy to mainstream philosophy is also asymmetrical in the sense that the position of a Christian is asymmetrical vis-à-vis the mainstream: if mainstream philosophy sets the centre for what counts as philosophy, then feminist philosophy, no less than religious philosophy, is on the margins of this circle.

But feminist philosophy rejects the charge of subjective irrationality and contests its marginalization. The arguments and analyses developed by feminist philosophy in defence of this charge can be applied to—and resonates with—a Christian philosophy. In particular, feminist philosophy has recognized the epistemic significance of the specificity of the knower, or what is often called the *situatedness* of all knowledge; that is, knowledge is constructed in and by the particular situation of knowers. The situatedness of all knowledge (and hence all philosophy), the fact that there is no neutral Archimedean vantage point from which to pass judgement on knowledge claims, challenges the very identity of philosophy as the arbiter of reason and as the legitimate judge of, among other things, religion and feminism.[7]

The Self-Understanding of Philosophy

It seems reasonable to deduce that if mainstream philosophy has a conflict with schools of thought that claim the name *philosophy* for themselves, then the conflict is most likely rooted in the self-understanding of philosophy. Criteria for membership in the discipline of philosophy conflict

with claims to status as a philosophy made by feminism and Christianity. A central figure such as Kant describes the project of philosophy as "a call to reason to undertake anew the most difficult of all its tasks, namely, that of self-knowledge, and to institute a tribunal that will assure to reason its lawful claims, and dismiss all groundless pretensions, not by despotic decrees, but in accordance with its own eternal and unalterable laws. This tribunal is no other than the critique of pure reason" (A^{xi}-A^{xii}). What is implied in this quotation from a "father of philosophy" is that philosophy is the discipline of reason alone. Philosophy begins with the self-critique of reason according to its "own eternal and immutable laws," and is practiced through reason's adjudication of any claims to knowledge. Reason is both the legislator of its own laws and the supreme court. It has the right to criticize everything, including itself. If reason is self-governing and governs all else, it is autonomous; that is, reason is literally a "law unto itself." The autonomy of reason is an important tenet of philosophy because Kant is concerned that philosophy has fallen into dogmatism. According to Kant, the solution to dogmatism is a critique of pure reason. If philosophy begins by submitting to reason's critical ability, philosophy can purge itself of all "groundless pretensions." Since the governance of reason is not "by despotic decrees," we can infer that only reason is truly critical because it alone has no prejudices or biases.

Philosophy governed by an autonomous reason is an antidote to the dogmatism of despotic decrees. Consequently, mainstream philosophy is committed to autonomous reason, because such a commitment is the way to impartial knowledge. As the discipline of pure reason, philosophy flatters itself that not only can it gain impartial knowledge, but it can also produce knowledge that is universal and general, rather than specialized or particular (like the knowledge of the *special* sciences). As the *Encyclopedia of Philosophy* states, philosophy is "that department of knowledge which deals with ultimate reality, or with the most general causes and principles of things." In fact, according to the *Encyclopedia*, although philosophy is hard to characterize because of the many different forms it takes, both Anglo-American and continental philosophy are marked by a concern for general conclusions (Passmore 217). So we can say that philosophy understands itself as the discipline of reason that gives us general, universal, impartial, neutral knowledge.

Even though it is not accepted uncritically by philosophers, Kant's conception of philosophy is useful for understanding the demarcation of philosophy because it has had so much influence on contemporary views of philosophy; hence, it serves as a representative example.[8] Following this history, Rorty, for example, describes philosophy as a "high priest of culture":

> Philosophers usually think of their discipline as one which discusses perennial, eternal problems—problems which arise as soon as one reflects....Philosophy as a discipline thus sees itself as the attempt to underwrite or debunk claims to knowledge made by science, morality, art, or religion....Philosophy can be foundational in respect to the rest of culture because culture is the assemblage of claims to knowledge, and philosophy adjudicates such claims....Philosophy's central concern is to be a general theory of representation, a theory which will divide culture up into the areas which represent reality well, those which represent it less well, and those which do not represent it at all (despite their pretence of doing so). (3)

So philosophy, at least on its own understanding, serves as a judge for society, and it judges according to the laws of reason. It examines problems that are general and universal. It validates or invalidates the knowledge claims of culture, including those of religion and feminism. It judges whether feminism and religion have represented reality well or not at all. It has the right to do so because, until feminism and religion (and the rest of culture) have been submitted to a critique of reason, they *precede* the *judicial* authority of reason and are, thus, *prejudices*.

Admittedly, this is a caricaturizing sketch of mainstream philosophy. It is unlikely that any philosopher would accept such an idealized and unqualified conception of philosophy. Indeed, it would be a mistake to think that all philosophers would agree with these definitions.[9] Nevertheless, this picture reveals a conception that functions as a regulative ideal in our tradition, as shown by the example of Kant, that philosophers either aspire to or contest (as in the case of Rorty). Moreover, the challenges—made by, for example, Rorty himself—to these definitions are evidence of their hegemony. The fact that there are different self-understandings of philosophy—ones that do not conflict with feminist and

Christian philosophy—does not negate the reality of the conflict that takes place with mainstream philosophy.

I have deliberately chosen the widest—and hence starkest—understanding of philosophy. Why would this self-understanding conflict with either feminist philosophy or Christian philosophy? While it might be the case that some feminist and some Christian philosophies also embrace this understanding of philosophy, both religion (since the Enlightenment) and sex or gender are commonly considered biases or prejudices that threaten the universality and impartiality of knowledge.[10] As Gadamer argues, "there is one prejudice of the Enlightenment that defines its essence: the fundamental prejudice against prejudice itself" (270). Hence, both feminist philosophy and Christian philosophy, insofar as they are philosophies, are viewed with suspicion. Evidently, both philosophies have commitments either beyond or in addition to reason. Put another way, they do not submit to the judgement of reason alone. And the fact that there is conflict between philosophy and feminist philosophy, and between philosophy and Christian philosophy, indicates that both feminist philosophy and Christian philosophy refuse to accept this identity.

Since philosophy makes traditional claims to providing general (that is, universally valid) knowledge that has been subjected to the critique of reason alone, it prohibits the intrusion of that which is particular or individual, interested or committed. Mainstream philosophy purports to be general and universal; it is disinterested and committed to nothing but reason. As such, this is a conception of reason that transcends both sex/gender and faith. For people who have been trained in and work in philosophy, any identity as either feminist or Christian must be bracketed, must not be allowed to influence their philosophic work. But some of these same people—trained in the methods and history of philosophy—are suspicious of the definition of philosophy as sexless and secular. And they insist that they do a *particular kind* of philosophy. Moreover, they are *committed* to the tenets of feminism and Christianity respectively. The fact that both names—*feminist* philosophy and *Christian* philosophy—specify their respective identities as a *particular type* of philosophy highlights the conflict they have with *philosophy* in general.

I daresay that those who identify themselves as either feminist or Christian philosophers would immediately acknowledge the influence of

their feminist or religious commitments, respectively, in their philosophy. Indeed, these sorts of feminist philosophers and Christian philosophers insist on integrating their political or religious commitments in philosophy, rather than bracketing them. Moreover, both the feminist and the Christian have pre-philosophic political or faith commitments, and these commitments play a role in their theorizing. These commitments are *pre*-philosophic because they arise out of a philosopher's life in its entirety; that is, a philosopher is always more than a philosopher, and it is this entire, multi-faceted identity that is brought to philosophy.[11] Many feminist philosophers and Christian philosophers are unapologetic about this influence in their philosophic work. After all, it is because these commitments are visible that there is *feminist* philosophy or *Christian* philosophy.

I have argued that mainstream philosophy is committed to an autonomous form of reason and sees itself as universally impartial and, hence, as generally valid. Such a self-understanding implies that, if feminist philosophy and Christian philosophy are valid at all, they are valid only for women or for Christians; or, more subtly, feminist philosophy is only valid when discussing sexism, whereas Christian philosophy deals validly only with matters of faith. Therefore, neither feminist nor Christian philosophy has anything distinctive to say, for example, about logical analysis. I have also argued that while feminism and Christianity may be in conflict, feminist philosophy and Christian philosophy share a similarity in their symmetrical conflict with mainstream philosophy; hence, they share their difference from mainstream philosophy. I hinted that the different and/or additional commitments (to something other than reason) of both feminist and Christian philosophy may be the reason they are viewed with scepticism qua examples of philosophy. We need to look more closely at this shared difference from mainstream philosophy.

Situated Knowledge

A common criticism made of feminist philosophy is that it is irrational, that feminist commitments are prejudices, and, like all and any prejudices, they are inimical to philosophy proper. Although most feminists would not describe themselves as "prejudiced," most are quite candid about their

deepest commitments and about the role these commitments play in their philosophy. For example, in one of the earliest anthologies of feminist philosophy in Canada, Susan Sherwin writes that "feminists readily admit to bias in their perspective, while philosophers continue to assume that bias should and *can* be avoided," and "feminists have political as well as intellectual aims that they are quite willing to admit to" (Code, Mullett, and Overall 20–21). Lorraine Code argues that "few feminists would claim value-neutrality for their own inquiries, which have avowedly political motivations in their feminist commitments" (*What Can She Know?* 31). In other words, they do not pretend nor aspire to neutrality.

This relatively new candour about commitments other than to reason comes out of feminist research on the maleness of reason, including understandings of *rational* and *philosophy*.[12] Mainstream philosophy, with its particular ideal of reason, must be construed differently because, as Code asserts,

> It is impossible to sustain the presumption of gender-neutrality that is central to standard epistemologies [or philosophy]: the presumption that gender has nothing to do with knowledge, that the mind has no sex, that reason is alike in all men, and man "embraces" woman. ("Taking Subjectivity" 20)

The feminist reconceptualization of philosophy is a heterogeneous project that is not complete. However, feminist critiques of reason and philosophy do not necessarily require an abandonment or rejection of reason. Rather, feminist philosophy argues that feminist political commitments have a legitimate role to play in philosophy, and the role such commitments play does not lead to irrationality. In their introduction to *Feminist Epistemologies*, Linda Alcoff and Elizabeth Potter argue,

> For mainstream philosophers, feminist work in philosophy is scandalous primarily because it is unashamedly a political intervention. The philosophical myth, like the myth of natural science, is that politics may motivate a philosopher to undertake philosophical work and that work may be put to better or worse political and social uses, but that a philosopher's work is good to the extent that its substantive, technical

content is free of political influence. Holding to this myth, traditional philosophers conclude that one need not even read feminist philosophy to know, a priori, that it is bad philosophy. (13)

Although a common criticism made of feminist philosophy is that it is irrational because it allows political motivations to influence philosophical work, such criticism derives from a myth that philosophy (and reason) can be impartial. This myth explains why feminist philosophy is not on a level playing field vis-à-vis mainstream philosophy, since feminist philosophers refuse to bracket their deepest—feminist—commitments.

Many religious philosophers also refuse to bracket their commitments.[13] In the case of Christians, these are specifically religious commitments, but I want to make two points about the similarities of the positions of Christians and feminists. First, feminist philosophers find themselves in a position similar to that of religious philosophers with respect to their deepest commitments. Second, feminist philosophers have a similar interest in levelling the playing field for all philosophers. I am not suggesting, by any means, that feminist philosophers and religious philosophers are communities that have overlapping membership; quite the contrary, there is often hostility between the two groups. Nevertheless, I think there are remarkable—even startling—similarities between the two. Both a commitment to sex/gender equality and religious faith are seen as detrimental biases. Hence, both feminist philosophy and religious philosophy, insofar as they claim to be philosophy, are viewed with suspicion.

We need to look more closely at the sense in which feminist philosophers think that the playing field of philosophy is not level. It is a commonplace in feminist philosophy that reason, far from transcending sex and gender as an ideal of philosophy, is construed in opposition to females and the feminine. For example, Genevieve Lloyd, in her classic work on the maleness of reason, *The Man of Reason*, argues that "rationality has been conceived as transcendence of the feminine" (104); indeed, many feminist philosophers have demonstrated that rationality has been conceived as male. Insofar as reason is a core ideal, philosophy itself is gendered masculine.

Hence, feminist philosophy begins with the recognition that women and the feminine have been excluded by philosophy. This exclusion is

no "simple" matter of the sexism of philosophers and their theories.[14] Mainstream philosophy excludes women and femininity because reason, as an ideal of philosophy, is construed as not transcending sex and gender, but as being in opposition to the feminine. As Lloyd argues, "our ideals of reason have historically incorporated an exclusion of the feminine" (x). Although feminist philosophers have diverse ways of dealing with this exclusion, I am particularly interested in the responses of feminist philosophers who contest a construal of reason as sex/gender neutral. This response takes the denigration of the feminine seriously by dealing with the underlying masculinity of reason. For example, Lloyd demonstrates the connection between the common ideal of reason and the hegemonically masculine character of our philosophic tradition. She argues,

> What is valued—whether it be odd as against even numbers, "aggressive" as against "nurturing" skills and capacities, or Reason as against emotion—has been readily identified with maleness. Within the context of this association of maleness with preferred traits, it is not just incidental to the feminine that female traits have been construed as inferior—or, more subtly, "complementary"—to male norms of human excellence. Rationality has been conceived as transcendence of the feminine; and the "feminine" itself has been partly constituted by its occurrence within this structure. (104)

In other words, because reason is valued, it is gendered masculine. Hence, insofar as reason is a core ideal, philosophy itself is gendered masculine. At the same time, reason and philosophy are allegedly general, universal, and impartial; however, if they are masculine, neither reason nor philosophy, as its guardian, meets its own criteria to be general, universal, and impartial. Despite philosophy's claim to be subject to the tribunal of pure reason alone, the masculinity of philosophy betrays the influence of a specific, particular, and partial gender-value in this tribunal itself. Philosophy has not purged itself of all "groundless pretensions" by submitting to reason alone when reason itself is not without bias or prejudice. If reason is masculine, why should women be exclusively, or even chiefly, committed to reason even if they are philosophers? Such a commitment has not delivered philosophy from bias and prejudice. Feminist philosophers are

justifiably critical of the valorization of an ideal of reason that excludes them solely on the basis of their sex and/or gender.

The evidence that has been adduced regarding the maleness of reason is prodigious, and the ways in which the ideal of reason of mainstream philosophy is male are complex. Moreover, these issues have been well documented in feminist literature, so I shall not recite the arguments here. What is important to note for my purposes is that the uneven playing field for feminist philosophers is not only due to the devaluation and exclusion of women and femininity by a mainstream ideal of reason. Rather, the lack of symmetry is because, in addition to the construal of reason as male, reason—even worse—masquerades as a neutral, impartial ideal; hence, philosophy claims to be a neutral, unbiased, impartial discipline. In other words, feminist philosophers, understandably, contest the construal of reason (and philosophy) as male; however, they also contest a construal of reason as sex/gender-*neutral*. If reason is male, then neither reason, nor philosophy as its guardian, meet their own criteria to be, and their own self-identification as, universal, impartial, unbiased, neutral: reason itself is not without biases or prejudices. So, according to many feminist philosophers, the playing field of philosophy is not level because, although reason and philosophy do not live up to their own ideals of neutral impartiality, they continue to pretend that they do. That is, feminist philosophers not only "have a problem" with the maleness of reason and philosophy, they take exception to the claim that reason or philosophy is sex/gender-neutral. What makes the playing field particularly uneven is the *pretension* to neutrality and impartiality. Feminist philosophy can be accused of being political, agenda-driven, and biased, but philosophy proper is allegedly beyond reproach as neutral, impartial, disinterested.

In addition to arguing against the maleness of reason and philosophy, many feminists argue that, perhaps, reason and philosophy are never neutral. There is no simple agreement among feminist philosophers about whether reason is able ultimately to transcend sex and gender. Lloyd argues,

> The confident affirmation that Reason "knows no sex" may likewise be taking for reality something which, if valid at all, is so only as an ideal....Notwithstanding many philosophers' hopes and aspirations

to the contrary, our ideals of Reason are in fact male; and if there is a Reason genuinely common to all, it is something to be achieved in the future, not celebrated in the present. (107)

If the ideal of a reason "genuinely common to all"—that is, the very core of the mainstream philosophical tradition—does not exist, then there is good reason to question whether reason does, or can ever, transcend the deepest commitments of philosophers.

If reason—and philosophy as its discipline—is not neutral and impartial, what alternative is there? Many feminist philosophers argue that all knowledge is situated; that is, knowledge (no less than reason and philosophy) is constructed in and by the particular situation of knowers. The use of the term *situated knowledge* first came to prominence in the work of Donna Haraway, who argued that "feminist objectivity means quite simply *situated knowledges*" (188). The implications of *situatedness* (not to mention the question of feminist objectivity) are still being worked out in feminist philosophy. However, there is a common understanding that, while not denying the existence of a real world shared by knowers—who would deny that?—the situational factors that particularize knowers-in-the-world are sometimes relevant to our ensuing knowledge—situational factors such as the cultural, physical, and historical. According to Code, one of the characteristic effects of feminist epistemology "is to move the question 'Whose knowledge are we talking about?' to a central analytic position" ("Feminist Epistemology" 138). As an epistemically relevant question, "who knows?" is virtually equivalent to asking about the locational particularities of the knower insofar as these particularities are some of the relevant conditions that make knowledge possible. Thus, rather than arguing that feminist philosophy is just as *rational* as mainstream philosophy, many feminist philosophers argue that mainstream philosophy is just as *situated* as feminist philosophy.

Feminist philosophy is subversive because it argues that a feminist political commitment has a legitimate role to play in philosophy. Despite the various ways in which feminist philosophers choose to express their commitment to feminism, they are engaged in a fundamental critique of philosophy. Although a common criticism made of feminist philosophy

is that it is irrational because it allows political motivations to influence philosophic work, such a criticism derives from a myth that philosophy (and reason) can be impartial. This myth leads to the marginalization of feminist philosophy. It is marginalized when philosophy is construed as the discipline of autonomous reason that demands that all other commitments be subject to its dominance. It is marginalized because it is *feminist*; that is, it is marginalized because it refuses to bracket its feminist commitments, however various they may be.

An Analogy in the Amsterdam School

In feminist philosophy, the attention to the specificity of the knower takes the form of examining and arguing for the epistemic relevance of the gender of the knower. I contend that this attention is analogous to Christian examination of and arguments for the relevance of the religious motivations and orientation (qua ultimate commitments) of the knower. Moreover, since feminist philosophers have also had to reject the rationalist credo of a mind that knows no sex, they have offered devastating critiques of rationalism. And they have done so in the interests of levelling the playing field for all philosophers. These critiques of rationalism are analogous to the critiques of rationalism made by some in the Amsterdam School. For example, Robert Sweetman argues that although our "habitual understanding of the intersection between reason, religion, and social conflict" leads us to believe that the Christian religion is responsible for the modern West's tendency to persecute minorities,

> it does not appear to be the case that Western religious discourse is to be blamed for the modern West's difficulty in managing social pluralities without persecuting. At the very least, such an accounting is too simplistic. While Christian clerics do appear to have been responsible for the "invention" of a rhetoric of persecution, they did so not so much as heirs to a Christian discursive practice but rather as inheritors of the Aristotelian modes of logical opposition which they applied in service of a secularizing process of modernization....Indeed, it might be said

that late medieval use of the rhetoric of persecution in the management of social pluralities worked to cultivate a taste for persecution in subsequent ages. (24, 31)

In other words, it may be our philosophical legacy regarding Aristotelian (i.e., classical) logic that leads to a tendency to marginalize.

However, feminist philosophers have argued that the very identity of reason itself as neutral leads to marginalization, and this argument too has something like a counterpart in the Amsterdam School. Like feminist philosophers, these Christian philosophers also recognize that philosophy has excluded their particular commitments as either irrelevant or as inimical to philosophy as the project of reason. Gadamer, for example, points out that "Enlightenment critique is primarily directed against the religious tradition of Christianity—i.e., the Bible" (272). But this sort of philosophy begins with the refusal to keep "religion within the bounds of reason" (to invert Kant's famous title); *pace* Kant, it refuses to recognize the autonomous rule of reason.[15] This refusal to bracket religious commitments in the practice of philosophy is no mere negative gesture; it is intended to open up a place in philosophy for "knowing *other*-wise."[16] Moreover, this refusal is intended not only to have an effect in philosophy of religion—as important as that might be—but to have an influence in even the core areas of philosophy such as epistemology and ontology.[17] Put positively, to allow religious commitments to imbue philosophy as the commitment to reason has done is, in James Olthuis's words, to suggest that "developing non-oppressive (or, at least, less oppressive) ontologies, epistemologies, and ethics calls for another way of knowing, a way of knowing 'the other,' a knowing other-wise, a knowing of the heart with the eye of love" (1). Such an openness to "the other" is, at the very least, an antidote to the dogmatism of a commitment to reason alone.

What many Christian philosophers conclude is that to accept philosophy's self-understandings as the discipline of pure reason is itself a religious choice. As Hendrik Hart says, "the Enlightenment's adoption of autonomous reason as the road to emancipation was not a choice *against* faith or the authority of revealed religion, but a *religious* choice *for* faith in reason" (*Walking* 44). Put another way, if choosing to remain within the bounds of reason is itself a pre-philosophic choice, why should Christian

philosophers have to bracket their own pre-philosophic, religious commitments? Many Christian philosophers are comfortable with acknowledging the religious roots of their own theories, just as many feminist philosophers are candid about their political commitments.

This argument is not widely accepted in mainstream philosophy. For those committed to reason's autonomous rule, such a commitment forbids them from seeing this as a religious and pre-philosophic, rather than rational, choice. However, such a view of this choice is only possible if one accepts the assumption that reason is opposed to faith; that is, if one accepts the assumption that a philosopher *must* choose between being religious or being rational. Moreover, the Enlightenment conception of philosophy as the domain of absolutized reason that adjudicates knowledge claims is under attack from feminist philosophers (for different reasons) and from other philosophers on the margins. For example, Rorty argues that philosophy since the Enlightenment illegitimately absolutizes reason:

> "Philosophy" became, for the intellectuals, a substitute for religion. It was the area of culture where one touched bottom, where one found the vocabulary and the convictions which permitted one to explain and justify one's activity *as* an intellectual, and thus to discover the significance of one's life. (4)

Religion, in the sense Rorty is using it here, means the practices of institutional religion. However, when philosophy becomes a *substitute for* religion, it is analogous to religion in the sense that, like institutional religion, it provides convictions and a "final vocabulary" to explain and justify the *ultimate* meaning of life and reality.[18]

Negotiating an Identity
Toward a Level Playing Field

Taken together, the two arguments of certain feminists and of certain Christians is that philosophy is not neutral and impartial. From a feminist perspective, philosophy is not neutral and impartial because it is gendered masculine.[19] From a Christian perspective, philosophy is not neutral and

impartial because it is religiously committed to the autonomy of reason. The point is that *no* philosophy is universal and impartial in that sense. The feminist philosophers and Christian philosophers I have cited argue that *every* philosophy, including that of the mainstream, is influenced by pre-philosophic commitments.

This argument, that all philosophy is imbued by commitments, is an important point of convergence between feminist philosophy and Christian philosophy. However, if the feminist and Christian arguments are right, it is a similarity that is shared by all philosophies, and, hence, it is not unique to feminist and Christian philosophy. What is unique is the acceptance of this argument, for we have seen that it is not accepted by mainstream philosophy. It is the recognition of an argument for the legitimacy of this particularity that marginalizes both feminist philosophy and Christian philosophy.

I have argued that mainstream philosophy is hegemonic. In light of the feminist and Christian arguments, we can see that it can only maintain its hegemony as long as it can make the following two assertions: first, that our pre-philosophic commitments must not influence philosophy, and, second, that this first assertion is not itself a commitment. If mainstream philosophy can maintain that philosophy cannot be influenced by any pre-philosophic matter, then it can also rule the influence of sex/gender and faith (among other things, such as race, class, sexual orientation, etc.) inadmissible. At the same time, mainstream philosophy must insist, on pain of circularity, that this view, that philosophy must not be affected by pre-philosophic commitments, does not itself depend on a pre-philosophic commitment. Feminist and Christian philosophers argue against both claims. They maintain that all philosophy is influenced by the pre-philosophic, and that mainstream philosophy is itself influenced by pre-theoretic matters—that is, it is gendered masculine and it requires a commitment to autonomous reason.

The fact that both feminist and Christian philosophies are marginalized by these two assertions is the reason for their similarity. When faced with the hegemony of mainstream philosophy, any theorist will have to challenge that which keeps her marginalized; that is, in this case, she will have to challenge the assumption that philosophy can be unprejudiced by pre-philosophic matters. Feminist philosophers and Christian

philosophers seek to make room for themselves in philosophy by challenging that which excludes them.

Many feminist philosophers recognize that being marginalized means that we can see assumptions that are difficult to see from the centre; this recognition is a corollary of the recognition that all philosophers have a perspective. For example, Evelyn Fox Keller's remarks concerning science and gender also apply to philosophy and gender. She argues that unself-consciously internalized assumptions, such as gender-neutrality or the autonomy of reason, are difficult to see when one is part of a community: "such parochialities, like any other communal practice, can be perceived only through the lens of difference, by stepping outside the community. As a woman and a scientist, the status of outsider came to me gratis. Feminism enabled me to exploit that status as privilege" (Keller 12). In itself, the exclusion of women from philosophy—or science—is a bad thing, but feminism can help women turn their exclusion to their advantage, and hence to the advantage of philosophy. Likewise, Sandra Harding argues throughout *Whose Science? Whose Knowledge?* that feminist standpoints can generate philosophic insights that are not visible from the mainstream, and Patricia Hill Collins argues that the centre can learn from marginal scholars who are "outsiders within" their disciplines (15). The recognition that being on the margins of the dominant community allows one to see assumptions that members of the community do not see does not depend on embracing a feminist standpoint and theory with all its problems. Nor does it depend on an essentialism with regard to standpoints: being marginalized is a socio-political contingency and not an essence. Rather, it deals with the implications of the socio-political and theoretical practices of hegemony and consequent marginalization. Because feminist and Christian philosophers do not share the *exclusive* commitment to reason that purportedly grounds philosophy, they can see that it is exactly that: one possible commitment amongst many. The point is not that *no* feminist philosopher or Christian philosopher accepts a mainstream conception of reason; rather, my point is that feminist and Christian commitments can render such an acceptance contestable.

It may be surprising to find similarities between feminist philosophy and Christian philosophy given their different motivations for challenging mainstream philosophy. However, considering that they are both

marginalized by mainstream philosophy, one on the basis of sex/gender and the other on the basis of religion, it is not so improbable that we should find a number of commonalities between the criticisms they make or the alternatives to mainstream philosophy that they offer. Indeed, we need to do more philosophic work exploring the convergences between feminist and Christian philosophy.[20] We also need to engage in the theoretical analysis of the pre-philosophic commitments at play in philosophy as a way to make room for *both* feminist *and* Christian philosophy in mainstream philosophy—to paraphrase a feminist tenet, we need to look at the identity of the philosopher who is doing the theorizing.

Feminist and Christian philosophers might have common philosophic interests in challenging the philosophic status quo. There are compatible lessons to be learnt from feminist and Christian philosophies. If any philosophy is partial and contingent, we should not be surprised that other philosophers may have analogous insights. For example, Code says, "the main assumption to be countered is that there can be a single, monolithic philosophy that yields access to the Truth, and that all rival discourses should be dismissed or suppressed as diversions from the true path" (*What Can She Know?* 305-06). Similarly, Olthuis argues that, although we may be committed to our interpretation as true,

> it remains, nevertheless, an interpretation....To say anything else is not only to pretend to bracket our subjectivity, but also to risk considering ourselves to be the blessed possessors of the Truth with all the attendant dangers of oppression, or complicity in oppression, to which history so eloquently, and tragically, bears testimony. (5)

The contingency and multiplicity of any philosophy can be clearly seen from the perspective of feminist and Christian philosophers *because* of their marginalization.

Seeing all knowledge—and, by extension, reason and philosophy—as situated opens up the possibility that the playing field can be made more level. It may be true that feminist philosophy, with its particular political commitments, is not universal or impartial or neutral, but now the same is true for mainstream philosophy. It is no longer an asymmetrical conversation when feminist philosophy comes with particular commitments that

limit its applicability while mainstream philosophy, as the discipline of reason, can claim universal extension since it represents the point of view of "any human." Instead, a conversation can begin in which, although the conversation partners may not be the same, they are equal with respect to situatedness—namely, they each have a situation that particularizes their philosophy.

I think some Christian philosophers have something like this in mind as an ideal: that is, that religious philosophy is no more (or less) rational or prejudiced or partial than feminist philosophy or mainstream philosophy. There is no neutral vantage point from which to conduct these conversations; as Code argues, "the detached, disinterested knowing subject, who is a neutral spectator of the world, has to be displaced. Subjectivity is itself produced, constructed in social-political-racial-class-ethnic-cultural-religious circumstances" (*What Can She Know?* 140). Of particular interest to my analysis is that in Code's list of examples of situational factors is the religious. Thus, some feminist philosophers are ready to acknowledge religion as one of the potential situational factors that can legitimately influence knowledge and philosophy, and they do so because they understand knowledge as situated. An acceptance of the situatedness of knowledge, philosophy, and reason does not mean that there will no longer be disagreement. In fact, more lively discussions are likely since each conversation partner can now speak freely of his or her own situation, since these situations will now be on the table. What will be different, though, is that no conversation partner can lay claim to exclusively occupying *the* rational position, or claim that he does not occupy a position at all but is simply being rational or reasonable. A level playing field means that all the players are on the field, and they all play some position; they are all situated. And if we acknowledge philosophy as an activity that is situated with respect to, among other things, various commitments, does such an acknowledgement not go a long way toward accomplishing the level playing field that a Christian philosopher like Hart was after in his argument that all philosophy is religious in the sense of being formed by the ultimate commitments of the philosopher?

This is a very different approach from one that takes its own viewpoint as the viewpoint of reasonableness—from which, naturally, the views of others look irrational. Of course, everyone thinks that his or her particular

view, belief, theory, knowledge is the best or the right one; and, as philosophers, we try to persuade others that this is so. But a feminist proposal for situated knowledge can encourage epistemic humility by showing that, a priori, no one has a privileged perspective. And a level playing field can surely benefit Christian philosophy.

For those trying to integrate the identities of philosopher, feminist, and Christian, the marginalization experienced as both a feminist and as a Christian can be turned from harm into good. We can take the best insights from each as we negotiate our identities. These identities are multiple and possibly conflicting; hence, the negotiation is not easy nor is the outcome pre-determined. However, for the feminist Christian philosopher, the analysis of common motivations and strategies between feminist philosophy and Christian philosophy can be the starting point for integration.

Notes

1 For example, the metaphysician Peter van Inwagen matter-of-factly states, "In Christian Europe...there was an intimate relation between philosophy and the Christian religion, a relation that persisted in one form or another form soon after the beginnings of Christianity till the eighteenth century" (90). What is significant here is that this is an offhand remark made by an acknowledged expert in the discipline in a text that I (and many others) routinely use for undergraduate courses in metaphysics; philosophy and Christianity have only recently parted company.

2 The adjective *Reformational* here—which is the way the Amsterdam School prefers to identify itself—refers to a tradition of Christianity that has its roots in the Protestant Reformation.

3 For example, I shall rely in particular on the philosophic discussions about reason and religion that are collected in the volume *Walking the Tightrope of Faith,* since this collection is structured around conversations between a Marxist atheist (Kai Nielsen) and a reformational Christian (Hendrik Hart). Nielsen argues that religious faith is irrational, whereas Hart argues that relying on reason alone is a religious act; and C.G. Prado, in one of the pieces in this volume that is more or less dissatisfied with and disavows both Nielsen's and Hart's positions, says that "Hart is right that Nielsen relies on an ambiguous conception of rationality, but [simultaneously,] Hart's conception of the religious is vacuous" (128). I give these one-sentence summaries of

positions—knowing that they are superficial and only partly accurate—in order to begin to shift the conversation. One of the reasons I want to shift the focus is because I think Prado is right that a different perspective (or new resources) will open up philosophy of religion conversations like that of Hart and Nielsen et al.

4 For example, Nielsen says that Christian philosophers' "religious *beliefs* (including some of the most central ones), in the circumstances in which they are held (including the intellectual circumstances), are irrational beliefs for them to have" (Hart, Kuipers, and Nielsen 171).

5 For example, Hart uses this metaphor throughout *Walking the Tightrope of Faith*.

6 See Susan Sherwin in Code, Mullett, and Overall's *Feminist Perspectives*.

7 The feminist philosopher Donna Haraway, speaking of the belief that one can have a neutral vantage point, calls this the "god-trick," because it presupposes that one has the same vantage point as God (189). Interestingly, one of the founding members of the Amsterdam School, Herman Dooyeweerd, argued in 1935 something quite similar: that there is no neutral "Archimedean point" for theorizing (20).

8 The editors of *After Philosophy*, for example, claim that "Kant's thought provides a convenient reference point for identifying some of the general themes in the 'whither philosophy?' discussions today, for they are often presented as critiques of or variations upon Kantian themes" (Baynes, Bohman, and McCarthy 3).

9 See, for example, the various definitions offered by the *Encyclopedia of Philosophy*.

10 See, for example, Lloyd's analysis of a conception of reason that is sex/gender-neutral and Rorty's remark (already cited) that philosophy thinks it can legitimate or invalidate claims made by religion.

11 In "Points of Convergence Between Dooyeweerdian and Feminist Views of the Philosophic Self," I show that both feminist and Christian philosophers argue that only entire human beings do philosophy; moreover, I show that this argument has philosophic significance.

12 For example, Genevieve Lloyd, *The Man of Reason*.

13 See, for example, Hart's arguments in *Walking the Tightrope of Faith*.

14 Jean Grimshaw writes that "it is supposed [that] no one holds views like that about women any more (least of all intelligent, liberal-minded philosophers), so they are not really worth discussing. But this view is only tenable if you make two assumptions. This first is that the sorts of attitudes to women held by philosophers in the past *are* dead or disappearing, and there might be good reason to question that. The second is that such attitudes are a mere question of 'prejudice,' supposedly belonging to a past age, so that we can, in effect, simply delete all the passages where philosophers have said embarrassing things about women, ignore them as unfortunate relics of the past and go about our philosophical business as usual. But this supposes it is always possible

to *isolate* what a philosopher says (or implies) about women from the rest of their philosophy, to cut it away and leave the rest intact. And it is this in particular that needs to be questioned" (2-3). Susan Sherwin writes that "most contemporary philosophers are more careful in their discussions of gender than the historical figures were; they tend to be liberal on such matters, and generally excuse their predecessors as being naively misguided by the culture of their times when it came to the question of women. It is commonly accepted that we can simply excise the offensive empirical claims from their philosophy and maintain the pure intellectual core" (17-18).

15 I am alluding here to Nicholas Wolterstorff's book dealing with these issues, *Reason within the Bounds of Religion*.

16 I am alluding here to the title of the collection of essays *Knowing Other-wise: Philosophy at the Threshold of Spirituality*.

17 Characteristically, philosophers in the Amsterdam tradition have broader notions of truth and knowledge. For example, see *Artistic Truth*, in which Lambert Zuidervaart argues that a careful examination of contemporary art can show how both knowledge and truth have allusive, non-propositional elements; see also *Critical Faith*, in which Ronald A. Kuipers argues that understanding religious life requires one to understand knowledge and truth as more than propositional.

18 For examples of analyses of Rorty's work from the Amsterdam School, see D. Vaden House's *Without God or His Doubles: Realism, Relativism and Rorty*, and Carroll Guen Hart's dissertation, *Grounding Without Foundations: A Conversation Between Richard Rorty and John Dewey to Ascertain their Kinship*.

19 The classic work on the gender of reason is Lloyd's *The Man of Reason*. For a recent discussion of the gender of reason see the collection of essays in *Feminism and the History of Philosophy*.

20 For examples of work in this direction, see *Hypatia*'s special issue on "Feminist Philosophy of Religion," as well as Joy and Neumaier-Dargyay's *Gender, Genre, and Religion*, and my essays in *Knowing Other-wise* and in *Philosophy as Responsibility*.

Works Cited

Alcoff, Linda, and Elizabeth Potter, eds. *Feminist Epistemologies*. New York: Routledge, 1993.

Baynes, Kenneth, James Bohman, and Thomas McCarthy, eds. *After Philosophy: End or Transformation?* Cambridge, MA: MIT P, 1987.

Code, Lorraine. "Feminist Epistemology." *A Companion to Epistemology*. Ed. Jonathan Dancy and Ernest Sosa. Blackwell Companions to Philosophy. Oxford: Blackwell, 1992. 138–42.

———. "Taking Subjectivity into Account." *Feminist Epistemologies*. Ed. Linda Alcoff and Elizabeth Potter. New York: Routledge, 1993. 15–48.

———. *What Can She Know?: Feminist Theory and the Construction of Knowledge*. Ithaca, NY: Cornell UP, 1991.

———, Sheila Mullett, and Christine Overall, eds. *Feminist Perspectives: Philosophical Essays on Method and Morals*. Toronto: U of Toronto P, 1988.

Collins, Patricia Hill. "Learning from the Outsider Within: The Sociological Significance of Black Feminist Thought." *Social Problems* 33.6 (October–December 1986): 14–32.

Dooyeweerd, Herman. *A New Critique of Theoretical Thought*. 4 vols. Philadelphia: Presbyterian and Reformed Publishing, 1958.

"Feminist Philosophy of Religion" [special issue]. *Hypatia: A Journal of Feminist Philosophy* 9.4 (Fall, 1994).

Gadamer, Hans-Georg. *Truth and Method*. Trans. Joe Weinsheimer and Donald G. Marshall. 2nd ed. New York: Crossroads, 1990.

Grimshaw, Jean. *Philosophy and Feminist Thinking*. Minneapolis: U of Minnesota P, 1986.

Haraway, Donna. *Simians, Cyborgs, and Women: The Reinvention of Nature*. New York: Routledge, 1991.

Harding, Sandra. *Whose Science? Whose Knowledge?* Ithaca, NY: Cornell UP, 1991.

Hart, Carroll Guen. *Grounding Without Foundations: A Conversation Between Richard Rorty and John Dewey to Ascertain their Kinship*. Toronto: Patmos P, 1993.

Hart, Hendrik, Ronald A. Kuipers, and Kai Nielsen. *Walking the Tightrope of Faith: Philosophical Conversations About Reason and Religion*. Amsterdam: Rodopi, 1999.

———. "Conceptual Understandings and Knowing *Other*-wise: Reflections on Rationality and Spirituality in Philosophy." *Knowing* Other-*wise: Philosophy at the Threshold of Spirituality*. Ed. James H. Olthuis. New York: Fordham UP, 1997. 19–53.

House, D. Vaden. *Without God or His Doubles: Realism, Relativism and Rorty*. Leiden, Neth.: E.J. Brill, 1994.

Joy, Morny, and Eva K. Neumaier-Dargyay, eds. *Gender, Genre, and Religion: Feminist Reflections*. Waterloo, ON: Wilfrid Laurier UP, 1995.

Kant, Immanuel. *Critique of Pure Reason*. Trans. Norma Kemp Smith. London: Macmillan Education, 1929.

Keller, Evelyn Fox. *Reflections on Gender and Science*. New Haven, CT: Yale UP, 1985.

Kuipers, Ronald A. *Critical Faith: Toward a Renewed Understanding of Religious Life and its Public Accountability*. Amsterdam: Rodopi, 2002.

Lloyd, Genevieve. *The Man of Reason: "Male" and "Female" in Western Philosophy*. Minneapolis: U of Minnesota P, 1984.

Olthuis, James H. "Love/Knowledge: Sojourning with Others, Meeting with Differences." *Knowing Other-wise: Philosophy at the Threshold of Spirituality.* Ed. James H. Olthuis. New York: Fordham UP, 1997. 1–15.

Passmore, John. "Philosophy." *Encyclopedia of Philosophy.* Ed. Paul Edwards. 8 vols. New York: Macmillan, 1967. 6: 216–26.

Rorty, Richard. *Philosophy and the Mirror of Nature.* Princeton: Princeton UP, 1979.

Sherwin, Susan. "Philosophical Methodology and Feminist Methodology: Are They Compatible?" *Feminist Perspectives.* Ed. Lorraine Code, Sheila Mullett, and Christine Overall. Toronto: U of Toronto P, 1988. 13–28.

Sweetman, Robert. "Plotting the Margins: A Historical Episode in the Management of Social Plurality." *Towards an Ethics of Community: Negotiations of Difference in a Pluralist Society.* Ed. James H. Olthuis. Comparative Ethics 5. Waterloo, ON: Wilfrid Laurier UP, for the Canadian Corporation for Studies in Religion / Corporation canadienne des sciences religieuses, 2000. 13–36.

Van Inwagen, Peter. *Metaphysics: An Introduction.* Boulder, CO: Westview, 2001.

Wesselius, Janet Catherina. "A Responsible Philosophy: Feminist Resonances in Hendrik Hart's Reading of Objectivity." *Philosophy as Responsibility: A Celebration of Hendrik Hart's Contribution to the Discipline.* Ed. Ronald A. Kuipers and Janet C. Wesselius. Lanham, MD: UP of America, 2002. 225–39.

———. "Points of Convergence Between Dooyeweerdian and Feminist Views of the Philosophic Self." *Knowing Other-wise: Philosophy at the Threshold of Spirituality.* Ed. James H. Olthuis. New York: Fordham UP, 1997. 54–68.

Wolterstorff, Nicholas. *Reason Within the Bounds of Religion.* Grand Rapids, MI: Eerdmans, 1976.

Zuidervaart, Lambert. *Artistic Truth: Aesthetics, Discourse, and Imaginative Disclosure.* Cambridge: Cambridge UP, 2004.

Celluloid Temple

Viewing the Televised *Ramayan*
as a Hindu Ritual Act

ROBERT MENZIES

On 25 January 1987, a new and experimental program premiered on Doordarshan, India's government-run television network. While there is a long history of religious films in India, this was the first time that either of India's epics was serialized for television. The first recorded telling of the *Ramayana*, the shorter of the two epics, is in Sanskrit and is attributed to the poet Valmiki.[1] It has been retold numerous times in the two millennia since Valmiki. Nearly every language in India has a version, and it is also common in Southeast Asia. The *Ramcaritmanas* ("The Holy Lake of Rama's Acts"), the sixteenth-century Hindi retelling by the poet Tulsidas, is one of the best-known and most frequently reprinted texts of modern north India. The adaptation of the *Ramayan*[2] shown on Doordarshan was produced and directed by Ramanand Sagar. The initial plan of Sagar and Doordarshan was to broadcast fifty-two episodes of forty-five minutes each, one each Sunday morning at 9:30 a.m., a time slot with few viewers and less revenue. Expectations seemed low, but demand became so great that the serial was extended, ultimately running for seventy-eight episodes; it was then finalized to include the "Epilogue" (*Uttarakanda*) of the Sanskrit epic (Jain 81).[3]

The final episode of the main story aired on 31 July 1988, and by then it had become the most popular program ever shown on Indian television. Because of the rural nature of India, it is impossible to know precisely how large the serial's audience was: *India Today* suggests sixty million, and *Illustrated Weekly of India* suggests eighty million.[4] Yet, despite its popularity as a cultural phenomenon, Sagar's *Ramayan* is also at its heart a Hindu religious film. As was done at the "mythologicals" shown in theatres, people prostrated themselves before the screen when the divine characters

came into the frame, garlanded their television sets, and performed rituals in front of them.

To understand what is happening here we must examine a number of interconnected elements. While "Hinduism" does include philosophical and meditative systems that focus on liberation from the world, most Hindus practice *bhakti* ("devotion") concentrated on worship of images of particular anthropomorphic deities. Television and films of religious stories are not only narratives of the deities, they are specific visual representations of these deities that evoke image worship. In these Hindu mythologicals there are particular scenes that can only be comprehended through an understanding of the dynamics of Hindu worship (*puja*). *Puja* is such an all-pervasive notion in the Indian consciousness that many mainstream, commercial "Bollywood" films reference it. The "superhit" *Ham Aapke Hai Kaun* ("Who am I to You," 1994) revolves around two weddings and has several characters performing *puja*. In Deepa Mehta's film *Fire* (1996), the two main female characters make reference to "Karva Cauth," a "women's vow" (*vrat*) ritual common in north India. For Hindus, the mention of *vrat* performance tells as much about these characters as does Fredo Corleone in *The Godfather II* making reference to catching fish by reciting a "Hail Mary."

What follows is an examination of "technologized worship" via a focus on the overtly religious television serial. That is, I will explore some of the dynamics involved in watching the television as a ritual. What is taken by most people in the world as a vehicle for entertainment is taken in certain contexts by certain Hindus as a religious activity.[5] I will first begin with a description of *puja* and several of its crucial elements. Then I will briefly discuss the reliance that mythological film and television serials have on the aesthetic of folk drama, particularly the *Ramayana* traditions. Finally, I will present the findings from informal interviews I conducted with Hindus in North America who have watched the *Ramayan*. This assessment draws on the most preliminary stages of my research into rituals in the Hindu diaspora, and it is neither "representative" of the vast numbers of Hindus in North America nor an exhaustive ethnography.

Before this examination, however, we must consider the notions of margins, peripheries, and centres.[6] In many religious traditions, actions that are at one point considered peripheral become the new standards. In Hinduism, devotionalism (*bhakti*) was a populist movement in which

theology and practices were modified and eventually became the new norm. Founders of the various *bhakti* subtraditions were iconoclastic, but many of these notions are now considered mainstream. The rejection of caste and gender distinctions, for example, by such figures as Bassava, Mahadeviyakka, Mirabai, Kabir, Ravidas, and many others, had a profound impact on the face of Hinduism as we know it today. But however highly valued their critique, it reinforces the fact that caste and gender oppression still exists. That is to say, ideas once considered marginal or peripheral have become central as the tradition created a new synthesis that incorporated these critiques.

With respect to Hindu ritual practices, the same situation pertains. The ritual system of ancient India, sometimes called "Brahminism," is very different from the ritual one would currently find in a Hindu temple or home, either in South Asia or in North America. As the paradigmatic rituals came to be critiqued by "peripheral" traditions such as Buddhism and Jainism, the paradigm shifted and new standards of ritual activity developed. Meditative traditions that were once the domain of ascetics, which in the Hindu thought-world are, by their very nature, marginal to society, have become so mainstream that meditation is often practiced by householders. And these are but a few examples.

Thus, I would contend that Hindus' modifications of their ritual practices to accommodate technological innovations and living in diaspora are at once peripheral and central, marginal and mainstream. Further, I would contend that the modifications I will discuss below are merely the Hindu response to these new situations. All religious traditions, I contend, find ways to engage marginal and/or peripheral movements and activities, and most traditions find ways to mainstream them.

Puja and its Elements

Puja is the act of making an offering to a deity as a ritual act of devotion. Temple *puja* consists of sixteen elements, although there is an alternative *puja* that has only five required elements. Domestic *puja* is much more flexible. The acts of worship most often seen in the domestic setting are *snan* ("bath"), *upavas* ("fast"), *darshan* ("visual communion"), *pushpanjali* ("offering

of flowers"), *arti* ("offering of light"), and *prasad* ("sanctified food"). I will deal with each very briefly.

Bathing (*snan*) is considered a normal part of a Hindu's regular daily activities. Only after one has bathed and dressed in clean clothes should religious activity be considered. *Upavas* ("fast") is most accurately translated as "food restriction." The specific requirements may include complete abstinence, even from water; it may simply prohibit particular foods or foods cooked in certain ways, or it may require the consumption of particular dishes. *Darshan* comes from the Sanskrit verb "to see." This is not merely the one-way act of seeing the image of the deity; images of Hindu deities have eyes, and so there is a powerful mutuality of vision between the devotee and the deity that can be called visual communion.

It is the norm in a Hindu *puja* to offer flowers (*pushpanjali*) to a deity's image, or to a priest or other person of special sanctity, including foreign dignitaries. Whole flowers or flower petals will be offered by "tossing" them onto or in front of the image. It is equally common to offer a garland of flowers (*pushpamala*), similar to a Hawaiian *lei*. *Arti* is the offering of light to the deity. It can be the waving of an oil lamp in front of the image or it can be the burning of a block of camphor; in either case the flame is offered to the deity. *Arti*, *darshan*, and *pushpanjali* can be performed by the individual either in the home or at the temple, but the devotee must be there to experience them: they cannot be performed on behalf of other devotees not present at the *puja*.

Possibly the most all-encompassing element of *puja*, and one that can be taken away and shared, is *prasad*. This is anything that is offered to, partaken of by the deity, and then distributed back to the devotees. In a temple, the camphor flame of *arti* will be carried through the congregation, and devotees will "share" it by wafting the flame over their heads. Here *arti* functions as *prasad*. The most common *prasad*, however, is food, and a devotee commonly carries some home to share with his or her family. Sharing *prasad* is an obligation of the participating devotee, and it is impossible to refuse it once offered. Devotees who are fasting will break their fast with *prasad*.

Central to all of this is the physical image (*murti*) of the deity. Certain natural objects, such as stones and plants, are venerated, but more common are constructed images. They may be of wood, brass, carved marble,

or of earth. Some are installed in temples and are worshiped for centuries. Others are created, consecrated, worshiped during a particular festival, and then disposed of by immersion in a river. Pictures have recently come into vogue, particularly in North America where the communities are smaller and less affluent. Regardless of the material of which it is made, a *murti* is understood to *be* the deity in this time and place.

Mythologicals and the Sagar Ramayan

Commercial films are a mainstay of South Asian culture, both in South Asia and in the diaspora. Any store catering to South Asians will carry row upon row of VHS and DVD copies of films and TV serials. Hindu religion has been associated with Indian films from the beginning. The first Indian films were religious films, pioneered by Dadasaheb Phalke who, inspired by a film on the life of Jesus, produced a series of filmed versions of Sanskrit Hindu myths, including the *Ramayana*. This genre, dubbed "mythologicals" by Indian film-goers, draws on the aesthetics of Sanskrit drama, narrative, and folk-performances, as well as the specific *Ramayana* performance traditions (Lutgendorf, "Ram's Story," as well as his *Life of a Text*, and "All in the (Raghu) Family").

Mythologicals comprise only about 5 per cent of the number of films currently produced. While Anglicized Indians often consider these films unworthy of attention because of the "cheesy" special effects, sluggish pace, poor acting, and tacky sets, mythologicals are viewed by the film-going populace as positive and "safe" "family entertainment," and they continue to be made and watched. This occurs in part because, even though mythologicals contain the formulaic elements that the public has come to expect (stock characters, fights, and song and dance routines), they do not contain the same types of dances that the commercial films include (which may include a woman dancing in a *sari* in the rain), which are considered quite risqué by conservative Hindus; in addition, the male and female leads in mythologicals are always virtuous and devout. Songs are rarely love songs, and neither the songs nor the dances are vulgar; rather, they are versions of Hindi hymns (*bhajan*). Frequently, the "song and dance" scenes are a part of the *puja* performed by the main characters. So while these typical elements

of a Hindi film are included, they are reframed within the context of devotion, worship, and family-friendly entertainment.

So what is the aesthetic in these "sluggish and hackneyed" mythologicals that makes them so popular? To answer that, we must reframe the question. Indian cinema does not follow the same form or use the same aesthetics as English-language films; rather, Hindi cinema bases its aesthetic on indigenous performance genres. First of all, there is a tradition, in both the "folk" and Sanskrit genres, of frame stories, and this is reflected in Hindi cinema. The epics situate their narratives in a series of tales-within-tales; the opening credits of an Indian film are "frames" that indicate the beginning of the narrative.[7] Mythologicals are thus a creation of cinematic "ritual time" that is clearly separated from the mundane or profane time of the normal world, and thus such films recapitulate the stylistic conventions of epic performances (Booth 173; Lutgendorf, "Ram's Story" 272–88).

Second, Indian folk plays present lengthy, familiar stories with long digressions. Players are usually quite clearly characterized as good or evil, and they are usually given interludes of song and dance. Hindi film is simply a filmed version of these elements. Perhaps most importantly, however, is the sense of the story's predictability. The most popular Indian films are those in which the stories are the most familiar. The point is not to produce some new and unexpected "surprise ending" but to show how the director tells the story and provides the familiar ending. It is about the *bhav* ("essence," "emotion," "vibe") of the telling.

Finally, it is the visual representation of deities that transforms the TV or theatre screen into a *murti*. Accordingly, we have to turn to a second set of aesthetics: *Ramayana* performance traditions. There are two key issues that are germane for us: the *jhanki* ("tableau") found in Ramlila, and the participatory nature of the performance and the text.

Svarup and Jhanki

A *murti* can be of stone, wood, clay, or metal, but it can also be an otherwise ordinary human being. The term for a human "becoming" a *murti* is *svarup* ("shape," "form," "appearance"). In a Hindu "passion play" (*lila*), it is understood that the actors are not merely in costume acting the roles of the

deities: they *are* the deities. This is implied in the word for the performance itself. *Lila* literally means "play" in the sense of "sport" and in the sense of "playfulness." Deities do not need to act in order to be complete, so their actions cannot be understood in human terms. Thus, all gods' acts are *lila*, "playfulness," and the passion plays are at once a commemoration of the acts of the deity and an offering of worship to the deity—worship in which actors become *svarups* for the duration of the performance period (Kapur 12). Ramlilas are sponsored by various groups, and the quality of a particular performance varies depending on the economic status of the sponsors. For example, the Ramlila of Ramnagar, a suburb of the Hindu holy city Banaras, is sponsored by the Raja of Ramnagar. It is one of the longest Ramlilas, running for thirty days in the autumn. At this time the devotees are concerned with *darshan* of the *svarups* because they are, in effect, living *murtis* (Sax 131–32). William Sax interviewed more than 450 Ramlila attendees and found that they ran the gamut of caste, education, and devotional divisions. All, however, took Ram seriously and saw the *svarup* as god incarnate (Sax 147 ff.). Seeing these *svarups* gives one *phala* ("fruit"), and this is understood to be the same fruit that one gets when attending a temple. Even the Maharaja of Ramnagar personally washes the feet of the *svarups* and does *arti* to them (Schechner and Hess 77 ff.).

A *jhanki* is a moment in the performance when the *svarups* simply stop and stand as living "statues." In Ramlilas, *jhankis* occur when the focus of the audience is on the singers or on others "narrating" the action. The actors have no lines at that moment but do not disappear offstage. Rather, by standing stock-still they provide the audience with an opportunity to take *darshan* of the *svarup* (Hein 17–30). *Jhankis* are important in religious performances, but also in the secular Parsi theatre of the late nineteenth and early twentieth centuries; a form of *jhanki* also appears in a tribal dance genre (Binford; Chatterji; Dwyer and Patel 43–47; Kapur 409 ff.). The *jhanki-svarup* association can spill over into daily life. Richard Shechner notes the gradual association of a Ramlila actor with his mythological character. Because he had been the *svarup* for so long, he was seen as a permanent *svarup* (Schechner 94–96). This association also has political overtones. Several film stars from south India, including N.T. Rama Rao, M.G. Ramachandran, and Jayalilitha Jayaram, have parlayed their recurring roles as deities into political careers (on Rama Rao and Ramachandran, see

Das Gupta, "Painted Face" 127-47; Das Gupta, "Seeing and Believing" 15-16; Hargrave; on Jayaram, see Jacob 140-65).

Seeing is Doing
The Participatory Nature of the Ramayan

One of the reasons that Ramlila is so powerful, and one of the reasons that the *jhanki-svarups* are such strong emotional triggers, is the participatory nature of the *Ramayana* traditions. This participation takes a number of forms; I will focus only on two: *katha vacana* ("expounding") and the participatory nature of Ramlila performances. Philip Lutgendorf discusses the *katha vacana* tradition, in which a professional "story-teller" (*katha vacak*) performs, recites, and expounds a particular religious text. Here the original story is treated less like a bounded text and more like an outline for imaginative elaboration. The truth of the telling lies in the balance of emotional truth and adherence to the factual details; what matters is the *bhav*. Most important for the tradition, and particularly germane for our purposes, is the inherent understanding of *katha* ("story") as a verb: it is a *telling*. *Katha* is more active than the nominative sense we usually associate with "story" and is inherently participatory for both teller and hearer (Lutgendorf, "Ram's Story" esp. 36-39). In the folk genre of *vrat katha*, also, the reading is actional because, for religious texts, "to read" means "to recite," not to read silently (Menzies). The expounding is an action, and the reception is understood as the active verb "to listen" rather than the more passive "to hear." Thus to be present at a *katha vacana* session is to participate in the story by listening.

Even more participatory is the Ramlila. In Ramnagar, for example, a large tract of land is set aside specifically for the Ramlila. It is very well attended: a slow evening will draw five thousand people, and an average night twenty thousand, and on the most spectacular nights the crowd can approach one hundred thousand (Hess, "The Poet" 237). Using a grand and varied outdoor environment that includes town, field, village, buildings, lakes, and groves, the performance sets up a microcosm of the sacred *Ramayan* geography in a delimited area. *Svarups* and audience move together from scene to scene, often walking several miles in an

evening (Hess, "Rāma Līlā" 173–79; Hess, "The Poet" 237; Kapur 23–25, 253–55; Shechner 238–88; Schechner and Hess 55 ff.). As with the *katha vacana* sessions, audience members do not merely "see" or "hear"; they understand themselves as participants *in* the *lila*, and therefore are participants *in* god (Sax 150). They chant, carry the *Ramcaritmanas*, sing hymns, worship, take *prasad*, and so on. They walk barefoot, as pilgrims, and view the very earth beneath their feet as sacralized, just like the floor of a temple. The actors who play Ram and the other characters are *svarups*, and therefore *are* the deities. There is thus an intensity and degree of participation in the myth that simply observing a passion play on a stage could never reproduce.

This performative aspect of both *katha vacana* and Ramlila carries over into television viewing. Just as *darshan* is not understood as passively receiving the divine vision, *Ramayan* viewing during its initial broadcast was not simply "seeing," it was doing—an event in which one participated. People gathered in groups, fit the program in between beginning and ending ritual activities, and distributed *prasad* (Lutgendorf, "All in the (Raghu) Family" 243).

To return to the core text of our analysis, the question is this: if Sagar's *Ramayan* became the most popular television program in Indian history, why? It was resoundingly panned by the English-speaking Indian media as a sluggish, amateurish melodrama, commercializing a venerable tradition. It is slow-moving. The presentation of the characters is stylized: Ram and his brother Lakshman are clean shaven, despite their forest exile; Hanuman and his monkey legions have muscular but hairless human bodies, with long, padded tails and stylized masking, and their wives are fully human women; one character looks more like Big Bird from *Sesame Street* than the powerful king of the birds. Why, then, is the *Ramayan* so popular?

It is simply not enough to give the pat, condescending answer that Indians are naïve enough to tolerate mediocrity. A better answer is that the production values have nothing to do with either the serial's success commercially or its impact socially. Rather, they have to do with the aesthetic of the whole of the *Ramayana* tradition. What critics were missing was the whole tradition of *katha vacana*, Ramlila, frame stories, and *jhankis*. "Seeing the wires" is not a problem as long as the overall *bhav* is maintained.

English critics also missed the sense of consecration inherent in *Ramayana* performance traditions. *Katha vacaks* enter a consecrated

condition before they expound on the story. They bathe and fast before the sessions, and almost always follow a vegetarian diet as a way of maintaining ritual and moral purity. Performers in Ramlila also undergo these purifying activities as they prepare for their role as *svarups* of the deities. One *katha vacak*, Gopal Mishra, always bathes before watching the *Ramayan* (Derne 192n3). There is an implicit understanding that something about this participatory story of Ram requires physical purification before viewing. Finally, and most importantly, Sagar's *Ramayan* is not something to *see*: it is something to *do*. Individual viewers *participate* with Ram and Sita in the forest, and their garlanding of the TV is as participatory as the many miles walked by those who attend Ramlila in Ramnagar.

Ramayan Watching in North America

Since *darshan* of the *svarups* in the *jhanki* is so important in live performances, there is little wonder that "*darshan* moments" occurred in early Indian films (Dwyer and Patel 43–47). Inside the theatre, the devout respectfully took off their shoes and sat with piously folded hands; some even threw offerings at the screen (Das Gupta, "Painted Face" 12; Dharap 79–83). Cinema halls were understood to be temporary temples, and all of the rules of worship applied. Wealthy Indians took stars of the early mythologicals home and worshiped them (Das Gupta, "Painted Face" 13). As Indians became more "Westernized" and "secular," one would have expected prostration to the screen to diminish, but such was not the case. One of the biggest film successes of the 1970s was the mythological *Jai Santoshi Ma* ("Victory to Our Lady of Satisfaction"), and *puja* in theatres during screenings was common.

It should come as no surprise, then, that the *Ramayan* generated the same sort of response. In many homes, watching the *Ramayan* became a religious ritual: the television set was garlanded, decorated with sandalwood paste and vermillion, and people bathed before the broadcast, blew conch shells, and delayed meals so that the family was purified and fasting before the program (Lutgendorf, "All in the (Raghu) Family" 224; Melwani 56–57; Miller 789–90). All around the country, news stories described *pujas* done to television sets, and the burning of incense or prostration before

the screens, which had been so common with mythologicals in the-
atres. When Arun Govil and Dipika Chikhlia (Ram and Sita) made public
appearances as themselves, they were venerated as *svarups* (Derne 192n3;
Lutgendorf, "All in the (Raghu) Family" 241). This is totally in keeping with
Hindu traditions in which the *katha vacak* and his seat are sanctified, reli-
gious performances are bracketed with religious rites, dancers perform
an action "turning the stage into a temple" before their particular per-
formance, and crowns, ornaments, and weapons of the Ramlila actors are
worshiped before the performance. Thus, for a family to extend this kind
of logic to include an electronic device showing a picture of the deity is
not a stretch. And not only Hindus, but people of all faiths delayed their
activities during airtime (Deshpande 2215; Mankekar). The whole thing
was inherently participatory, intensely emotional, and "another retelling"
of the story. It had such an impact that, within days of the ending of the
serial, a national malaise seemed to have developed. Viewers felt a hole in
their lives, as their Sunday mornings were now bereft of god (Lutgendorf,
"All in the (Raghu) Family" 225-26).[8]

Some of these responses to *Ramayan* watching in India has carried over
into the activities of North American Hindus as they watch the *Ramayan*,
but there are key differences. In talking to my informants, I made refer-
ence to sweet vendors setting up televisions on makeshift altars and
distributing sweets as *prasad*; nearly all of my participants had witnessed
something similar. But the universality of *prasad* distribution was not
reflected in the universality of *prasad* donation. Several informants com-
plained either that the sweet vendors inflated their prices or were prom-
ised fair recompense by some local patron, only to be bullied in public into
donating the sweets. In this regard my informants' opinion was unani-
mous: the offending party sinned. In India, making a profit on religious
items is not bad; it is simply business. To gouge or make false promises
of payment is unfair business, but to do so in front of an image of Ram is
"such a sin" (*kitna pap*), as one woman put it.

Currently, when the *Ramayan* is watched on video, actual *puja* activities
show a remarkable diversity. There are *jhanki* moments in the *Ramayan*,
and frequently it is at such moments that people feel most "connected"
to god through the TV. One woman stated, "When we watch it on video, I
always sit with my flowers ready, waiting for this time when I can offer

flowers [by tossing them at the screen (*murti*)] to Ram." Yet she seems to
be in the minority. Most describe *puja* as if the TV itself were a temporary,
if static, *murti*: the set is garlanded, food and incense are placed in front of
the screen, but *arti* is rare. But this also seems to be bifurcated: it is not the
television itself that is sacralized, but it enters a sacralized state *because* of
the image it broadcasts. What seems to be most common is *snan, upavas,*
the offering of food, and its distribution as *prasad*. In other words, there
is a distinct focus on the individual and his or her preparation for wor-
ship, rather than on the more complex, multi-element *puja*. When I asked
people about this, again, the answer was universal: the other components
of *puja* are fine, but *darshan* is the key. These *jhanki* moments are the most
"sluggish" scenes because they show in excruciatingly slow action the
faces of each important character set to repetitive music. What is impor-
tant here is the physical direction of the actor with respect to the camera.
At these times the other characters look at each other and not at the cam-
era; Ram, on the other hand, looks near enough to the camera that it seems
darshan is possible. These scenes drag, but this is intentional. The music in
the background is repetitive and *bhajan*-like, Ram is virtually looking at us
from the screen, and there is a sense of powerful emotion. Why would the
devotee want the scene to move any faster?

Conclusions

In sum, one may criticize *Ramayan* for being slow-moving, but that is a
flawed criticism. The *Ramayan* builds on indigenous rather than Western
aesthetic theories for its audience. And that is the point. The *Ramayan* is not
a television show to be received passively: it is an interactive medium. The
point of these stories and the religious dramas is not to "read" a text, but
to see, hear, feel, and participate in an interactive genre in the mythic or
sacred time of the story. Seeing Ram and Sita enables the devotee to partic-
ipate in a way that no *jhanki* or Ramlila can. The participation generates a
sense of immediacy not found in other genres. It is another telling that has
an impact on the devotees in its own unique ways. Far from the *Ramayan*
de-mystifying or secularizing the deities by giving them form, associat-
ing them with human actors, and historicizing them, video has added to

the mythologies by providing yet one more text, one more telling, and one more visual image of an already existing collection of *svarups*.

Several conclusions can be drawn from this, admittedly brief, examination of *puja* during *Ramayan* screenings. The first is that these Hindus do not see the television itself as a *murti*. Rather, the particular image of the deity triggers the (temporary) *murti* state. While the television sets are "garlanded," it is only in their functioning as carriers of the moving picture that they are "special." The *murti* is the tenuous, flickering, amorphous image, and by garlanding the box from which it is projected, Hindus come as close to garlanding the living image of Ram as they physically can.

The second conclusion we can make is that there is a bifurcation of worlds. On the one hand, these Hindus do not distinguish between the image on the screen and the image in the temple. On the other hand, they recognize the scientific principles behind the image. It is a piece of technology that has the potential to show vulgar images as well as those of a *svarup*. Unlike a temple *murti*, the television slips in and out of the *murti* state depending upon what program is shown. But these Hindus see no contradiction here. At this particular moment and for this particular duration, it is the *murti*. Later, it is simply the TV showing secular channels, and at that time is not worthy of veneration.

The third point we can make is that these Hindus bracket their religious performance. They begin their "transformation" of the TV into a *murti* by taking *snan*, garlanding the set, lighting incense, and setting food in front of it. Afterwards, they actively remove all elements of the *puja* before other programs are watched. Depending on the families, this removal can be more or less ritualized. They perform a general "cleanup" and de-garland the set. If some flowers or food happen to be left behind, most do not see it as a major issue. Thus they follow the general rules of ritual purity, but not with the same precision that might be exercised by Brahmin ritual specialists in a temple.

A fourth conclusion is that they do what they would usually do in other *puja* contexts, including fasting, bathing, offering and sharing food, and so on. This performance requires no more devotion or ritual precision than would occur in a temple or in another domestic *puja*—but no less, either. That is, this activity is *puja* and is conceived as *puja*, with all of the family's normal religio-ritual activities being performed.

A fifth point, and one that I can mention only as an area for further research, is the centrality of women. It is primarily the matriarchs of a nuclear family who control how and when the *Ramayan* is watched, the activities involved in the *puja*, and, in theory at least, the general attitude of the rest of the family toward the serial. This is not particularly surprising. Often Hindu families' religious activities are run by women. While men are ostensibly the "religious" specialists and are, by and large, the ritualists and philosophers, in the domestic sphere it is women who hold sway. Because women control the diet of the family, it is up to them to determine which foods are eaten on which days. They are also responsible for the activities in the home that may have "religious impact."[9] Several of my informants stated in no uncertain terms that the males of the family were supposed to follow certain dietary guidelines, like vegetarianism, but this was strictly enforced by the matriarch on days of religious significance.

The sixth conclusion has to do with the flexibility of Hindu worship. Hindu temples in North America often have a specific schedule of events. The same is not true of Hindu temples in India. Every temple has its own daily ritual routine, but devotees are free to come and observe or to participate in the temple *puja*, or simply to come and take *darshan* in their own way and on their own schedule. The same differentiation can be made between the original broadcast and the recordings. In India, people watched the *Ramayan* at 9:30 a.m. on Sundays when it was broadcast, while North Americans have DVD technology: this is a key difference for several informants. Most of the middle-aged women who watched the *Ramayan* with their families in India twenty years ago remember the ritual activity of the family as it prepared itself for *darshan*. Today, however, their schedules often preclude following a television broadcast schedule. They watch pre-recorded versions but venerate them as they did when they were younger. Ram *is* on the screen, whether delivered by a broadcast or a DVD. Frequently the families with whom I was speaking—or, more precisely, the matriarchs—choose an evening when their schedules permit, and they modify their food intake: they will be particularly careful about their family's diet for the day. They might not bathe again before the evening viewing, but they will take time to "prepare" themselves. And they will garland the television, do *puja*, and eat the *prasad* offered to the TV-*murti*.

There are several things that need to be mentioned explicitly here. The first is the flexibility of performance. These women feel that the *Ramayan* must be watched, so they will make time in their schedule to accommodate it. Second, they fit it in. That is, their work schedule might otherwise preclude watching it, but by owning or borrowing a DVD, they can be sure to do *puja* at a time that is not only convenient but possible. They are watching a pre-recorded image on their own schedule, and, most importantly, they *are* watching it. One woman stated that it is actually better to have a pre-recorded version than to have it broadcast. Devotees can ensure that they are totally focused on the *puja*. They make whatever arrangements are necessary, and then put themselves in the proper frame of mind before they push the play button. For this woman, this enables a deepening of her faith and leads to a more intense experience than would be possible if the episode were to start before she was truly ready. Here the devotee continues her *darshan* tradition in a proactive way, using technology to increase the depth of emotional commitment to the *puja*.

The final conclusion I would like to draw ties together and broadens those previously mentioned. *Bhakti* requires worship. My Hindu informants may or may not be exclusive devotees of Ram, but when they are doing *puja* to their televisions, they are in *bhakti*-mode. They bring the deity into their homes via pre-recorded video technology at a time that is convenient for them, in a mode that is convenient for them, and in such a way that they can demonstrate their *bhakti* for the deity. This is not to be understood cynically as a modification of the rules in order to make it "easier" for the devotees. Rather, it is something they feel strongly enough about to invest several hours in watching the recording and performing *puja*. They are thus using their watching as a marker of intensified, rather than reduced, *bhakti*. They are demonstrating the vibrancy of the Hindu traditions in their creative use of technological innovations that, on the one hand, are clearly "new" and, on the other hand, reinforce the "old." This is true even of those who do not consider themselves particularly focused on ritual. One woman told me that she would never do something as "superstitious" as *puja*, because that is a "veneration of the physical" and god is beyond forms. But she watches the *Ramayan* regularly and insists that no one in her family comment negatively on the film as they

watch. "It is not Ram, but it *is* Ram's story," she observes; "Therefore, it is worthy of reverence but not worship." Even here, there is a sense of *bhakti*.

So this particular manifestation of Hindu devotion is quite familiar. It demonstrates the vibrancy of the tradition by using a new technology, and in so doing modifies the use of that technology to maintain the continuities with the past. It uses the logic of *puja* and its components and simply modifies the flexible elements within the ritual. So it is perhaps better to see this as a creative modification of an older tradition for the purpose of maintaining the ritual activity than it is to see it as some innovation. The celluloid temple is thus peripheral, to the extent that it is not the usual form of image worshiped in *puja*, but it is also central, to the extent that most of the activities, and the *bhakti* emotions within the worship, are recognizable in "mainstream Hinduism." Thus, this activity is marginal yet central. Above all, it is meaningful.

Notes

1 Dating versions of this story is awkward. Valmiki is generally dated at 300 BCE–200 CE. We can date the medieval Tamil telling by Kamban (*Iramavataram*) to the twelfth century CE, and the heavily philosophical *Adhyatma Ramayana* to the fifteenth century CE. It seems that Sagar was making a conscious decision to be inclusive of all languages and culture areas of India in order to make the *Ramayana* story a marker of pan-Indian solidarity. The other epic, the *Mahabharata*, dates from about the same period as Valmiki. It is a longer, much more convoluted story. Its core, like the *Ramayana*, is inter-familial conflict over accession to a throne. The solutions offered are quite different. Where Valmiki's *Ramayana* posits a non-violent focus on *dharma* ("righteousness"), the *Mahabharata* supports military conflict. Both texts, however, focus on *dharma* and the problem of ethical action in difficult situations. Both stories have been the subject of many film and television versions. Perhaps the latest, and most familiar to Western audiences, is *The Legend of Bagger Vance: Golf and the Game of Life* (Pressfield, 1995), which is a retelling of the *Bhagavad Gita*.

2 To avoid confusion I use *Ramayana* to refer either to the Sanskrit Valmiki telling or to the tradition as a whole. *Ramayan* refers to Sagar's serial, as its title would be pronounced in Hindi. Equally, I use the Hindi "Ram" rather than the Sanskrit "Rama" for the titular character.

3 Madhu Jain gives an account of how, in Jalandhar, the "sanitation workers" (a euphemism for low-caste or untouchable street sweepers), who claim descent from Valmiki, went on strike to insist that their mythological progenitor was seen on screen. On the politics of this "sequel," see Jain, "Ramayan: The Second Coming."

4 One of the difficulties in determining exactly how many people watched the *Ramayan* has to do with the nature of Indian television viewership. India is still heavily rural, and for this television event people would gather in droves but would not necessarily watch it on their own televisions. Often there would be only one television per village, so the whole village, or as many people as was feasible, would take time off work and find space in front of the screen. So even with some sort of best "guesstimate" of the number of televisions tuned in, it is impossible to know precisely how many people watched each television set. However, it is perhaps not too hyperbolic to estimate the numbers to be very nearly one hundred million. For comparison of the numbers here, *India Today* ("Epic Spin-offs" 72) suggests sixty million, while the *Illustrated Weekly of India* ("The Ramayan" 17) suggests that the number is closer to eighty million. It is estimated that, by September 1987, Doordarshan's income for each episode was 2.8 to 3 million rupees ("The Ramayan" 17).

5 In the North American context, *The Ten Commandments,* for example, may be shown every Easter, but it is understood merely as "good, wholesome family values" entertainment. Even *The Passion of the Christ,* while telling a version of the Christ story, was not "worshiped" as a religious icon. Congregations attended screenings, but no one for a minute understood Jim Caviezel to *be* Jesus, though, as we will see, such would have been perfectly logical within the Hindu thought-world.

6 For a more detailed discussion of the connection of margins and centres, see Victor Turner, *The Ritual Process: Structure and Anti-Structure.* Here Turner focuses specifically on the notion of *communitas* as a rejection of social norms by means of the creation of new social structures in the fledgling group.

7 The *Mahabharata,* for example, is so long because of the multi-layered frame stories: one character tells a story in which characters tell stories, and so on. Many folk genres, such as the stories told in *vrat* rituals, also have frames in which a religiously significant personage tells of the efficacy of the *vrat.*

8 This malaise is also an offshoot of Ramlila. Linda Hess ("Rāma Līlā" 190) and I had nearly the same experience almost two decades apart at the Ramnagar *Ramlila.* Both of us came across an elderly man weeping because he "would have to wait a year to see Ram again." He did not mean seeing the *murti* of stone in a temple, but rather that he would have to wait a year until he could see the living, breathing *svarup* again.

9 A woman's primary ritual activity is the form of domestic ritual called *vrat*.
 Vrats include fasting, prayer, and *puja*, but, when men are involved (even as
 performers), it is almost always the women who control ritual activity. *Vrats*
 are performed for the protection and maintenance of the family, which is
 understood to be the woman's primary social and religious responsibility.

Works Cited

Binford, Mira Raym. "Innovation and Imitation in the Contemporary Indian
 Cinema." *Cinema and Cultural Identity: Reflections on Films from Japan, India, and
 China*. Ed. Wimal Dissanayake. Lanham, MD: UP of America, 1988. 77–92.
Booth, Gregory D. "Traditional Content and Narrative Structure in the Hindu
 Commercial Cinema." *Asian Folklore Studies* 54 (1995): 169–90.
Chatterji, Roma. "Authenticity and Tradition: Reappraising a 'Folk' Form."
 Representing Hinduism: The Construction of Religious Traditions and National Identity.
 Ed. Vasudha Dalmia and Heinrich von Stitencron. London: Sage Publications,
 1995. 420–41.
Das Gupta, Chidananda. "The Painted Face of Politics: The Actor-Politicians of South
 India." *Cinema and Cultural Identity: Reflections on Films from Japan, India, and China*.
 Ed. Wimal Dissanayake. Lanham, MD: UP of America, 1988. 127–47.
_____. "Seeing and Believing, Science and Mythology: Notes on the 'Mythological'
 Genre." *Film Quarterly* 42.4 (Summer, 1989): 12–18.
Derne, Steve. *Culture in Action: Family Life, Emotion, and Male Dominance in Banaras,
 India*. Albany: State U of New York P, 1995.
Deshpande, G.P. "The Riddle of the Sagar Ramayana." *Economic and Political Weekly*, 22
 October 1988. 2215–16.
Dharap, B.V. "The Mythological or Taking Fatalism for Granted." *Indian Cinema
 Superbazaar*. Ed. A. Vasudev and P. Lenglet. New Delhi: Vikas, 1983. 79–83.
Dwyer, Rachel, and Divia Patel. *Cinema India: The Visual Culture of Hindi Film*. New
 Brunswick, NJ: Rutgers UP, 2002.
"Epic Spin-Offs." *India Today*, 15 July 1988. 72–73.
Hargrave, Robert. "The Celluloid God: MGR and the Tamil Film." *South Asian Review*
 5.4 (July 1971): 307–14.
Hein, Norvin. *Miracle Plays of Mathura*. New Haven, CT: Yale UP, 1972.
Hess, Linda. "The Poet, the People, and the Western Scholar: Influence of a Sacred
 Drama and Text on Social Values in North India." *Theatre Journal* 40 (1988):
 236–53.

———. "Rāma Līlā: The Audience Experience." *Bhakti in Current Research, 1979–1982: Proceedings of the Second International Conference on Early Devotional Literature in New Indo-Aryan Languages, St Augustin, 19–21 March 1982.* Ed. Monika Theil-Horstmann. Berlin: Dietrich Reimer Verlag, 1983. 171–94.

Jacob, Preminda. "From Co-Star to Deity: Popular Representations of Jayalalitha Jayaram." *Representing the Body: Gender Issues in Indian Art.* Ed. Vidya Dehejia. Delhi: Kali for Women, 1997. 140–65.

Jain, Madhu. "Ramayan: The Second Coming." *India Today*, 31 August 1988. 81.

Kapur, Anuradha. *Actors, Pilgrims, Kings and Gods: The Ramlila at Ramnagar.* Calcutta: Seagull Books, 1990.

Lutgendorf, Philip. "All in the (Raghu) Family: A Video Epic in Cultural Context." *Media and the Transformation of Religion in South Asia.* Ed. Lawrence A. Babb and Susan S. Wadley. Philadelphia: U of Pennsylvania P, 1995. 217–53.

———. *The Life of a Text: Performing the "Ramcaritmanas" of Tulsidas.* Berkeley: U of California P, 1991.

———. "Ram's Story in Shiva's City." *Culture and Power in Banaras.* Ed. Sandria Frietag. Berkeley: U of California P, 1989. 34–61.

Mankekar, Purnima. "National Texts and Gendered Lives: An Ethnography of Television Viewers in a North Indian City." *American Ethnologist* 20 (1993): 543–63.

Melwani, Lavina. "Ramanand Sagar's Ramayan Serial Re-Ignites Epic's Values." *India Worldwide*, February 1988. 56–57.

Menzies, Robert. "Of Myth and Mantra: The Slippery Taxonomy of Printed and Oral *Vrat Kathas*." *Studies in Religion*, 36.1 (2007): 3–21.

Miller, Barbara Stoller. "Presidential Address: Contending Narratives: The Political Life of the Indian Epics." *Journal of Asian Studies* 50 (1991): 783–92.

"The Ramayan." *Illustrated Weekly of India*, 8–14 November 1987. 8–17.

Sax, William S. "The Ramnagar Ramlila: Text, Performance, Pilgrimage." *History of Religions* 30 (1990): 129–53.

Schechner, Richard. *Performative Circumstances: From the Avant Garde to Ramlila.* Calcutta: Seagull Books, 1983.

Schechner, Richard, and Linda Hess. "The Ramlila of Ramnagar." *Drama Review* 21 (1977): 51–82.

Turner, Victor. *The Ritual Process: Structure and Anti-Structure.* New York: Aldine de Gruyter, 1969.

Contributors

SHEILA DELANY is Professor Emerita in English at Simon Fraser University, where she specialized in medieval literature and culture. She received her PHD from Columbia University, her MA from UC Berkeley, and her BA from Wellesley College. She is the editor of *Chaucer and the Jews: Sources, Contexts, Meanings* (Routledge, 2002) and *Turn It Again: Jewish Medieval Studies and Literary Theory* (Pegasus, 2004), the translator of *A Legend of Holy Women* (U of Notre Dame, 1992), a late Middle English work by Osbern Bokenham, and the author of *The Naked Text: Chaucer's Legend of Good Women* (U of California, 1994) and *Impolitic Bodies: Poetry, Saints, and Society in Fifteenth-Century England: The Work of Osbern Bokenham* (Oxford UP, 1998), among other monographs and collections. *Impolitic Bodies* won the first Labarge prize for best book in medieval studies, awarded by the Canadian Society of Medievalists in 1999. Professor Delany spent the Fall semester of 2009 at the Camargo Foundation in Cassis completing her project on the French revolutionary journalist Sylvain Maréchal.

PAUL DYCK is Associate Professor of English at Canadian Mennonite University in Winnipeg. He received his PHD, MA, and BED from the University of Alberta. He has served as associate editor of *Early Modern Literary Studies*. His publications include "'A New Kind of Printing': Cutting and Pasting a Book for a King at Little Gidding," in *The Library: The Transactions of the Bibliographical Society* 9 (September 2008), "'Thou didst betray me to a lingring book': Discovering Affliction in *The Temple*," *George Herbert Journal* 28.1–2 (Fall 2004–Spring 2005), and "Locating the Word: The Textual Church and George Herbert's Temple," in *Centered on the Word: Scripture and Literature in Elizabethan and Jacobean England,* ed. Daniel Doerksen and Christopher Hodgkins (U of Delaware P, 2004). His current research continues to focus on the material book and devotional practices in the work of George Herbert and the Ferrars of Little Gidding.

DAVID GAY (BA, MA Queen's, PHD Alberta), Professor of English and Film Studies at the University of Alberta, specializes in Early Modern literature. His teaching and research interests also include religion and literature and biblical-literary studies. He is the author of *The Endless Kingdom: Milton's Scriptural Society* (U of Delaware P, 2002), and co-editor of *Awakening Words: Bunyan and the Language of Community* (U of Delaware P, 2000). He has published articles in *Blackwell's Concise Companion to Milton* (Blackwell, 2007), *Milton, Rights, and Liberties* (Peter Lang, 2007), *Milton Studies, Milton Quarterly, SEL, ESC, Semeia*, and *Christianity and Literature*, among other journals. He has served as Secretary of the International John Bunyan Society. He is currently Director of the Interdisciplinary Program in Religious Studies at the University of Alberta.

CHRIS K. HUEBNER is Associate Professor of Theology and Philosophy at Canadian Mennonite University in Winnipeg. A graduate of Duke University, his work is primarily in the area of philosophical theology, and can be located at the intersection of politics and epistemology, with special interest in questions of violence and peace. He is the author of *A Precarious Peace: Yoderian Explorations on Theology, Knowledge, and Identity* (Herald P, 2006). He is currently writing a book on martyrdom, knowledge, and the theological virtues.

MYRNA KOSTASH is an Edmonton-based writer of nonfiction. Her most recent books are *Prodigal Daughter: A Journey to Byzantium* (University of Alberta Press, 2010), *The Frog Lake Reader* (2009), *Reading the River: A Traveller's Companion to the North Saskatchewan River* (2005), and the national bestseller *The Next Canada: Looking for the Future Nation* (2000). Her creative nonfiction has appeared in *Brick, Border Crossings, Descant, The Camrose Review, Capilano Review, Rhubarb, Prairie Fire, Geist, dandeLion, CV II, Literatura na swiecie* (Warsaw), *Stozher* (Skopje), and *Mostovi* (Belgrade). Her essays and articles have appeared in anthologies such as *The Thinking Heart: Best Canadian Essays; The Vintage Book of Canadian Memoirs; Why Are You Telling Me This?: Eleven Acts of Intimate Journalism; Fresh Tracks: Writing the Western Landscape; Threshold: An Anthology of Contemporary Writing From Alberta; AWOL: Tales for Travel-Inspired Minds; The Wild Rose Anthology*

of Alberta Prose; and *Edmonton on Location: River City Chronicles*. She has taught widely, most recently in the Writing With Style program at the Banff Centre for the Arts. She has been writer-in-residence at the Regina Public Library, Saskatoon Public Library, the University of Alberta, and Campbell River as Haig-Brown Writer-in-Residence. In 2001 she was a finalist in the Writers' Trust of Canada's Shaughnessy Cohen Prize for Political Writing. In 2008 she received the Writer's Guild of Alberta Golden Pen Award for lifetime achievement. In 2009 she was named to the Edmonton Arts and Culture Hall of Fame. She is a member of the Board of the Parkland Institute at the University of Alberta and is active in many writers' organizations. She is founder and president of the Creative Nonfiction Collective.

ROBERT MENZIES received his PHD from the University of Iowa in 2004. He is currently a member of the Contract Faculty in the Department of Religious Studies at the University of Winnipeg. His research focuses on folk ritual, ritual texts, and women's ritual activity. His dissertation, *Symbols of Suhag*, examined the *vrat katha*, the tradition of Hindu women's domestic ritual stories. He is currently working on a volume of translations of these folktales from the Hindi as well as a second volume of analysis of the themes they contain. He is also beginning a project on how these and other Hindu ritual and story traditions are modified by Hindus living in North America.

EVA MARIA RÄPPLE is Professor of Philosophy and Religious Studies at the College of DuPage in Glen Ellyn, Illinois. She received her PHD from the University of St Andrews (Scotland), an MA in Theology from the Catholic Theological Union in Chicago, and MA equivalents in Latin and Theology from the University of Frankfurt. She is the author of *The Metaphor of the City in the Apocalypse of John* (Peter Lang, 2004), and has published several articles in professional journals, and co-edited books. Her interests in continental philosophy, art, and theological studies are reflected in her interdisciplinary research. Her current research is on intersections between textuality and visuality, employing a range of hermeneutical methods, including historically situated metaphorical, biblical, and literary readings.

STEPHEN R. REIMER (BA [Hons] Winnipeg; MA York; PHD Toronto), Professor of English and Film Studies at the University of Alberta, teaches and conducts research in the literature of the English Middle Ages, focusing especially on textual criticism, manuscript studies, editing, and enumerative bibliography; he is currently working on the fifteenth-century poet John Lydgate. He is the editor of *The Works of William Herebert, OFM* (Pontifical Institute of Mediaeval Studies, 1987), co-author (with Ann Howey) of *A Bibliography of Modern Arthuriana, 1500–2000* (Brewer, 2006), and co-author (with Michael Fox) of an exhibition catalogue, *Mappae mundi: Representing the World and its Inhabitants in Texts, Maps, and Images in Medieval and Early Modern Europe* (U of Alberta Libraries, 2008). He has also published articles in the *Chaucer Review*, the *Journal of the Early Book Society*, *English Language Notes*, *Textual Studies in Canada*, and elsewhere.

JANET CATHERINA WESSELIUS holds a PHD in philosophy from the Vrije Universiteit in Amsterdam, for which she wrote a dissertation entitled *Objective Ambivalence: Feminist Negotiations in Epistemology*. Most recently, she co-edited *Philosophy as Responsibility* (2002). She is Assistant Professor of Philosophy at the Augustana Faculty of the University of Alberta.

SUSAN (SHYA) YOUNG completed her Master's thesis on Christian interpretations of Kabbalah, with an emphasis on one of the most influential texts of this particularly syncretic endeavour, *De arte cabalistica*, written by Johannes Reuchlin and published in Germany in 1517. This text continues to influence contemporary Western spiritual and esoteric traditions. She is currently teaching as a lecturer in the Program in Religious Studies at the University of Alberta. Her research and teaching reflect her interest in mystical and magical traditions, both modern and historical.

Index

Bold page numbers indicate illustrations

death, 85
Demetrius, St, 93–94, 95
devil, 25, 26
dialogical texts, 63–64, 68n21
Dionysius the Areopagite (pseudo), 34, 40n25
Du Guesclin, Bertrand, 5

Erasmus, Desiderius, 30
Eve
 in Baldung's *Eve*, 84–88, **86**
 and Cathedral of St Lazare, 76–78, **77**
 portrayed in Beatus, 73–76, **75**
 and problem of evil, 78–81
 in Uccello fresco, 82–84, **83**
Eve, the Serpent, and Death (Baldung), 84–88, **86**
evil, 78–81

Faerie Queene (Spenser), 59
Fall, the
 in Baldung's *Eve*, 84–88, **86**
 and Cathedral of St Lazare, 76–78, **77**
 portrayed in Beatus, 73–76, **75**
 and problem of evil, 78–81
 in Uccello's fresco, 82–84, **83**
 visual/textual interpretations of, 72–73
feminism
 on level playing field with
 mainstream philosophy, 165–70
 and marginal position in philosophy,
 151, 153, 163
 as particular branch of philosophy,
 156–57
 similarity to Christian philosophy,
 159, 166–67, 167–68
 situated knowledge of, 157–59
 view of reason as masculine, 159–62
 view of reason as situated, 162–63
Ferrar family
 and book making, 60–64
 and moving to Little Gidding, 49–50

project of, 47–49
relations with outsiders, 51–53
tensions within, 50–51
Ficino, Marsilio, 26, 27
film
 and Hindu myths, 179–80, 184
 and recombining art forms, 113,
 117

Galli, Joannes, 7, 15n11
Garsias, Pedro, 26, 30
gaze, the, 72, 78, 85–88
Genesis 3, 72–73
Gislebertus, 76–78
Glagolitic script, 109–10
global capitalism, 132–33
Goekoop, Cees, 115
gospels, 60–64
Gratius, Ortwin, 30

Hadrian, Pope, 111
Halevi, Samuel, 4
Henry of Trastamara, 4–5
Herbert, George, 48
Hinduism
 marginal rituals becoming
 mainstream, 176–77, 190
 and murtis, 180–82
 and mythological films, 179–80
 and participatory nature of Ramayan,
 182–84, 186–88
 and puja, 177–79
 and televising Ramayan, 175–76,
 183–85, 191n4
 and watching Ramayan in North
 America, 185–86
 and women, 188, 192n9
historicism, 1–2
holiness, 57, 59–60
Homer, 119–20
Hoogstraten, Jacob van, 30

Iamblichus, 33
identity
 as Jew, 122-23, 124, 125
 and marginalization, 125
 and martyrdom, 141-42
 and philosophy, 149-50, 156-57, 170
 in Sebald's *Austerlitz*, 141-42, 144, 145
 and St Paul, 134-35
 as victim, 141
images, 71-73. *See* visual experience
imagination, 76, 85-88

Jansen, Cornelius, 60
Jessey, Henry, 123
Jews
 artists' portrayals of, 122-25, 124
 characterized in *Prioress's Tale*, 2, 9-13
 Chaucer's knowledge of, 3-4, 5, 6
 conversion of, 28
 marginality of, 1
 and Marian miracle stories, 9
 persecution in France, 6-9, 14n6
 persecution in Italy, 14n6
 persecution in Spain, 4-6
 readmission to England of, 123-24
 and return of lost tribes, 124-25
Johannes Trithemius, 26, 28, 30
John of Gaunt, 4
Justinian, Emperor, 99

Kabbalah
 Christian interpretations of, 27-32, 40n26
 contemporary view of Christian
 interpretation, 35-36
 defined, 37n1
 and magic, 28, 30-32
 perceptions underpinning Christian
 interpretation of, 23-24
 Pico's interpretation, 27-28
Kant, Immanuel, 154-55
knowledge, 36-37, 153, 157-59

Laud, William, 50
Lazare (St), Cathedral of, 76-78, **77**
Lenton, Edward, 52
Little Gidding
 background to, 49-50
 and book making, 60-64
 and discipline, 53-57
 and reading choices, 57-60
 and religion, 48, 64n1
 tensions in, 50-53
love, 54-55
Luther, Martin, 30

Machaut, Denis, 7, 8-12, 16n17
magic
 belief in, 24-26, 38n5
 Christian view of, 30-31, 34-35
 contemporary view of, 35
 and Kabbalah, 28, 30-32
 and miracles, 2, 9, 34-35
marginality/marginalization
 art's impact on, 113, 115
 in *Austerlitz*, 143, 145-46
 in *Belshazzar's Feast*, 114-15, 127
 of Christianity in philosophy, 151-53
 and Church's view of theurgy, 34-36
 and clearer view of philosophy, 166-67
 definitions, xiii
 of feminist philosophy, 151, 153, 163
 of Ferrar family, 47, 48
 and global capitalism, 132-33
 of Hindu rituals becoming
 mainstream, 176-77, 190
 and identity, 125
 of interpretations of Kabbalah, 30-32
 of Jews, 1
 and Little Gidding's concordances,
 63, 64
 meaningfulness of, 131-32, 143, 146
 and moral judgement, 37
 nature of, 149-50